THE
ENCYCLOPEDIA
OF
AIRBRUSH
TECHNIQUES

THE
ENCYCLOPEDIA
OF
AIRBRUSH
TECHNIQUES

MICHAEL LEEK

CHARTWELL
BOOKS, INC.

A QUARTO BOOK

Published by Chartwell Books Inc
A Division of Book Sales Inc
110 Enterprise Avenue
Secaucus, New Jersey 07094

ISBN 1-55521-510-6

This book was designed and produced by
Quarto Publishing plc
The Old Brewery
6 Blundell Street
London N7 9BH

Senior Editor Kate Kirby
Art Editor Leslie Laskarin-Hanks

Editors Judy Martin
Maggi McCormick

Picture Research Jack Buchan

Art Director Moira Clinch
Editorial Director Carolyn King

Manufactured in Hong Kong by Regent Publishing Services Ltd.
Printed in Hong Kong by South Sea Int'l Press Ltd.

Special thanks to Ingrid Clifford

CONTENTS

INTRODUCTION

It is not so long ago that books on airbrushing were practically unobtainable simply because publishers did not think there was an adequate demand. However, the continued and increasing need for highly finished, *quality* illustrations in every area of graphic design has brought an awareness of airbrushing to a wider audience, even though the techniques themselves may still be elusive to many. Using step-by-step demonstrations and the work of professional illustrators, this book aims to cover the techniques employed. As skills improve and develop so will each illustrator introduce new approaches to his work, which others may find unacceptable or inappropriate, but to the illustrator using them they may become an indispensable technique in all his future work. Because of this, and because there are no rules which must be adhered to, no single book on airbrushing techniques can ever be definitive.

The majority of the readers of this book, I hope, will start by studying the professional examples reproduced here, rather than look at the step-by-step demonstrations first. While it is undeniable that the demonstrations have played a part in the choice of techniques used, the finished examples have been selected primarily on the strength of the airbrushing. Regardless of the fact that most of the illustrations reproduced here were for a specific purpose and would therefore be seen in a context, many do stand as illustrations in their own right – such is the standard being achieved today.

It is fortunate we live in a world where modern communication has allowed greater access to developments within other countries, including those in illustration. The realization that good illustration is often a better means of conveying a message than other methods, and does not require translating, has contributed directly to the demand for highly skilled and imaginative illustrators.

My introduction to the airbrush was a by-product of lectures on the theory of perspective and shadows! These were both subjects I found fascinating and quickly developed an understanding of them. This meant I was often ahead of my colleagues and had time on my hands to take exercises to finished artwork stage. My lecturer would encourage me to render these exercises using an airbrush, Winsor Blue or Payne's Gray watercolour and an old foot-pump with a reservoir - which was designed for use with an airbrush! Not only did this develop my skills in using a new tool, but it also taught me patience – it took a good two or three minutes to pump up the tank to the required pressure and then spray for about 30 seconds before having to start pumping again! All this after slowly and carefully cutting film masks on artwork drawn on paper which was often thinner than the film! (This explains why few of my works have survived – the majority just fell apart like jigsaws.)

Michael E. Leek.

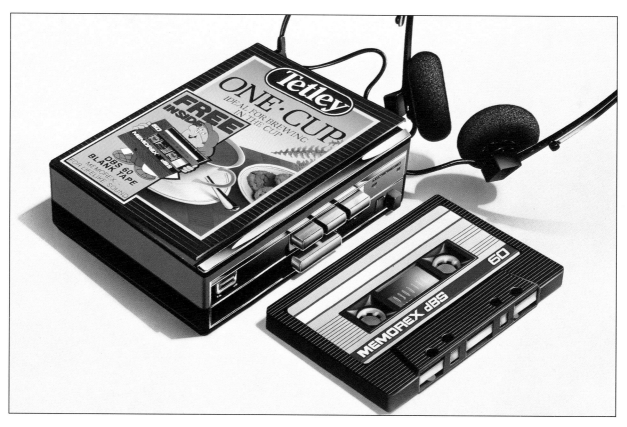

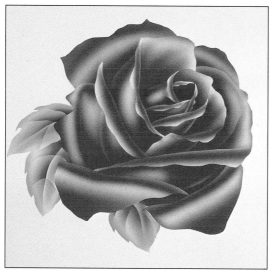

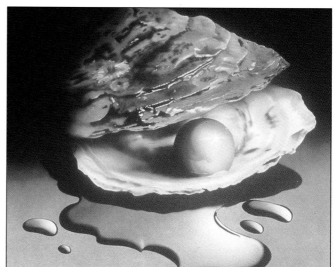

PART I • TECHNIQUES

The application and use of the airbrush as a means of rendering natural, man-made and fantasy or science fiction subjects has increased enormously over the past three decades (even though the airbrush has been with us since the 1890s). Illustrators have found this tool an invaluable aid either for rendering a complete illustration or in limited application to enhance detail, texture, form or contrast on an illustration which has been primarily hand-painted. The airbrush is no longer the exclusive tool of the photo-retoucher or the pure-bred technical illustrator; it is now widely accepted as an essential piece of equipment for anyone involved in the preparation and execution of graphic imagery on a two-dimensional surface. Indeed, its usefulness also extends to many practitioners of three-dimensional design, including architects, modelmakers, set designers and industrial designers.

Because of the more widespread use of the airbrush, various techniques have developed to arrive at the quickest and most effective means of achieving desired effects. Many of these techniques are peculiar to the airbrush and are the result of much experimentation by individual illustrators based on both the advantages and limitations of the airbrush. When the airbrush is in constant use, it will soon be apparent that there are techniques other than those described and illustrated here. They will be discovered or identified through a particular need and may well become essential to the illustrator who chances upon them. In this book, the purpose is to describe those techniques which have a wider and more general application in illustrative work, be it creative or technically based.

In using this book it is essential to remember one very important point about the techniques described and illustrated; because a particular technique may be shown in relation to a specified subject by way of demonstration, it does not mean that this technique is applicable only to that subject and no other. A close and detailed study of the examples of finished and commissioned illustrations reproduced here will identify techniques which at first may appear unsuited to the subject. If the technique allows the illustrator to arrive at a particular effect, the end result will justify the means by which it was achieved. It also follows that an illustration may use only one identified technique, while another may use all and perhaps some other peculiarly inventive method. Because of this, the widest possible range of finished examples has been selected, and all have been chosen because they demonstrate good technical skill in the application of the airbrush, the subjects themselves being almost secondary. It should also be mentioned that in studying the variety of styles used in the finished illustrations, you may find that there are in fact no hard-and-fast rules governing techniques. The technical detail is based on the accumulated experience of the illustrators who have kindly lent work.

Airbrushing is an acquired skill. It requires practice, patience, careful plannning, experiment and, to produce successful work, an understanding and awareness of color, light, tone and contrast. In addition an ability to draw is essential.

ACETATE MASKING

Acetate is a completely transparent, plastic material available in sheet or roll form and in a number of different thicknesses. It is useful in airbrushing as a substitute for, and complement to, self-adhesive masking film. Because it lacks adhesive, acetate will allow residual color to encroach underneath, creating a soft-edged effect which can be used to advantage. If this is not wanted, care must be taken to ensure that the mask is held evenly and flatly against the artwork to provide a firm edge to the sprayed area.

The cut or broken edge of a piece of acetate can be used to form a loose mask, or a whole shape can be cut out of the material corresponding to a particular part of the artwork. Because acetate is, like masking film, completely transparent, the mask can be accurately positioned in relation to previously sprayed areas of the image. When acetate is cut, especially for a mask which has sharp, hard-edged corners, it can be prone to splitting. Although a split may appear insignificant on the acetate mask, it is surprising how a small amount of sprayed paint passing through it will be sufficient to show up on the artwork.

1 Sweeping curves have been cut into a piece of acetate. This has been laid flat on the illustration board and color sprayed along the curved edge.

2 When the acetate is moved away from the sprayed area, it can be seen that the curve is accurately repeated by the spraying. The edge quality is slightly less crisp than would be the case if masking film had been used.

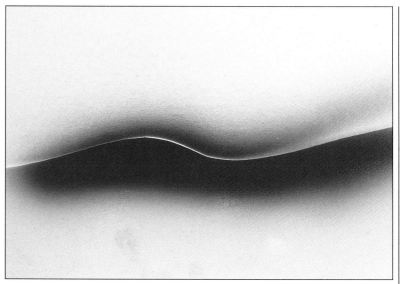

3 The same mask is used, but instead of leaving all of it flat on the artwork, one end has been lifted while spraying.

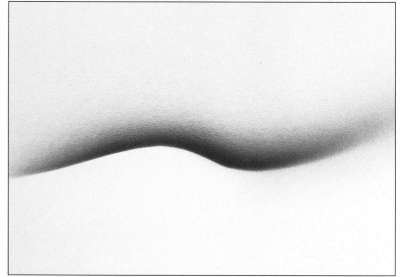

4 The removal of the mask shows that where the acetate was laid flat, the sprayed color has a firm edge, but where it was lifted, the color fades off and blends into the white of the board. This is a useful technique when both hard and soft edges are required at the same time.

ANGLED SPRAYING

This term is used to describe the technique of blending colors into each other, without having a hard, or clearly defined edge between them. It is achieved by the distance the airbrush is held away from the artwork and the angle at which the airbrush is in relation to the artwork surface. This technique may be used in conjunction with the section on GRADATED TONE.

Wide-band Blending
1 It is required to blend two colors together without an edge between the two being shown. After the over-all area for the color work has been masked off, the first color is sprayed from top to bottom, holding the air-brush at an angle of 90° to the art-work to create a very soft and gentle gradation.

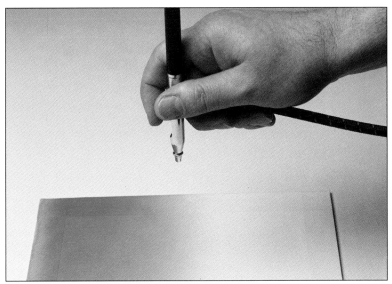

This photograph demonstrates the height and angle of the airbrush in relation to the artwork as the first color gradation is applied.

2 The second color is now sprayed at the same angle as the first, allow-ing the gradation to overlap and merge with the first color.

In applying the second color, the art-work has been turned 180° so that the color can again be sprayed from the top of the board, allowing greater control.

Narrow-band Blending

1 In this example a narrower band of blended color is demonstrated. At this stage the gradation from color to the white of the board is more sudden.

The first color is being sprayed from the top with the airbrush held at a shallow angle to the surface.

Using Cardboard in Angled Spraying

In both of the following examples, reference can also be made to CARD-BOARD MASKING, LOOSE MASKING and TORN PAPER MASKING.

1 In this example the cardboard is held slightly away from the artwork and the airbrush is at an angle of 90° to the surface. This will give a fairly firm, but soft edge on completion.

2 The second color is applied as in stage 1. The finished result shows a clearer definition between the two colors than in the wide-band demonstration.

The artwork has been turned 180° for the spraying of the second color, with the airbrush being held at the same angle as in stage 1.

2 In this photograph the cardboard is again used as a mask, but the angle of the airbrush has been brought down toward the horizontal, which will give a much softer edge and gentler color gradation.

BASIC EXERCISES

The preparation of any type of artwork or painting requires concentrated practice and patience. Time spent here will pay dividends later and prevent unfortunate and unnecessary mistakes from being incorporated into finished artwork. The airbrush is not a difficult tool to use, but as with all others, what it can and cannot do needs to be understood, and there is no better way than practice. Having said that, this section should not be seen in isolation from the other techniques described in this book.

For the beginner, it can be difficult at first to obtain full control of the flow of paint and air through the airbrush—smooth action in starting and stopping the spray, essential for freehand work, and control of an even spread of color, even when masks will be used to define specific shapes. In addition, the height and angle of the airbrush during spraying affect the final result. Basic exercises can take any form which helps to develop the artist's understanding of the tool's capabilities.

This sheet has been covered with different techniques and applications of the airbrush. All have been completed primarily without use of masks of any kind. This type of "doodle-sheet" is excellent practice, which enables the aspiring airbrush illustrator to develop skill and confidence in using the airbrush, and also in understanding the limitations of the tool.

BASIC FORMS

These exercises cover four basic shapes: a cube, cylinder, sphere and cone. They represent the principal geometric shapes which are likely to be encountered in airbrushing an incredible variety of subjects, whether taken individually, in groups or, as is more likely, parts from each in any combination. If specific and detailed areas in a large number of the finished illustrations in this book are closely examined, it will become apparent that many of the abstract shapes which make up the illustrative content are composed of surfaces such as angled planes and curves which can be extracted from these basic shapes.

Not only is practice essential in order to master the skill of handling the airbrush, but it is also useful in understanding the shapes themselves. Furthermore, if you extend the principle of these exercises by varying the colors and surface textures, you will acquire greater understanding of how light affects the shading and contrast from one surface to another, from one side to another, and from one object to another.

The Cube
1 The cube is drawn symmetrically with one corner directly facing the viewer. The cube and the surrounding area are covered with a single piece of masking film.

2 The film covering the left-hand face of the cube is cut and removed for the first stage in the spraying sequence. The left-hand face is sprayed with the greater depth of tone to the right and running parallel to the vertical edge. This is gradated on the left to show a subtle, reflected highlight.

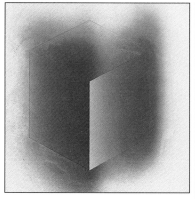

3 Leaving the left-hand face unmasked, the film masking the right-hand face of the cube is cut and removed. On this plane the depth of tone runs from right to left, but with increasing strength in the highlight toward the leading edge of the cube.

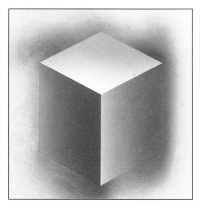

4 The horizontal surface of the cube is cut and removed, again leaving the two vertical surfaces unmasked. The depth of tone here is lighter overall than on the vertical plane and runs horizontally from the top to the bottom, with the nearest corner to the observer being almost devoid of color.

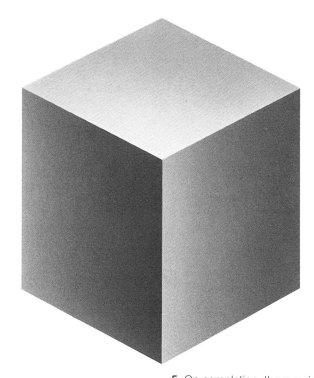

5 On completion, the remaining film is removed, showing the cube rendered in monochrome with enough depth of contrast to create a three-dimensional image.

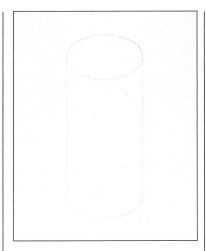

The Cylinder

1 A straightforward drawing of a cylinder, standing vertically on one end, is covered with masking film which extends also across the background area, as for the cube.

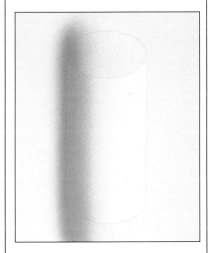

2 The body of the cylinder is cut and the film removed. The spraying begins from the left-hand edge, and the color is allowed to overlap the background masking. It is sometimes advisable to turn the artwork when spraying so that the cylinder is horizontal, with the first edge being sprayed at the top. This makes it easier to control the extent and depth of color, besides ensuring that the color runs parallel to the centerline of the cylinder.

3 On the right-hand edge, the same technique is applied as in stage 2. The important difference is that the color is applied within the edge of the masked shape to create a thin, reflected highlight at the extreme right of the cylinder.

Again the color is gradated quickly as it is brought toward the center of the cylinder. This gives a strong highlight at the center, running the complete length of the cylinder and parallel to the edges.

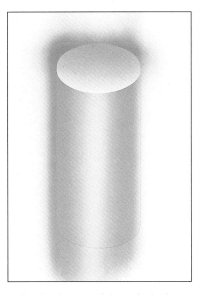

4 Finally, the top of the cylinder is sprayed. After cutting and removing the film from the elliptical plane, color is sprayed in a horizontal direction, concentrating on the outer or upper edge so that only residual color falls onto the leading edge.

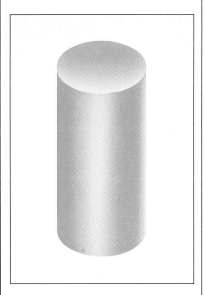

5 The masking film is removed, leaving a hard-edged cylinder illuminated by a light source immediately in front. This technique produces a simple but effective form with a "satin" finish.

The Sphere

1 A circle is cut directly into masking film which has been laid on the illustration board, using a compass cutter. A piece of masking tape is placed at the center to prevent the compass point for from marking the boardbeing marked and also to assist in removal of the mask.

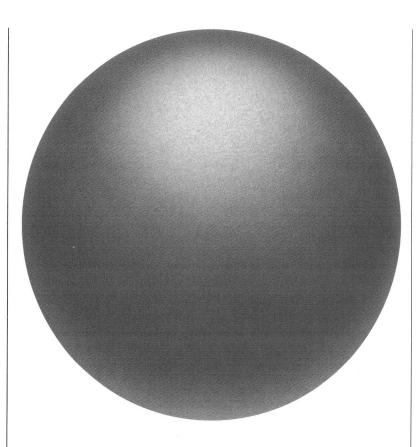

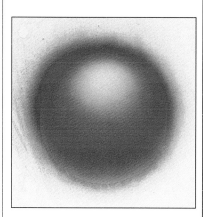

2 An oval of color is sprayed which encompasses the top and both sides of the mask, but does not extend as far as the lower edge. This gives a reflected highlight on the base of the sphere which will enhance its three-dimensional quality. This initial oval of color must be applied carefully and is best attempted after practicing with the airbrush on a freehand basis. As there are no planes within the overall shape of the sphere, the mask only defines its outline, not the internal areas of light and shadow.

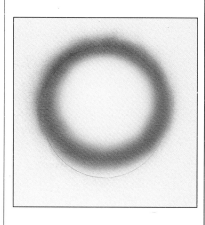

3 In the second stage of spraying, color is applied, leaving a soft-edged, roughly circular highlight near the top of the sphere. Residual color slightly softens the reflected highlight at the lower edge.

4 Once the masking film has been completely removed, the reflected highlight at the base of the sphere and the principal highlight at center top are more effectively appreciated. After practice in controlling the airbrush for freehand modeling within the masked outline, it will soon be possible to produce spheres with the light sources angled from other directions. A study of spherical objects and the way light falls on them, as well as the way in which other colors are reflected, will be of immense value for future practice and application.

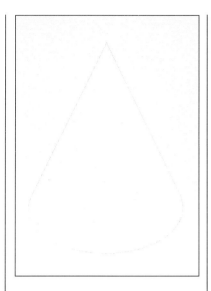

The Cone

1 The cone is drawn using an ellipse template for the base to give a three-dimensional impression. The artwork is covered with masking film and the cone shape cut out.

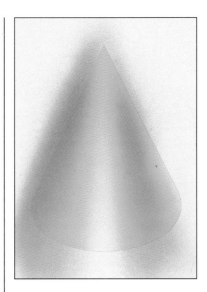

3 The same exercise is carried out on the right-hand side, but, as with the cylinder, the color is not concentrated on the masked edge; it is brought in slightly to allow a reflected highlight to be shown. Again the color is gradated quickly towards the center to create the main highlight.

2 In this example the illustrator has chosen the left-hand edge of the cone to be sprayed first. The color is taken over the masked edge and gradated quickly as it comes around towards the center of the cone. When spraying a cone, it is important to remember that the color should be applied from the base to the top and the area sprayed should follow the overall shape of the cone.

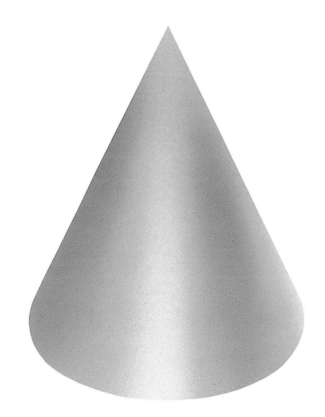

4 The final stage is the removal of the masking film. The cone is seen as a complete three-dimensional form with the central highlight and soft shading creating a "satin" finish like that of the cylinder.

CARDBOARD MASKING

This technique is on the same lines as ANGLED SPRAYING, LOOSE MASKING and TORN PAPER MASKING, and reference should also be made to them when following the sequences illustrated here.

The advantage of cardboard as a masking material is that it is readily available and inexpensive – you can use pieces left over from other studio projects. It can be used to mask particular shapes quite accurately and to create various edge qualities, but as it is opaque, it is less versatile than acetate or masking film.

Straight Edge
A piece of straight-edged cardboard has been laid flat on the artwork; the area of color resulting from spraying over the cardboard has a soft but clearly defined edge.

Shaped Edge
1 A piece of cardboard has been cut to a predetermined shape, in this case a gentle curve.

2 This is then laid on the artwork and, after spraying, shows again the clearly defined but soft edge.

3 When the same shaped mask is used, but held above rather than on the artwork, the resulting edge is gradated and much softer, due to residual color seeping under the cardboard. The further the cardboard is held from the surface when spraying, the more diffuse the effect.

Torn Edge
1 A piece of card has been torn in half. This can be done randomly or following a pencil guide, but in the latter case, remembered that it is not possible to achieve absolute accuracy.

2 The effect achieved from spraying over the torn edge when the mask is laid flat on the artwork.

3 The effect achieved when the mask is held above the artwork, showing the more diffused, gradated edge. Again the variation in the degree of gradation can be controlled by the distance the mask is held away from the artwork.

CAST SHADOWS

Cast shadows have a variety of uses in illustration. Not only do they help in visually making the subject stand out to the front, but they are also an effective means of enhancing the three-dimensional qualities of an illustration. The demonstrations here show a soft-edged shadow effect sprayed freehand and a hard-edged shadow created with masking film.

Shadows can be generated from an artificial light source or by natural light from the sun. Each have their own set of rules. The techniques of plotting shadow areas are a subject in themselves, and those wishing to experiment further should refer to books dealing specifically with perspective, besides observing what actually happens in reality. The scope of this book does not permit an extensive explanation of the many complexities of the theory and application of perspective in relation to shadows. However, some guidance may be gained by studying the many examples of professional airbrush work reproduced in this book and recognizing where shadows have been used for a specific purpose.

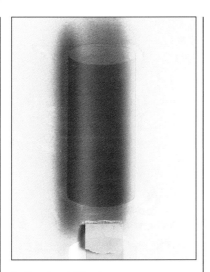
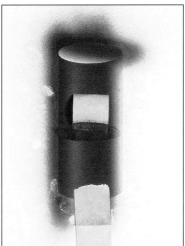

Soft-edged Shadow
1 A vertical cylinder is drawn and covered with masking film. When the outlines have been cut, masking tape is used to anchor the mask section covering the body of the cylinder to make it easy to remove and replace because this mask will be required again. Alternatively, the

piece of film can be lifted and placed on the backing sheet for protection until it is re-used. The cylinder is sprayed as previously described (page 15), but with adjustments made with regard to the position of the highlights, as it is intended to cast a soft shadow to the left and toward the observer.

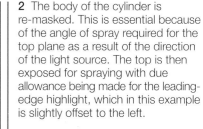

2 The body of the cylinder is re-masked. This is essential because of the angle of spray required for the top plane as a result of the direction of the light source. The top is then exposed for spraying with due allowance being made for the leading-edge highlight, which in this example is slightly offset to the left.

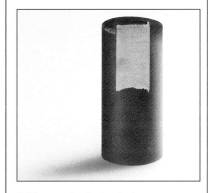

3 The masks for both the top and body of the cylinder are replaced to protect it while the shadow area is sprayed, but all background masking is removed. The shadow is sprayed from the approximate center of the base, gently bringing the color out to the extremities, but keeping well within an area relating to the width of the base. The length of the shadow should not be too long and should fade gradually and easily away from the cylinder.

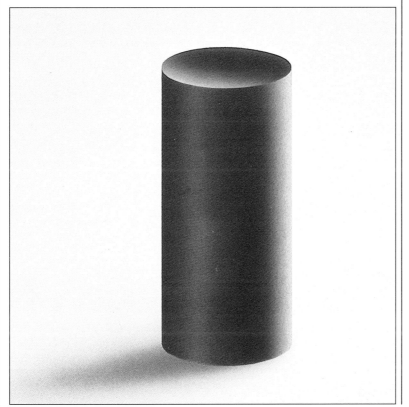

4 The final stage is the removal of the masking film from both the top and body of the cylinder.

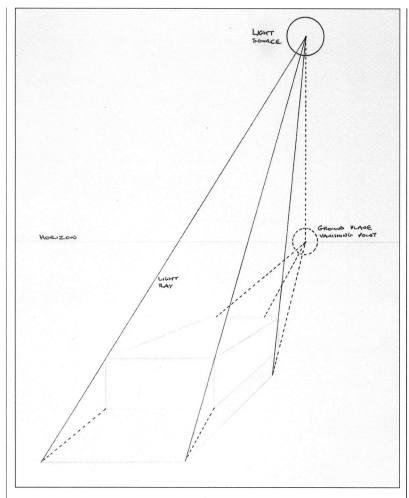

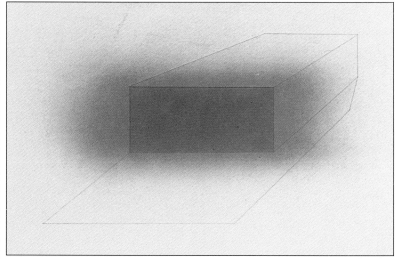

3 The side of the box nearest to the observer is sprayed first because this will be the side in complete shadow, without any reflected light. It should be sprayed with a medium-strength, flat of color.

Hard-edged Shadow

1 For the purpose of expanding this exercise in cast shadow techniques, a rectangular box is shown in three dimensions with the construction of its shadow, as if cast from the sun rather than from artificial light. The terms should be self-explanatory, but it must be remembered that the vanishing point on the ground plane will always lie on the horizon and also immediately below the light source.

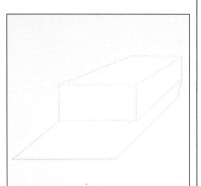

2 Having constructed the box and its shadow, the drawing is transferred to illustration board, but leaving out the construction lines. The whole surface is then covered with masking film.

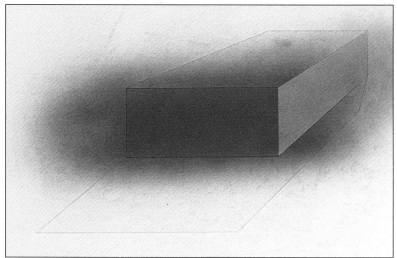

4 The right-hand side of the box is next, and the film covering this area is cut and removed. There is no need to replace the mask previously removed for stage 3, because this side needs to be the strongest in tone and leaving it exposed allows the color density to be built up in successive sprayings.

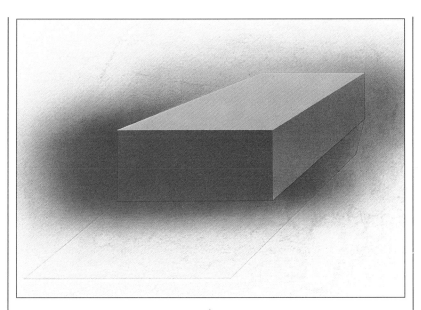

5 Next the top is sprayed, again leaving the previous stages exposed. With the viewpoint chosen, the top of the box is shown as receiving the maximum amount of light, thus having the highest overall tone, and this should be borne in mind when spraying.

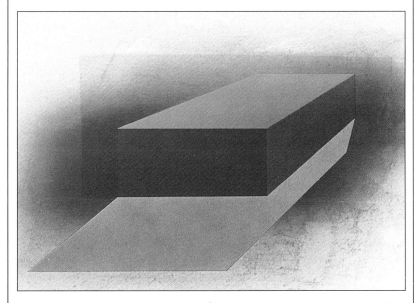

6 The box is re-covered with masking film. The masking film covering the shadow is cut and removed. In this exercise a flat tone is laid down to represent the shadow, but it is also acceptable, and in keeping with nature, to make hard-edged shadows gradated. The gradation may pass outwards from the object or inwards from the extremities of the shadow; it is all dependent on the effect and emphasis needed.

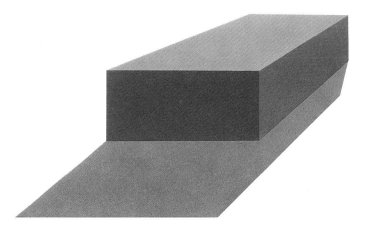

7 The final image shows the completed box and its shadow with all the masking film removed. Because of the sequence in which the box was sprayed, a certain luminosity is apparent, which assists in delineating the shape and defining the direction of the light source.

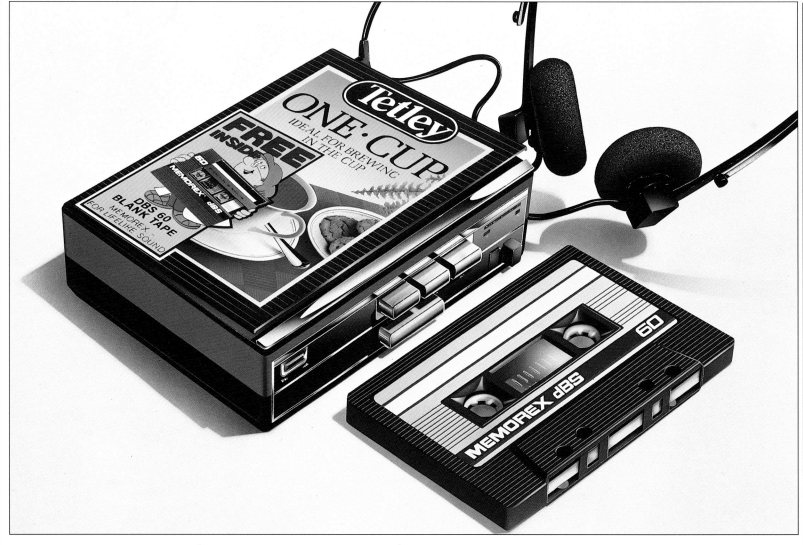

**Tetley One-Cup personal stereo
John Brettoner**

Modern hi-fi equipment and personal stereos are subjects which have proven popular with illustrators specializing in airbrush rendered illustrations. The subjects seem to be particularly apt, and the example reproduced here is excellent, showing the quality of overall finish which all students of airbrushing should aim to emulate. It is included in this section because it demonstrates clearly the application of GRADATED TONE to form soft-edged cast shadows. Without them, the three items would appear to float in space; as it is, the cast shadows create the impression that they are lying on a flat surface, even though no color or edges are visible on this imaginary surface.

The illustration is comparatively simple in terms of the accurate plotting of the shadows. Other subjects may not be, but all require careful observation to ensure that they at least look as if they are the true shadows of the object from which they are cast. When planning the inclusion of shadows, it is essential that their position and direction does not conflict with the direction of the light source, regardless of the material or surface of the subject being sprayed. Highlights and shadows should always be in harmony with each other.

There are two other airbrushing techniques used on this personal stereo which deserve to be mentioned here, because they represent excellent examples. First, the LETTERING TECHNIQUES, which have a quality indicating the obvious skill and care which the illustrator has applied; second, the very subtle application of SPATTERING on the speakers, which is just enough to indicate the surface texture.

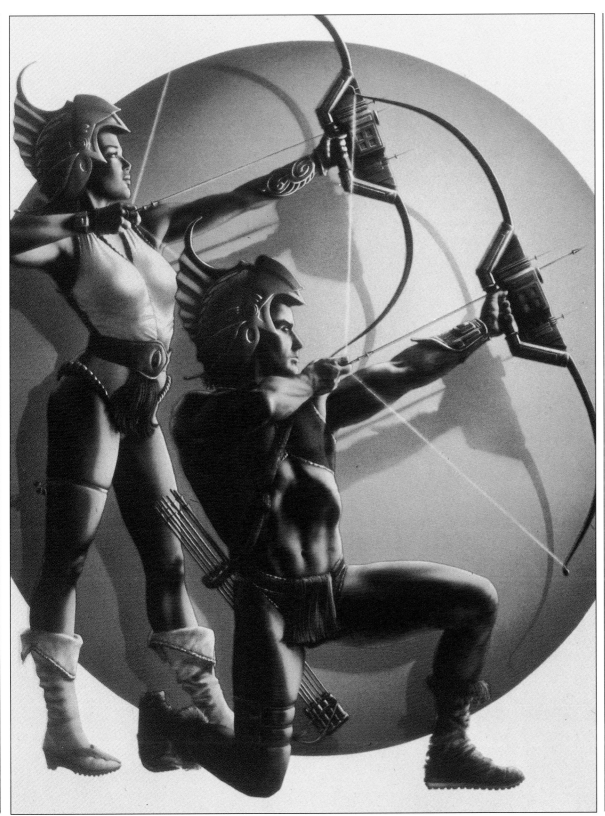

Archers
Andrew Farley

The importance of the light shadows being in harmony with the source of light is made even more apparent in this illustration. By defining the shadows and the angle of the light source, on both the sphere and the bodies of the archers, a clear impression is given of the time being at sunset. The color tones, strength and extent of the shadows on the bodies increase this impression. The cast shadows on the sphere [see BASIC FORMS], as well as the shading across its natural form indicate the direction of the light, with these shadows applied by loose masking or acetate masking.

The archers also demonstrate the degree of observation required when airbrushing the human form. Other examples may be seen in the second half of this book under the section focusing specifically on rendering HUMAN FORM with the airbrush.

CHROME EFFECTS

By its very nature, chrome, or any other highly polished or reflective surface, is difficult to reproduce convincingly in an illustration. While the airbrush is a more than useful aid, if the effect is not rendered with care and pre-planning, it can be extremely crude and simplistic. It therefore requires practice and a close study of actual examples, including the methods used in some of the illustrations reproduced in this book. This is because chrome is rarely seen without something else reflected in it, usually in close proximity.

These exercises introduce the technique of how to approach the airbrushing of chrome in both black-and-white and color. Each is demonstrated in isolation, and neither should be taken as the only method. When airbrushing chrome, the approach adopted must be judged on its merits and is dependent on such things as the location of the chrome in relation to other objects or materials, the base color of surrounding objects, and colors in the environment in which the chrome needs to be shown. All of these will obviously determine the base and reflective colors to be used when spraying.

The color exercise shown here uses a convention for creating the effect of reflected color. This is based on the assumption that the lower part of a chrome object might be reflecting earth colors from the ground, while the upper part reflects lighter tones from the sky. This ground/sky division requires the artist to establish an approximate horizon level across the chrome surface.

Finally, always ensure that the air pressure through the airbrush is correct. If it is too low, the finish will appear grainy and textured, which would take away the reflective appearance. Chrome has an extremely smooth surface.

Monochromatic Effect
1 As the basis of this example, a cylinder is drawn three-dimensionally and in a horizontal position. The artwork is covered with masking film in preparation for spraying.

2 The body, or length, of the cylinder is divided into various shaded areas and those needing the strongest or darkest shades are cut, unmasked and sprayed first. It is important that when spraying a black-and-white object, the darkest areas are sprayed first, as this not only saves time, but also requires the minimum of mask cutting. By following this sequence, any residue from subsequent spraying which automatically encroaches on the darkest areas will merely strengthen the darkest tones and, with proper control, improve the depth of contrast in the finished artwork.

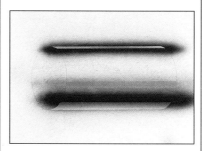

3 The areas of medium are exposed and sprayed.

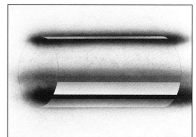

4 The first of the gradated tonal areas is now cut, removed and sprayed, making sure the color does not extend too far down and thereby diminish the strength of the highlight.

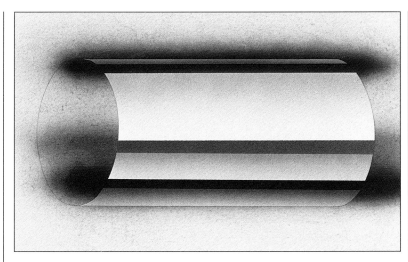

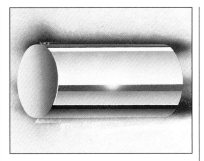

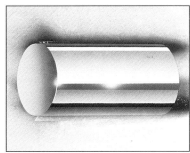

8 The masking film protecting the body of the cylinder is removed, and a thin highlight is scratched with an art knife along the curved edge between the body and the end of the cylinder.

9 Another opaque white highlight is applied freehand over the linear highlight scratched back in stage 8.

5 The second area of gradated tone is applied to the top half of the cylinder. Again, be careful not to spray too heavily as the color is brought down into the area of the white highlight.

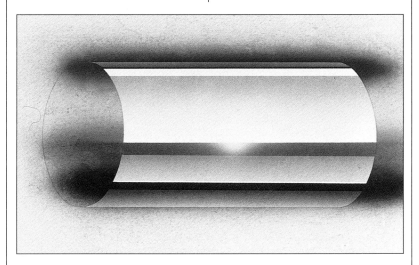

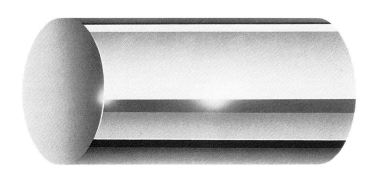

10 The surrounding masking film is removed, revealing the finished artwork. With more practice, and by observing actual examples, it will soon be apparent that there are many variations possible in rendering highly polished surfaces such as chrome.

6 Using opaque white, an intense highlight is sprayed freehand and in the approximate center of the body of the cylinder.

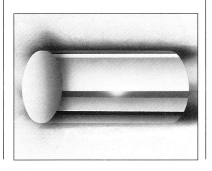

7 The body of the cylinder is now re-covered with masking film and the end of the cylinder is exposed for spraying. To emphasize the edge of the cylinder, the color is applied vertically and gradated from right to left, allowing a sufficient residue of color to extend over the complete surface of the end plane.

Ground/Sky Reflection

1 Using the same image, the cylinder is drawn and covered with masking film. The end of the cylinder is prepared for spraying and an acetate mask is overlaid, which has been cut to follow an approximate "horizon" level across the center of the cylinder. This exposed area is sprayed with gradated color, using yellow ochre and vandyke brown to represent the base or ground which would be reflected in the cylinder. The yellow ochre is sprayed first, covering the whole area. This is followed by an overspray of vandyke brown, but concentrating the color at the top edge of the mask, which represents the reflected "horizon." This is gradated down into the yellow ochre, but not so that it covers it.

2 The acetate mask is removed, and blue is then sprayed from the top of the cylinder end, gradating downward toward the "horizon." To be effective, this color should have enough gradation to allow the white of the board to come through between the brown and the blue, as shown here. The end of the cylinder is now completed.

3 The masking film is replaced over the sprayed area, and the film protecting the body of the cylinder is removed. Another acetate mask is prepared to allow exposure of the area covering the ground from the "horizon" down. This is sprayed using the same colors and following the same sequence as for the end of the cylinder.

4 The acetate mask is removed and the reflected color for the sky is sprayed, again being gradated from the top to the "horizon."

5 The linear edge between the end and the body of the cylinder is highlighted by scratching out color with an art knife. This is followed by a sprayed highlight of opaque white immediately above the "horizon" line across the body of the cylinder, using an acetate mask to protect the background color.

6 A highlight, again of opaque white, is sprayed freehand on both the linear highlight and approximately in the center of the body of the cylinder. Both are positioned at the level of the reflected "horizon."

Metallic tap fittings
John Brettoner

Effects similar to those appearing on the surface of chrome will be seen on any highly reflective and polished surface, such as brass, copper or stainless steel. This illustration of two single faucet flanking each side of a mixer faucet is an excellent example of how one illustrator has successfully rendered the same subject with three different metallic finishes. The faucet on the left is of brass; the mixer in the middle has a semi-gloss enameled finish and the one on the right has a chrome finish.

The majority of examples of airbrushed chrome finishes in illustrations can be found on vehicles, as demonstrated under TRANSPORT (pages 98-115). However, while vehicles spend much, if not all, of their lives in the open and therefore the rendering of their chromed surfaces lends itself to reflections of horizons and the blue of the sky, this is not appropriate to objects seen inside. A compromise is therefore necessary, especially if, as in the illustration reproduced here, no surrounding objects or surfaces are included. Under such circumstances the illustrator must resort to studio-shot photographs for reference, or, as is more likely, his or her skill and knowledge of how compound surfaces appear when reflecting nothing more than pure light and other parts of the same object. Such a technique may seem abitrary in application, but if the finished result looks as intended, then success is achieved.

Techniques used on this illustration include FILM MASKING, LOOSE MASKING, FREEHAND SPRAYING, LINING-IN and RULING. The background is a good example of ANGLED SPRAYING and GRADATED TONE. Worth special attention are the subtle reflections made by the sectioned part of the mixer faucet in the handle and body of the faucet on the right. Soft, gradated reflections of the faucets are also visible on the surface. To give contrast between the warmth of the brass and the hard coldness of the chrome, touches of dark green have been applied to the latter.

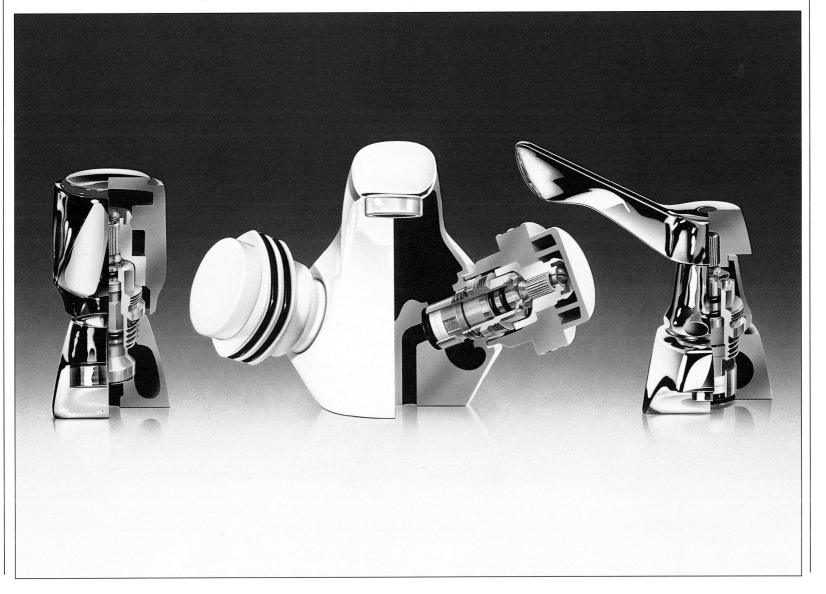

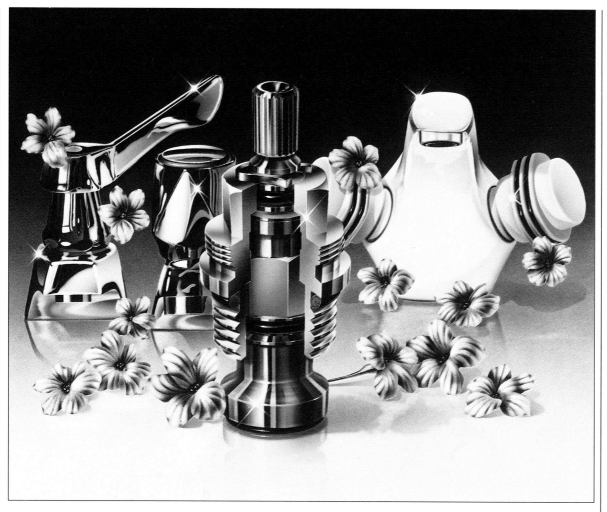

Black-and-white faucets
John Brettoner

As a contrast to the full-color rendering of faucets, an example is given here of a similar subject rendered with an airbrush in black-and-white. In the foreground is a valve assembly, with two single faucets offset to the left and behind it. To the right is an enamel-finished mixer faucet.

Because the illustrator has only black, white and the various shades of gray obtained by mixing the two base colors, the airbrushing demands a high degree of skill in the understanding of shading, contrast and light and shadow. It also requires very careful planning to prevent one area from blending in with another or the objects seeming to merge. This illustration achieves all, with not one part being illegible or vague. It has been rendered using the same techniques as the full-color illustration, including the background, but with the addition of STARBURSTS in seven selected, and carefully thought-out, places. Soft-edged CAST SHADOWS sprayed with GRADATED TONES have also been used, which adds to the impression of the faucets sitting on a surface.

Laser-cut bread
John Brettoner

Strong contrast between one material or texture and another is one of the distinct advantages of airbrush rendering as compared to hand-painting, where it can be difficult to achieve the same precision. With a considered approach and using the appropriate techniques, the effect can be quite stunning, as shown here in the definition applied to the robot's hand and a loaf of bread being cut by a laser beam. The robot's hand has been sprayed in what have become almost the traditional colors for rendering chrome, using FILM and LOOSE MASK-ING. In addition, reflections have been added to the hand where it is gripping the bread, and also from the laser beam. The addition of such reflections always makes an illustration look complete, but the illustrator must take care not to overdo them or place them in the wrong position.

Hand-painted and sprayed DOT HIGHLIGHTS have been placed on the hand and metallic base in positions reflecting the most intense light. These have not been used excessively, but just enough to add to the dramatic effect in the chromed finish of the hand and smooth surface of the base.

The loaf of bread combines brush-work with SPATTERING, which has also been used, in varying densities, to represent the starlit night. One star has been highlighted by the use of a STARBURST, DOT HIGHLIGHT and HALO. The laser beam is composed of a wide band of pink which has been LOOSE MASKED to give it soft edges, and then OVERSPRAYED with two thinner red lines within the pink. Between the two red lines, an opaque white line has been drawn in, ending at the metallic surface with a large, freehand dot highlight. The final touches to this illustration are the ruled lines representing both highlights and linear detail [see RUL-ING and LINING-IN].

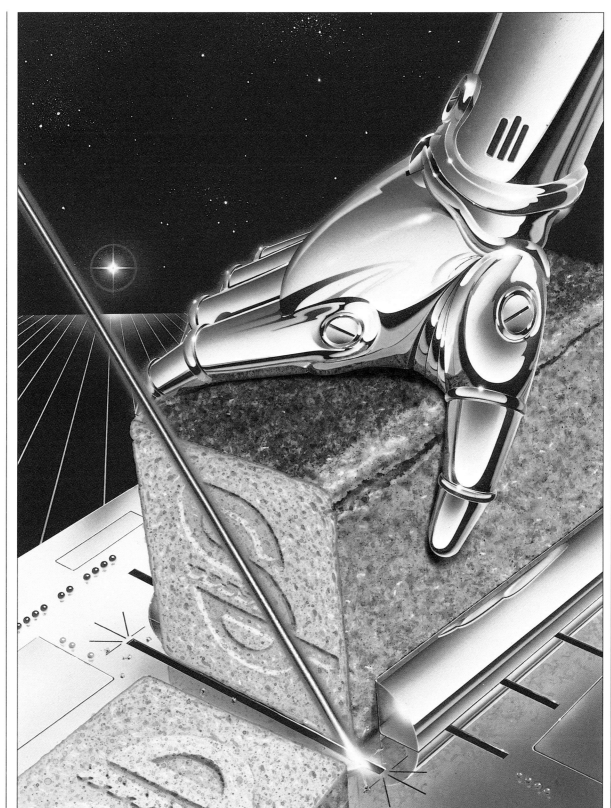

CORRECTION TECHNIQUES

Errors and accidents are unavoidable; it is therefore necessary to devise quick and effective techniques which can rectify the situation without having to resort to a complete re-start. The example illustrated here, an irregularity in the spray quality, is a common mistake, usually the result of lack of control. Sometimes it is caused by dried paint particles being blown onto the artwork through poor cleaning of the airbrush.

Over-spraying with White
1 It was intended to produce a piece of artwork with smoothly gradated color running from maximum strength of color at the top to a very soft and subtle strength at the bottom. However, it can be seen that a small but noticeable error has unfortunately been made in the lighter area of the spraying.

2 To rectify this mistake, opaque white is sprayed across the complete width of the colored area containing the irregularity, but gradating from the bottom to approximately the middle to maintain the original gradation.

3 To retrieve the required density of the tonal gradation, the area is resprayed with the original color after the white paint has dried.

4 When the mask is removed, the effect is of a clean area of gradated color.

Lifting Watercolor
When correcting small watercolor-based areas of the artwork, cotton buds may be used to remove paint. If the color is fairly strong, it may be necessary to use quite a few buds, especially if the area requiring correction must be brought back to the white of the original surface. This method is not always effective when used on a textured surface, such as rough board-mounted paper, because the pigments become ingrained in the surface. It is best restricted to smooth, china-clay coated boards.

Removing Color Bleed
In this example the paint was sprayed on too wet. Consequently, color has run under the mask, resulting in an unsightly, ragged edge. On a smooth, hard coated surface, such errors are best removed with an art knife when the paint is thoroughly dry. Reference should also be made to the technique of SCRATCHING BACK.

DOT CONTROL

Many people, when first introduced to the airbrush, believe it is only capable of spraying medium or large areas and is not suitable for fine, detailed work. Plenty of dot control exercises will not only prove them wrong, but will also build up confidence and skill in using the airbrush. It is also good practice for applying sprayed dots as highlights to give sparkle to the finish of a detailed illustration. This technique is covered under DOT HIGHLIGHTS in the following section.

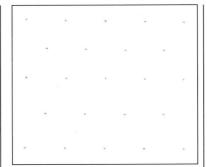

1 This shows a sheet of same-sized dots laid out in five horizontal rows. The control lies in attempting to achieve the same size and color intensity in each sprayed dot.

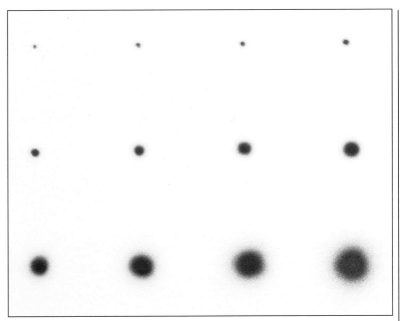

2 Here three rows of dots have been sprayed progressively from small to medium to large. As every dot in the sequence varies, this extends your control of the flow of medium and the distance of the airbrush nozzle from the board surface to achieve the right size of dot.

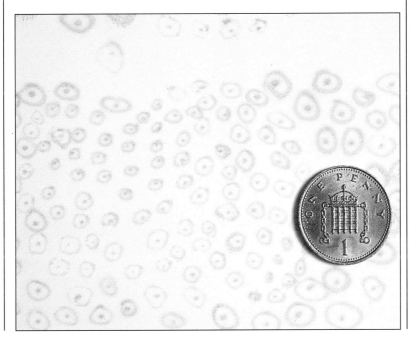

3 To increase control of the airbrush and both the air pressure and amount of paint allowed through it, these dots have been sprayed individually and encompassed in sprayed circles. The small penny coin gives a good indication of the scale of the original exercise.

DOT HIGHLIGHTS

The use of dot highlights is a particularly valuable means of adding that final, finishing touch to an illustration. Highlights must obviously be used only on those surfaces and on edges which would normally reflect light in such a concentrated way. They should appear as an integral part of the object and must always conform to the chosen direction of the light source.

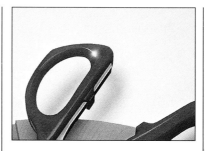

3 Opaque white is then sprayed directly over the dots to diffuse the edges, although in some cases this may not be necessary.

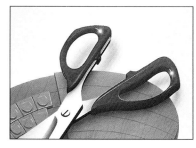

4 The completed image, by comparison with the first stage in this sequence, shows how the more complex highlight detail adds luster to the finished image.

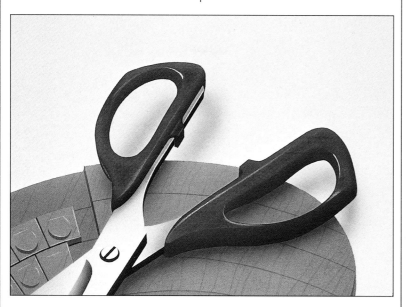

On a Curved Edge
1 To pick out the edges on which light would be intensely reflected and also to enhance the contrast and three-dimensional quality of the scissors in this illustration, white lines have been scratched onto the handles. It should be noted that these highlights are not short, blunt lines, but taper off toward the narrower part of the handles. This is important, because the highlights must appear to be on and part of the same surface, and not some distance away.

2 Opaque white dots have been applied with a brush in selected places on top of the scratched highlights. These are positioned at the point of the greatest light reflection.

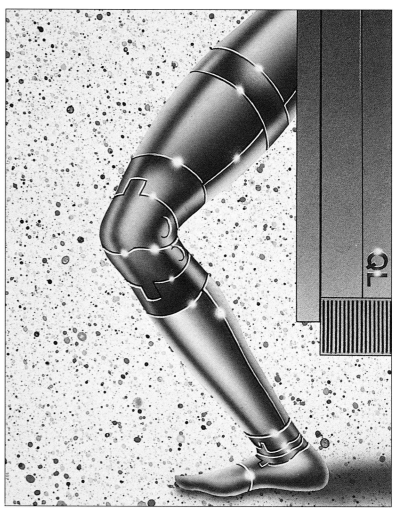

On a Metallic Surface
This example shows the application of dot highlights to the leg of a robot. These highlights are simply small bursts of opaque white spray which give extra sparkle to the effect of polished metal.

Porsche and tanker
John Spiers

Dot highlights are most commonly used on static subjects, but this illustration demonstrates an application when speed and movement are to be shown. STARBURSTS would be effective highlights on those areas where intense light would be reflected, but might tend to conflict with the sense of movement. In this example dot highlights have been used in the center of linear highlights, with soft-edged and loose-masked lines of opaque white leading from them in the opposite direction to that in which the vehicles are traveling.

Not only does this intensify the surface reflection, but the combination accentuates the feeling of speed. This makes an interesting comparison to the racing car shown on page 99. The body of the tanker is an interesting variation on the full-color chrome effects technique, with the addition of a reflection of the car passing it. The sky is an example of FREEHAND SPRAYING, while LOOSE MASKING has been used on the distant mountain ranges. SPATTERING has been used to establish texture to the ground surface and on the road.

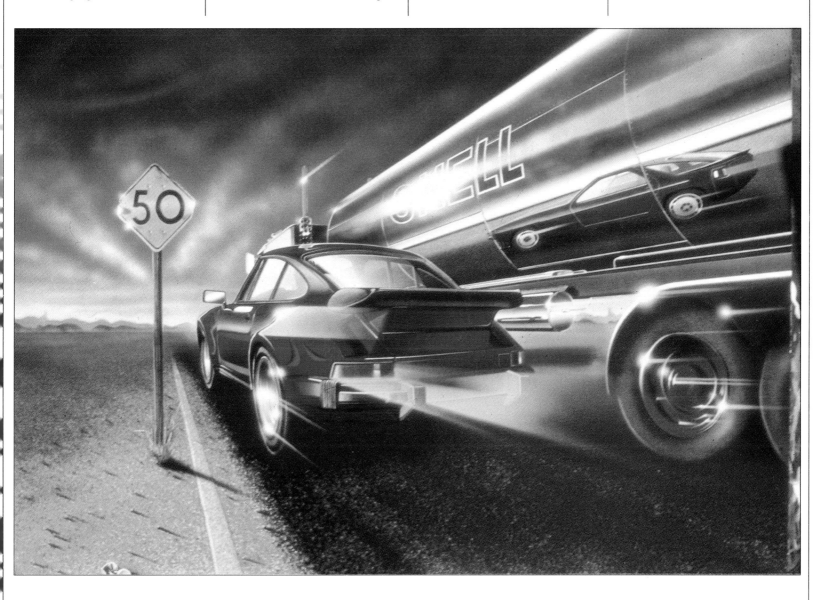

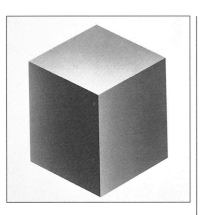

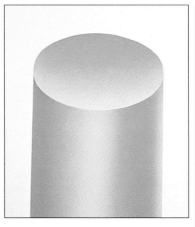

On an Angled Edge
1 The basic cube has been sprayed with a high degree of contrast shading.

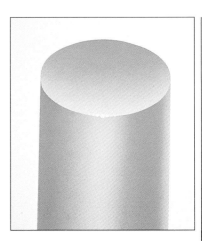

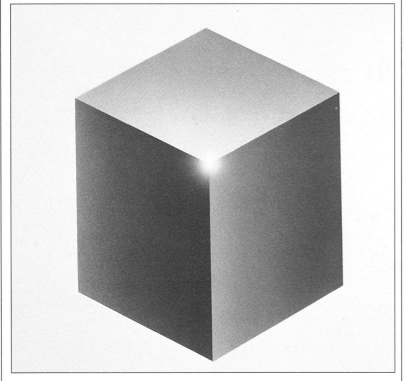

Multiple Dots
1 The upper part of a cylinder is shown before applying the highlights.

2 A number of opaque white dots have been brush-painted onto the leading edge; they are reduced in size as they get further away from the center of the highlight.

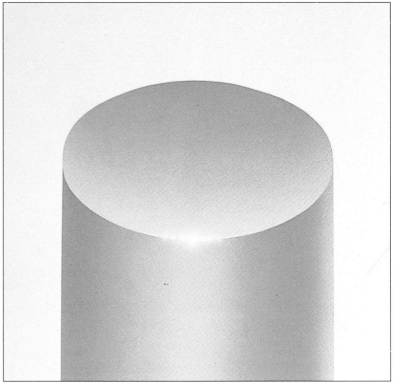

2 To enhance the contrast and to add glare, a dot highlight has been sprayed freehand on the nearest corner of the cube. The effect immediately makes the cube appear to be finished with a more reflective and brighter surface.

3 To diffuse the edges of the dots, the highlight is oversprayed with opaque white.

DROP SHADOW

Drop shadow is a method of using cast shadow to emphasize the principal object in an illustration, either in part or to throw the whole object into relief. The shadow areas can also be used to create the illusion of different levels. Refer also to CAST SHADOWS.

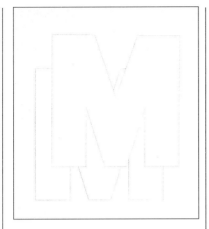

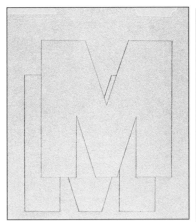

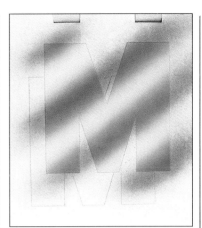

Using Masking Film
1 A sans-serif character "M" is used to demonstrate the drop shadow effect, and both the character and its shadow are drawn together in the required position.

2 The drawing is then transferred to the illustration board.

3 After covering the board with masking film, the character is cut out, the mask section hinged with drafting tape and pulled back to the top of the artwork. The exposed character is then sprayed using diagonally gradated, soft-edged stripes, to give a metallic effect.

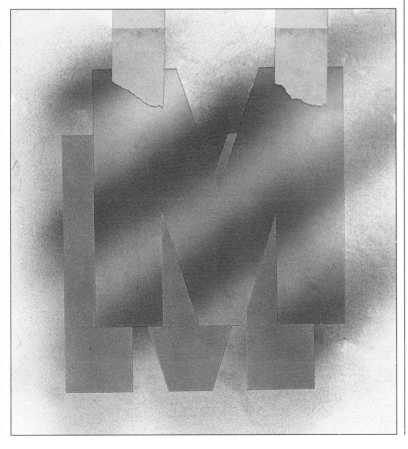

4 The hinged mask for the character is repositioned and the shadow cut out. This is sprayed with a flat, even color to add contrast between the character and the shadow.

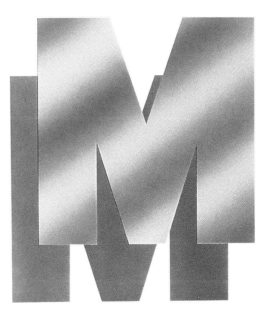

5 When the required depth of tone has been achieved, the masking film is completely removed, revealing the crisp, hard-edged character and solid area of shadow.

Using Acetate

1 The same character "M'" is used, but this time acetate is used as the masking medium.

2 To maintain the exact shape in shadow form, an acetate mask is firmly placed over the drawn character and the shape accurately cut out.

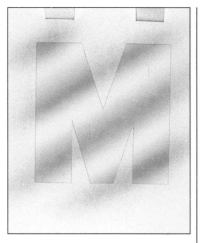

3 The main part of the acetate mask protects the area surrounding the character, which is exposed for spraying, while the acetate mask of the character, after correct positioning, is hinged to the top of the artwork awaiting further use. The character is sprayed, following the same style as the masking film example (pages 40-47).

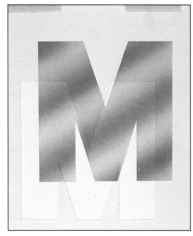

4 On completion of the spraying of the character, the larger part of the acetate mask is removed and repositioned downward and to the left for the spraying of the shadow.

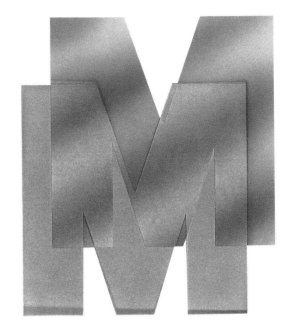

5 The hinged copy of the character is repositioned to protect the exposed areas of the sprayed character, and the drop shadow area is sprayed with an even tone.

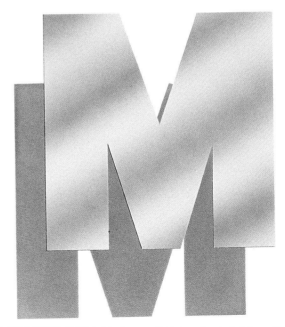

6 When both acetate masks have been removed from the artwork, it will be noticed that because acetate is non-adhesive, the drop shadow has acquired slightly soft edges. In some cases this effect may be preferred to the hard-edged finish obtained by using masking film.

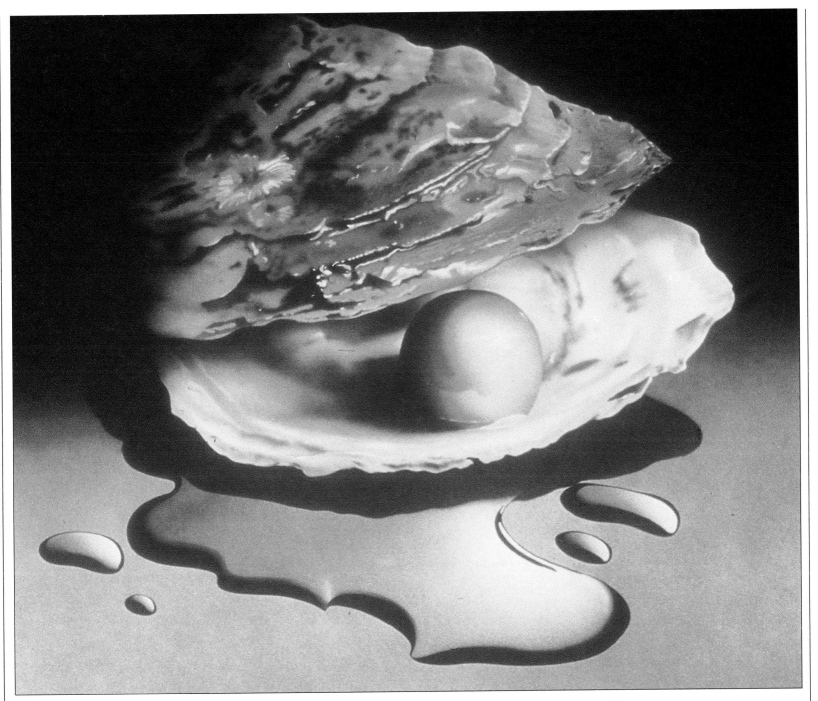

Oyster
Pete Kelly

An effective drop shadow has been included here. It serves to increase the contrast between the lower half of the shell and the GRADATED TONE of the backdrop.

ERASURE

This is a general heading referring to the use of erasers, both solid and the pencil type, which may be used for corrections and for applying highlights to specific areas of the artwork. This technique is usually only successful when applied to illustrations which have been sprayed onto a hard, smooth-coated board, of the type commonly used in the preparation of ink-line drawings. Furthermore, it is best applied to illustrations which have been sprayed with watercolors. This is because the surface layer of sprayed watercolor paint is extremely thin. On gouache and acrylic sprayed surfaces, there is more chance of damaging the surrounding color, and therefore overspraying with opaque white is far better and less risky.

As a correction technique, erasure should be limited to small areas. When used to create highlights, a hard, pencil-type eraser is by far the best, because it is possible to maintain a reasonably sharp point on the rubber core which will give greater control. The finish varies according to the amount of paint removed. This could range from complete exposure of the white of the board, to very subtle highlights such as would be seen on matte or unmachined surfaces. With care, the pencil eraser could also be used to enhance contrast, especially when much of the difference between the lights and the darks has been lost by excessive color application.

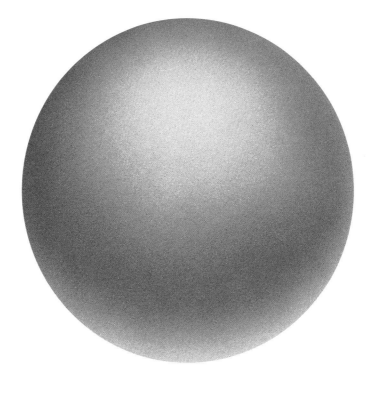

1 In this example a sphere has been sprayed, with a dull highlight to represent a non-polished surface.

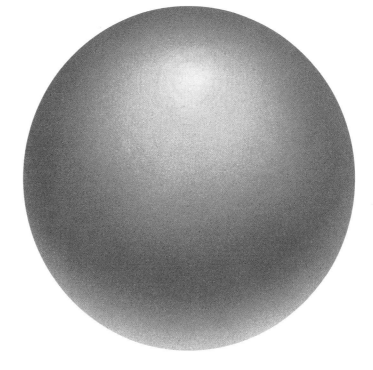

2 At the natural position of the highlight, the color has been erased with a circular motion using a pencil eraser. It will be noted that the amount of paint removed at the extremities of the highlight is decreased, so that the highlight fades into the base color.

FABRIC MASKING

There are occasions when traditional methods of rendering textured surfaces with an airbrush are not as effective as one would hope. The use of medium- to coarse fabric opens up additional opportunities which, when applied to an illustration, will give a surface texture not neccessarily identifiable with the fabric used. Some do reproduce the distinct fabric weave, and therefore experimentation is advisable before applying a fabric mask to finished artwork, unless, of course, the intention is to represent the specific effect. Besides testing a piece before use, it is also worth keeping samples of both the fabric and the spray effect from it for future reference.

Types of fabric suitable as masking materials are those which have an open weave to allow the sprayed color to pass through and between the fibers. The texture may be applied over large or small areas, which in themselves can produce additional variations of form and contrast. The material need not be used just because of its texture, for the frayed edge of torn fabric also offers a characteristic result. A form of repeat pattern could be applied using, for example, a figured open-weave as seen in old fashioned glass curtains, or indeed the many types of lace which are available.

A background texture can be applied over the artwork before the object or subject itself is sprayed. Naturally this requires the principal part of the illustration to be sprayed in an opaque medium in order to prevent the base texture from showing through. Small, controlled areas may be sprayed by overlaying the fabric on top of a previously cut piece of masking film.

1 In this demonstration of fabric masking, a piece of fine-weave embroidery fabric has been used. The resulting sprayed texture is a fine-grained, but even finish.

2 Masking tape is used to secure the fabric around all four edges, which also allows the finished artwork to be contained within straight, hard-edged borders. Here a piece of needlepoint canvas has been used, giving a more open and coarsergrained finish.

3 This example shows the effect using a tighter embroidery canvas, which on a large area remains even and regular. When used on small irregular shapes, with the spraying restricted to specified areas, it will appear more random and have a less obvious connection with the original fabric texture.

4 Loose cotton scrim has been used here, giving a more random effect.

5 A simplified checked or grid pattern is the result when spraying through rug canvas over a large area.

FILM MASKING

The use of transparent, self-adhesive masking film in air-brushing is the most popular method of protecting areas of the artwork which are not currently being worked on. Masking film is available with either a matte or a gloss finish and is supplied on a protective backing sheet, which can be used to save cut masks likely to be needed again. The adhesive on the film is low-tack, allowing masks to be placed over a clean or previously sprayed surface and subsequently lifted without damage to the underlying material.

Because the film is transparent, it allows those areas covered to remain visible, which is extremely useful when judging the strength of color and shading against those areas already sprayed. It is also possible to remove excess and residual paint from the film by carefully wiping over it with a damp cloth, tissue or absorbent cotton, without damaging the artwork or the area exposed for spraying (this of course applies to paints which remain water-soluble after drying).

When using masking film, always cut it with sharp, new blades, as old ones quickly lose their edge and tend to tear the film rather than cut cleanly through it. Gentle but even pressure is required when cutting, to avoid scoring the artwork.

In the two examples given here, particular note should be taken of the sequence used in applying the tonal ranges; they are not the same for transparent watercolor and opaque gouache. With a transparent medium, the depth of shade and color is built from dark to light by overspraying transparent layers; with the opaque medium, color mixes are made independently, and light colors can be sprayed over dark if required.

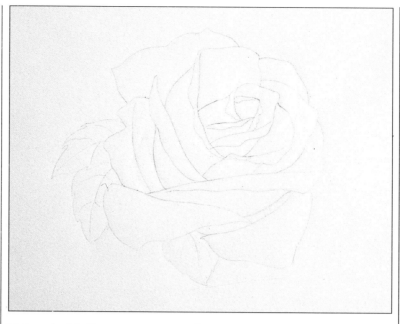

Watercolor Medium
1 To demonstrate a reasonably complex example, a rose is used as the subject matter. First, a drawing is prepared on detail paper, as shown.

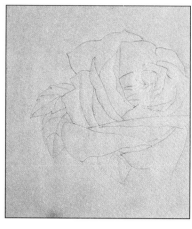

2 The drawing is then transferred to board using graphite paper or jeweller's rouge.

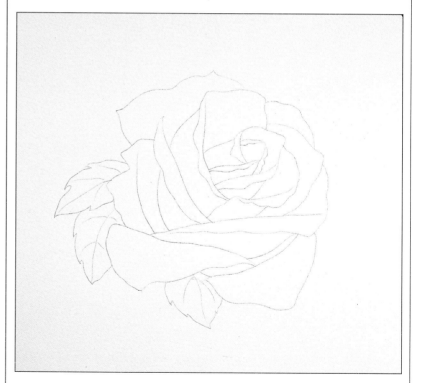

3 The transferred drawing on the board must consist of very faint guidelines, as they will not be completely obliterated when a transparent medium is used.

4 The artwork is covered with masking film and all lines describing the leaves are cut into the film.

5 The spraying sequence begins with removal of film from the leaf sections which will have the darkest shade.

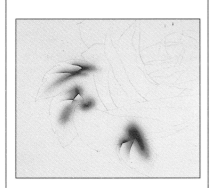

6 The medium tones of the leaves are now sprayed. Mask sections cut along the lines of the leaf veins are removed in sequence to give hard-edged areas of tonal gradation.

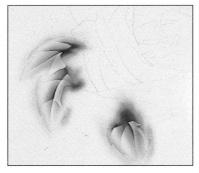

7 The final parts of the leaves to be sprayed are the lighter shades. At this stage, all the masking on the leaves has been removed and the lighter tonal gradations are executed freehand.

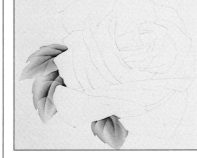

8 On completion of the leaves, all masking film is removed and a new piece is laid over the whole of the artwork. All lines surrounding the petals of the rose are then cut into the film.

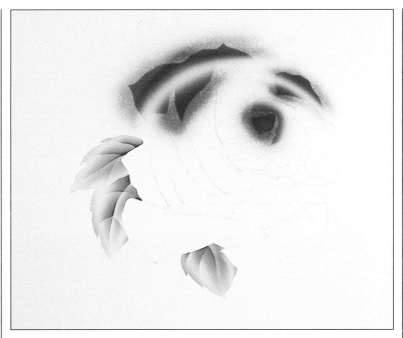

9 The sequence for the rose follows the same pattern applied to the leaves, working from the darkest shades first, followed by the medium and then the lighter ones. In the first stage, dark shades are sprayed in the upper part of the flower.

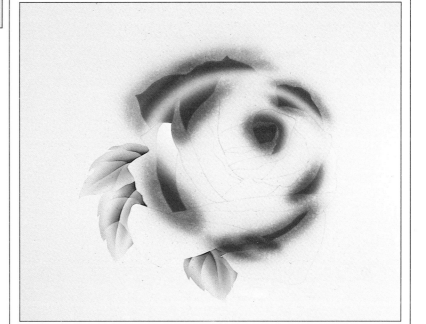

10 The tonal values and form are built up with the spraying progressing from the furthest petals to those in the foreground.

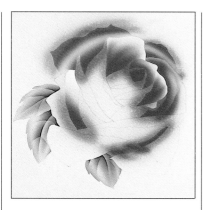

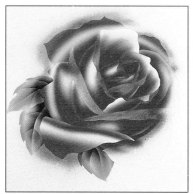

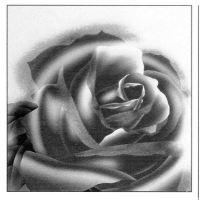

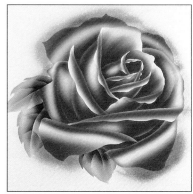

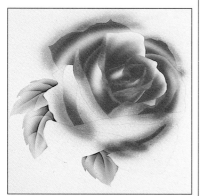

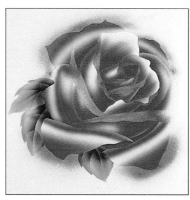

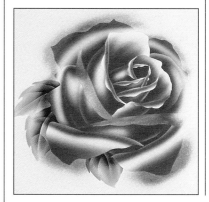

16-18 The curled edges of the petals are sprayed, also following the sequence dark to medium to light, and working from the center outward.

11-15 The process is continued, with the mask sections lifted in sequence to allow development of the medium and light shades.

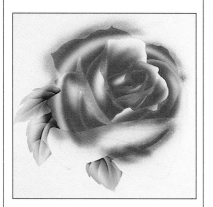

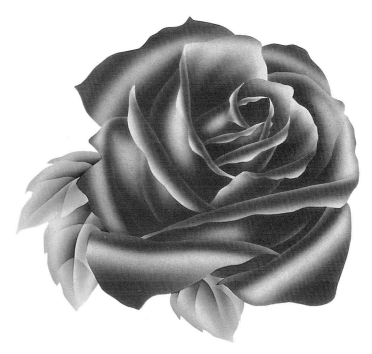

19 Finally, the remaining masking film is removed from the artwork, revealing a crisply defined rose.

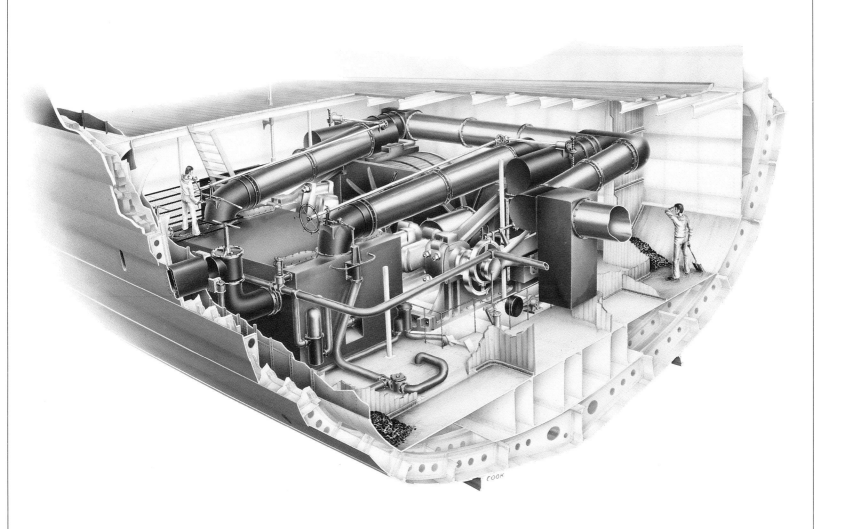

**HMS *Warrior*'s engine room, 1861
Gary Cook**

This three-point perspective illustration is a reconstruction of the engine room of the world's first iron-built warship, HMS *Warrior*, and was commissioned for the book *The Immortal Warrior*. The purpose of the illustration was to explain the layout and arrangement of the engine and condenser in relation to that part of the ship's hull structure which contained them.

The drawing was constructed on tracing paper using copies of the original Admiralty as-fitted drafts from the British National Maritime Museum as reference. It was then transferred onto CS10 board, which is a hard, china-clay-surfaced board ideally suited to both airbrush and ink-line work. The illustration was rendered primarily with the airbrush using transparent and opaque watercolor. Self-adhesive masking film was used throughout, with the exception of the bands of tone running along the copper steam pipes, for which cut paper [see LOOSE MASKING] masks were used. LINING-IN was completed using a ruling pen and a fine sable brush.

Because of the limited number of colors used to paint the engine room itself, great care was needed when spraying to maintain both the contrast and the different planes of the casings for many of the engine components, and the white structural details. These two important areas are basically black and white respectively. It was therefore decided to omit strong cast shadows, using darker shades only to aid legibility. In addition, enough contrast had to be shown between the matte or rough-surfaced casings, painted black on the original, and the polished copper steampipes. For the former, subtle GRADATED TONES of blue-black were used, while for the pipes the white of the board was allowed to show through the transparent color, increasing the strength of the highlights.

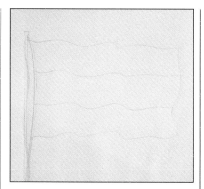

Gouache Medium

1 The intention here is to produce a piece of artwork showing a flag with movement. This is drawn first in pencil on detail paper.

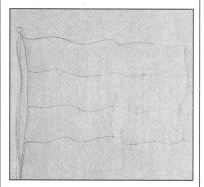

2 The drawing is transferred to board using graphite paper.

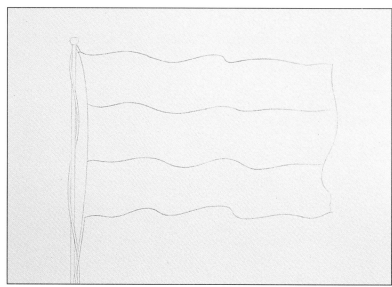

3 Both the detail paper drawing and the graphite paper are removed, showing the transferred drawing of the flag. The lines in this drawing will be gradually concealed by the spraying, due to the opaque quality of gouache.

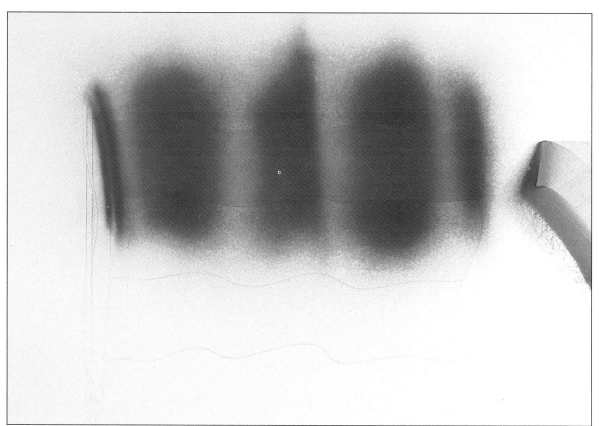

4 A piece of masking film, sufficient to cover the image and surrounding area, is placed over the artwork, followed by cutting of all lines of both the flag and staff. The mask section on the topmost horizontal stripe of the flag is hinged with drafting tape, lifted off and pulled back to the right. The exposed area is sprayed in a medium shade of red. This is worked as vertical bands of color, allowing residual spray to create areas of lighter shades.

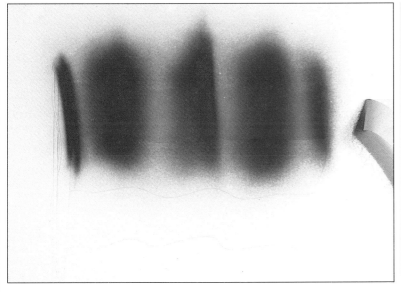

5 A darker shade of red is over-sprayed next, increasing the contrast.

6 The mask for the first stripe of color is replaced, and the lowest stripe is hinged, lifted off and pulled back to the right. This is then sprayed in blue to create the medium-strength and pale tones.

7 The darker shades are over-sprayed, following closely the pattern established with the first stripe.

8 The hinged mask for the lower stripe is replaced, and the first part of the rope halliard is exposed and sprayed.

9 The second part of the rope, nearest the observer, is next to be sprayed.

10 All of the rope is now re-masked with transparent tape, following which the flagpole is unmasked and sprayed in the appropriate color.

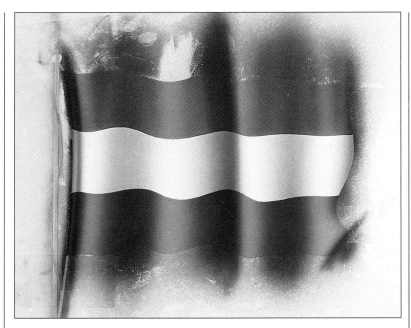

11 The pole is re-masked with transparent tape and the white, middle stripe of the flag is exposed, together with the red and blue stripes. A blue-grey gouache mix- ture is now sprayed over all three stripes in vertical bands, bringing the three colors together and adding a continuous depth of tone to the whole flag.

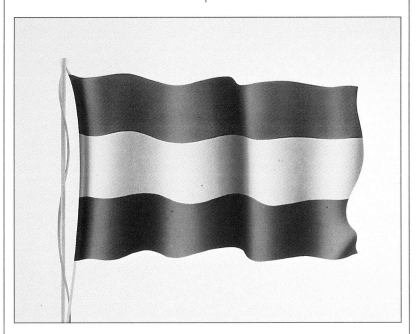

12 The masking film is removed, exposing the finished artwork.

Double Masking

Self-adhesive masking film is expensive. It can be wasteful to use film to cover a large, extensive area of the artwork, especially if the section being worked on is only a small part of the whole. To avoid wastage, detail paper or cartridge paper can be used to protect the majority of the artwork from residual spray, with film being applied only to the relevant area of detail. It is important to cut a hole in the paper larger than the area to be sprayed, because sufficient space must be given to allow the masking film to stick to the art- work. It is a widely used technique and may be applied to many of the other techniques of masking and spraying described elsewhere in the book.

This photograph shows the application of double masking. A small square section is to be sprayed. The artwork has been covered with paper with a rectangular hole cut in the appropriate place. Masking film has then been overlaid and the required shape cut out.

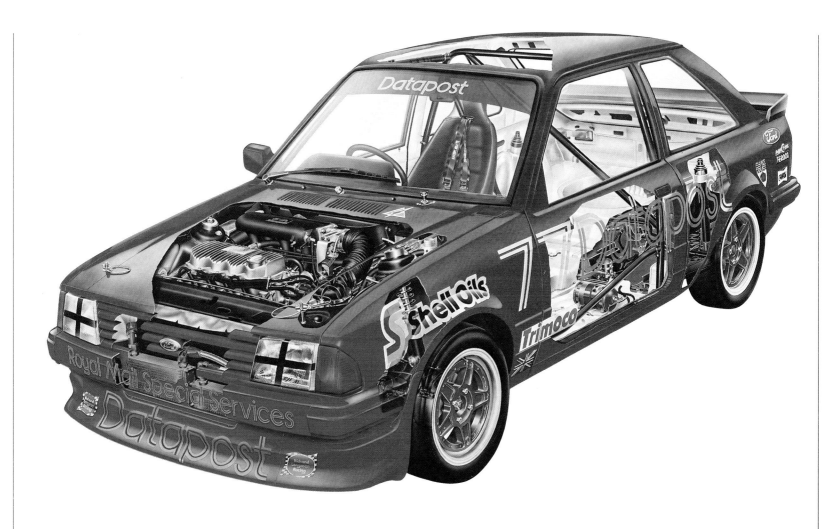

Datapost Ford Escort RS 1600i
Paul Shakespeare

This large illustration, measuring approximately 71 in x 59 in (178 cm x148 cm) was originally commissioned by Datapost to advertise both the British postal service and its racing team. It was produced with the close cooperation of the racing team managers, the Ford Motor Co. Ltd. and Richard Longman Racing, the organization responsible for converting the basic Escort model into a racing car. The brief specified that the illustration should show those areas of the car which did not conform to a standard production model, which explains why only limited areas have been cut away. The illustration was eventually purchased by The Patrick Collection, Birmingham, England, where it is now on display in this privately-run museum.

Once the pencil drawing was completed, it was transferred to a semi-smooth surfaced watercolor paper which had been dry-mounted on masonite. This proved unsatisfactory as a vehicle for airbrush rendering, because the fibers of the paper would lift whenever the masking film was removed. It was finally decided to photograph the original pencil drawing, from which a large, gray-line print was made and dry-mounted on masonite. This gave a sound and smooth surface on which to airbrush, although great care was needed when cutting masks to prevent the knife from cutting too deep and thereby damaging the lamination of the photographic paper. A particular advantage of spraying on photographic paper was the ease with which it was possible to remove any color that had run or small mistakes [see CORRECTION TECHNIQUES]. Because gouache, which is water-based, was the principal medium, the surface could be cleaned using surgical cotton. This left the surface in its original condition for respraying.

No particular problems were encountered in the spraying process, which began with those areas furthest away from the observer and within the cutaway sections. The body of the car, with the exception of the lettering, numbers and stickers, became, to all intents and purposes, a black-and-white study. This meant that when applying color, greater control was required to ensure the shape was not lost and the contrast was maintained, with reference being constantly made to areas already sprayed. The tonal values on the body of the car and the lettering had also to be kept in relation to each other, especially where they changed direction and were therefore affected by changes in the amount of light reflected on them.

The areas normally visible through the windows were sprayed with the same strength of color as the rest of the car. When completed, the windows were oversprayed using opaque white, but keeping the density light so the effect is semi-transparent. This has had the effect of KNOCKING BACK what is seen through the windows.

FLAT TONE

While it is perfectly possible to apply an even, flat shade of color by hand, much practice is necessary before the results are acceptable and without blemish, especially when using watercolor on gouache. The airbrush simplifies this process, although it still requires practice when applying flat shades of color which need to be trans-parent or translucent. When applying transparent watercolors with the airbrush, it is essential that the air pressure and amount of paint allowed through the airbrush remain constant, to prevent stripes from appearing. The distance the airbrush is held away from the artwork must also remain constant to avoid variations in tonal value. However, the advantage of being able to overspray any imperfections does give the airbrush the edge over hand-painting. As a technique, the application of flat tone is directly related to GRADAT-ED TONE and as an exercise should come before it.

1 The area to be sprayed with a flat tone has been masked and the spraying proceeds from the top to the bottom, passing the airbrush from side to side over the masked area. It is always advisable to start and finish the spraying on the masking film, as this ensures that the color is laid evenly at the edges of the masked shape.

2 Color is gradually built up following the same process until the required density has been achieved. A useful method of maintaining an even, flat color is to turn the artwork 90° after each layer of color has been sprayed. This also helps to avoid or cover up any stripes which may appear due to irregular spraying.

3 On completion, carefully remove the masking film.

"FOUND OBJECT" MASK-

The function of all techniques in airbrushing is to arrive at a given result. The technical means of achieving these results is unimportant if the illustration itself is successful. It may therefore come as a surprise to some to find natural and indeed manmade objects being used as masks for spraying. They open up an incredible variety of textures and images which can be put to good use in illustration. The following demonstrations are just a small sample.

When collecting sample objects, especially natural ones, always make sure they do not hold dirt or dust. Besides damaging and marking the surface of the artwork, some dirt might get ingrained, which would deaden the freshness and vitality of the finished artwork.

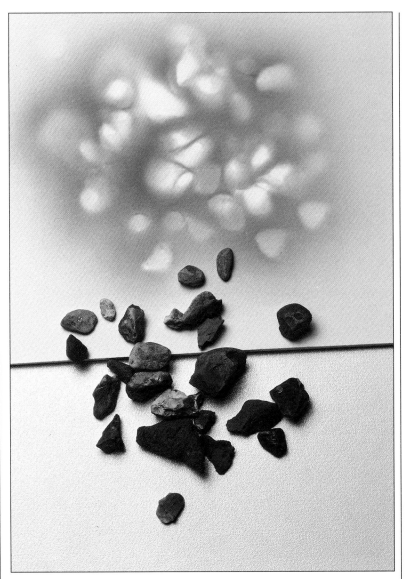

Stones
A collection of stones has been laid on the artwork and then oversprayed. The photograph shows the stones after they have been removed, with the effect on the artwork being apparent at the top of the picture. With practice, and possibly by making a test sheet first, you may find that the stones can be placed in set positions to achieve a particular pattern or texture.

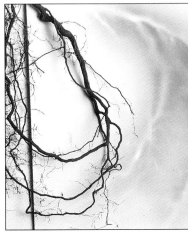

Twigs
The use of this twig as a mask has produced an effect similar to old leather or, possibly, marble veining. It would be impossible to simulate this effect by more conventional means.

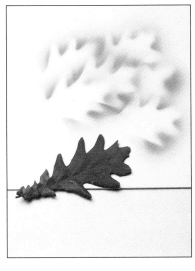

Leaves
In this photograph a leaf has been used as a mask. Its jagged outline produces a random repeat pattern.

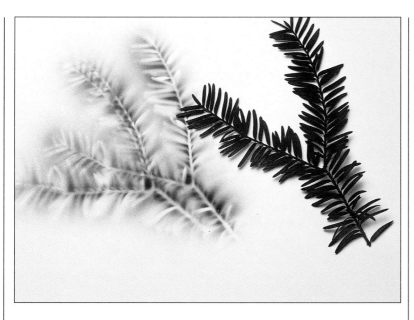

Branches

A piece of pine branch is shown with the repeat pattern achieved by moving it across the board and over-spraying to build up the texture.

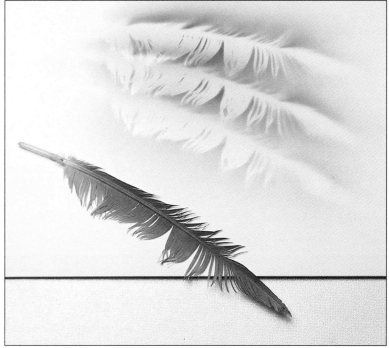

Feathers

A subtle and delicate effect has been achieved with a feather. Because of the light touch of the airbrush spray, it is possible to reproduce even such a fine texture quite accurately.

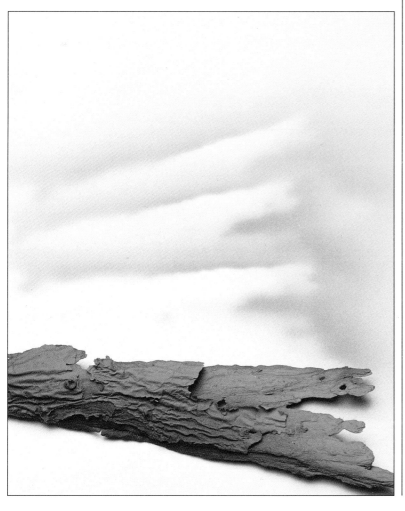

Bark

A strip of tree bark has been used here, and by slightly moving it on a pivot from the left, a repeat pattern is achieved which appears to fan out gradually. The spraying has been restricted in this example to the top edge of the bark, which gives a more interesting silhouette.

FREEHAND SPRAYING

This is a technique requiring much practice before it can be used effectively on finished artwork, because, as the title suggests, no masks are used to aid the illustrator and all control lies in the hand. It is a skill which should be acquired because there are very few occasions in illustration when some application of freehand spraying is not needed. Some illustrators have developed freehand spraying to such a high degree that all of their work is produced this way. However, freehand spraying will always give a soft edge which is not necessarily compatible with all subjects, and it is more general practice to work with masks which define individual shapes, but to use freehand spraying to develop form and detail within the masked areas.

1 Here the illustrator is demonstrating a wave effect by freehand spraying. The initial spraying is light and it is essential that the control of the airbrush flows easily in the required general direction, in this case horizontally.

2 The depth of color is gradually built up evenly from top to bottom.

3 The completed example shows how the interwoven lines have built up a complex tonal effect.

Freehand Spraying Within a Masked Shape

1 A neat and clean pencil drawing representing fabric is prepared, keeping the detail to a minimum. This could be drawn on detail paper first, which allows for corrections to be made so that the shape looks convincing, or, as here, straight onto the board for spraying. Whichever approach is used and after the drawing is completed, the board is covered with masking film.

2 The first stage in the spraying sequence is to remove film from the two hard-edged shadow areas formed by the deep inner fold of the fabric. These two shapes are sprayed with dark shades.

3 The masking film is then partly cut and removed in order to spray those areas of the fabric which require part hard-edged shadows, but which do not extend to the full depth of the drawing. It should also be noticed that in these areas and opposite the hard edges, the shadows gradate quickly to the white of the board.

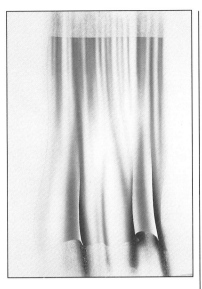

4 The remainder of the masking film covering the fabric is now removed, and the freehand spraying begins by building up the soft tonal areas. As this progresses, the impression of flowing fabric will slowly increase. Because of the very nature of manipulating and controlling an airbrush, it may well prove easier if the artwork is turned 90°. This is because a directional spray running from left to right allows more natural movement of hand and arm than from top to bottom. When following this exercise, great care should be taken to ensure that the tonal gradations soften at the appropriate points; otherwise, the completed image will lack subtlety.

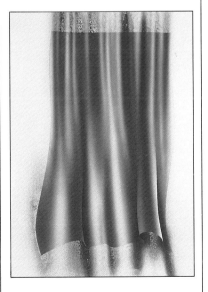

5 The tones and shadows to accentuate the "feel" of the fabric are built up in a freehand style.

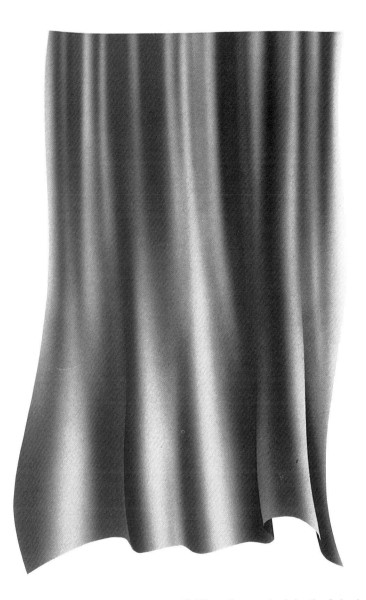

6 When the required depth of shade and strength of color have been reached, it is then necessary just to remove the surrounding masking film to reveal the finished artwork.

GHOSTING

When it is important to show the complete exterior shape of an object, but also selected internal shapes within it or behind it, ghosting is used. It is particularly used in technical illustration when descriptive three-dimensional drawings are being prepared. For example, a brief might require a complete cutaway view of a complex new four-stroke engine, but because of the compound form of the cylinder head, cylinder block and sump casing, the engine would be unrecognizable unless enough information was included of the exterior; it would therefore be practical and desirable to include ghosting. This would enable the engine as a whole to be understood, as well as the workings and design of the interior, or those areas not normally visible.

In application, ghosting relies on subtle color and shading changes which will not adversely affect the exterior in preference to the interior, or hidden object, and vice versa. Careful planning in the sequence of spraying is also a necessity, both to prevent unnecessary extra work and to avoid creating an image that is almost illegible on completion.

Ghosting Over a Section Cutaway
1 The form of a piston, its gudgeon-pin and part of the connecting rod is drawn on detail paper, with the location and shape of the cutaway area clearly indicated.

2 The drawing is transferred to illustration board and covered with masking film.

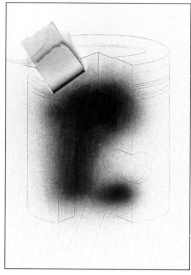

3 The masking film covering the inside surface of the piston, made visible by the angle and position of the section cutaway, is cut and hinged to allow for these areas to be sprayed first, as they are represented in heavy shadow, and therefore contain the darkest shades.

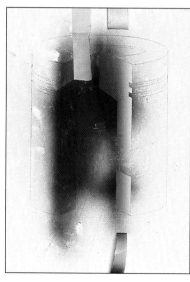

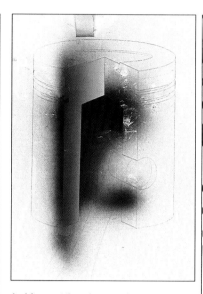

4 After cutting the mask to expose areas of the medium shades, these are sprayed, allowing for a reflected highlight to remain toward the inner edge. This represents the left-hand face of the cutaway. When spraying vertical sections, it may be easier to turn the artwork 90° so the airbrush can pass horizontally across the surface.

5 The same process is completed for the right-hand face, but now the reflected highlight is toward the outer edge of the piston.

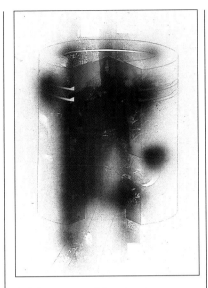

6 Other areas of the drawing are sprayed in medium shade to build up the form and shape of the piston. The areas concentrated on here are the recess to the top of the piston, the shadow and form within the grooves for the piston rings (which are not included in this example), and the form on the hole into which the gudgeon-pin is fitted.

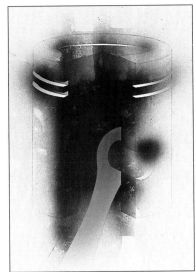

7 The process started in stage 6 is continued, varying the depth of tone according to the direction of the light source and the location of the area being sprayed. Here the facing side of the connecting rod, the vertical surface to the top recess and the horizontal surfaces on the grooves for the piston rings are sprayed.

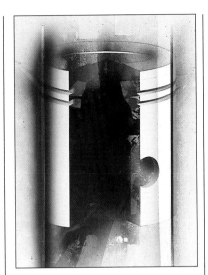

9 Replacing all previous masks, the body of the piston is sprayed using acetate to mask the vertical bands of color. This part of the work involves spraying the darkest shades and hard-edged areas first, then developing the medium and light shades and gradated areas.

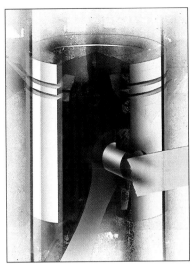

11 The central section of the exterior of the piston is the last stage to complete the body of the piston. Also shown completed is the cylindrical head of the gudgeon-pin, with a principal highlight across the center and reflected highlight at the base.

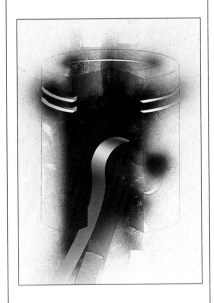

8 This stage shows the thickness or depth of the connecting rod sprayed up, with sufficient contrast and form to indicate the shape clearly. Notice should be taken of the use of hinged mask sections, which not only allow for accurate repositioning but prevent accidental or damage loss.

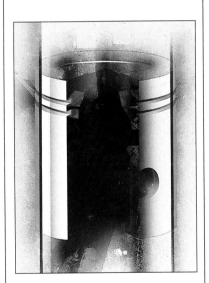

10 The gradated shades have been sprayed at this stage to model the cylindrical form of the piston.

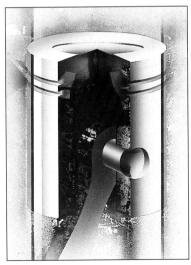

12 The top of the piston has been sprayed with enough variety to differentiate between the recess and the body of the piston. At the same time, the end of the gudgeon pin is unmasked and sprayed with gradated tone.

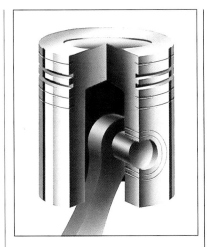

13 The solid, cutaway rendering of the piston is completed and the remaining masking film removed prior to detail work being applied by hand with pencil and brush. Highlights are scratched in using a sharp art blade.

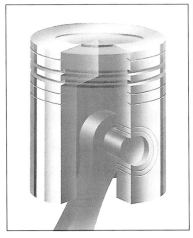

15 Next the medium shades of ghosting are sprayed, which include the continuation of the grooves for the piston rings.

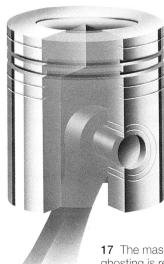

17 The masking film laid on for the ghosting is removed, leaving an image which shows the complete exterior of the piston as well as the cutaway section, revealing the connecting rod and gudgeon-pin.

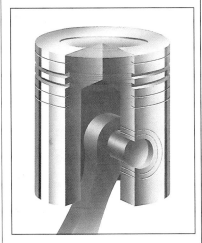

14 The artwork is completely re-covered with new masking film in preparation for the ghosting to be sprayed. Those areas which are to be the lightest are cut and removed first. In this example these areas include the top of the piston. Light-shaded ghosting is sprayed using opaque white.

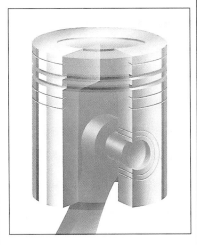

16 The darkest shades are the last to be applied, giving emphasis to the depths of the top recess, the grooves for the piston rings and the thickness of the piston base.

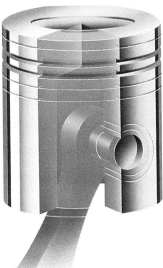

18 To improve the depth of contrast and detail, it is necessary to line-in the ghosted areas of the illustration using pencil and brush-painted opaque white. This also improves the quality and finish. Great care must always be taken when ghosting, because it is so easy to lose detail and contrast, which would defeat the exercise and make for a flat illustration. It is advisable to practice with a black-and-white piece first, as the tonal values are relatively controllable, before moving on to more complex color work.

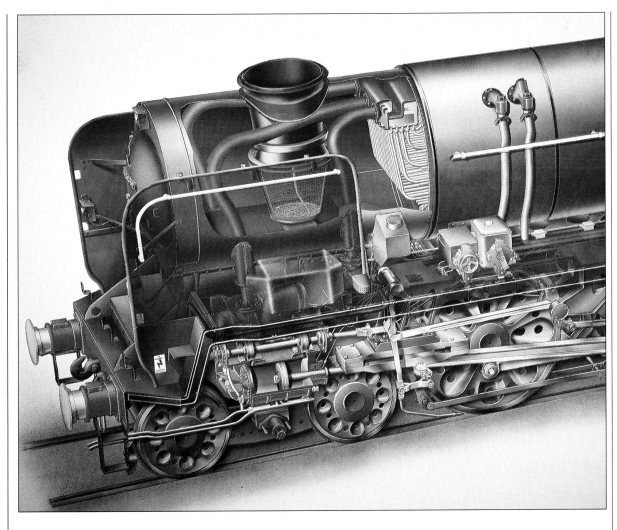

Southern Railway Merchant Navy Class 4-6-2 locomotive *Ellerman Lines* (detail)
Mark Franklin

Complex, three-dimensional cutaway perspective illustration in full color presents difficulties when it is required to show as much detail as possible without confusing the viewer. In this example, a detail taken from a large airbrushed illustration commissioned by the Science Museum, London, every aspect of the working parts of a particular steam locomotive had to be clearly shown. The part of the illustration reproduced includes the fire box, smoke deflectors, boiler casing, running-board, bogies and part of the driving wheels with motion gear. As with most steam locomotives, the fire box includes a blast pipe and ash filter, as well as steampipes leading from the front of the boiler down into the valve chests. The exhaust steam is also fed through pipes which lead into the fire box. On this particular locomotive, smoke deflectors were fitted immediately alongside and projecting slightly in front of the fire box.

Without the nearest smoke deflector, there would have been no problem in showing the area described with a conventional cutaway. However, with the deflector, an integral and important part of this locomotive, in position, the problem arose as to how to show both the deflector and the interior of the fire box. The solution, as shown here, was to render the fire box and its contents as solid objects, while spraying the deflector as if made of tinted glass, that is, ghosting its form, with the exception of the rim and handrail which remain solid to enhance the shape and location of the deflector.

To a lesser extent, the running board has also been shown ghosted, revealing detail through it.

GRADATED TONE

Gradated tone means the application of color which changes gradually from dark to light, either fading into the white of the board, or blending into another colour. When the contrast is controlled, a gradated tone can eliminate the need for oversprayed highlights. If sprayed with transparent watercolor over a previously applied color, a translucent effect is possible in which the first color appears to shine through the second. Tonal gradation is the principal means of modeling three-dimensional form in an illustration, and broad areas of gradated tones and colors make atmospheric backgrounds.

Gradated tones are particularly effective in creating skies. If, for example, a midday sky is desired, the first gradated tone would be a soft base of yellow ochre or Naples yellow running from the horizon up, and blending in with the white of the artwork about a third of the way into the sky area. A second gradated tone is then oversprayed, but with a weaker mix of cadmium red, also blending in at about the same point. Finally, a gradated tone of cerulean or cobalt blue is sprayed from the top of the artwork to blend with the previous two colors, but further down towards the horizon.

The facility which the airbrush gives in producing gradated tones, whether on a large or small scale, is one of the distinct advantages of this tool. While it is possible to achieve the same result by hand, it becomes increasingly difficult to manipulate within areas which restrict the free flow of a brush and keep within predetermined boundaries. In this, the control provided by masking techniques and the delicate quality of the airbrush spray enable the illustrator to produce flawless gradations.

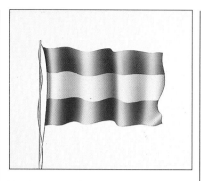

Background Gradation
1 A gradated tone is to be applied as a backdrop to the flag. The complete working area is covered with masking film, and the background area is cut and removed, leaving only the flag protected prior to spraying.

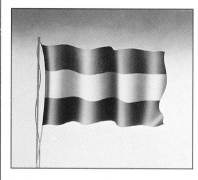

2 The color is applied by spraying from dark to light, building up the deeper shaded area first, avoiding the spraying of an excessive and concentrated strength of color too quickly.

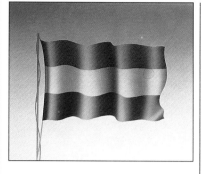

3 The process is continued and the color slowly increased in depth as it is also brought further down toward the lower edge of the artwork.

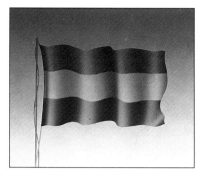

4 The final stage in spraying is to strengthen the shading of the color, again working from top to bottom.

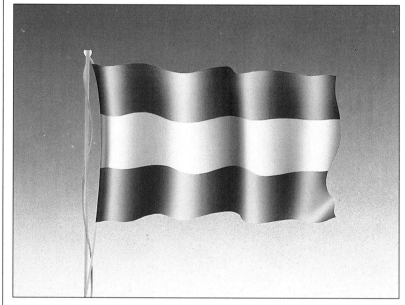

5 Finally, the masking film is removed from the flag and border, revealing the gradated backdrop in relation to the three-dimensional image of the flag. The overall effect is to throw the flag even more to the fore.

Gradation Within an Object

1 A drawing of a ribbon making a flowing S-shaped curve has been prepared on illustration board and the whole artwork covered with masking film. All of the lines making up the ribbon are then cut into the masking film, including those which make the transitions from inner to outer curves.

2 The film covering the top part of the ribbon is removed and hinged back with a piece of masking tape. This section is then sprayed vertically with bands of gradated color following the shape of the curve.

4 The final stage is spraying is the lower part of the ribbon, after replacing the previous mask and hinging back the last one.

3 The hinged mask from stage 2 is replaced. The second mask, which is also hinged, is pulled back to expose the central curve of the S-shape. The gradations on this section are formed in the same way as on the first.

5 All masking film has been removed, showing the ribbon airbrushed with three-dimensional form, relying only on gradated tones of color. No dark shades or white highlights have been added.

HALOING

Haloing, as its name implies, is the application of a circle of light and should appear as a soft, gentle glow, fading away outward from the circumference. The technique can be used to create an effect of distant radiance, as in the "galaxy" example shown here, or to soften and diffuse highlights in closer objects.

1 Various-sized stars have been painted as white dots and over-sprayed to diffuse the edges; others have been sprayed with a splatter-cap as dots of various sizes to give an illusion of immense depth.

3 A circle cut from masking film is placed over the center of a starburst and gently sprayed around the edge with opaque white. It is important not to apply too much white when spraying the halo to maintain the effect of diffusing light.

4 When the masking film is removed, the effect can be quite subtle, as demonstrated here.

2 Starburst shapes have been cut into masking film (acetate could also have been used) and positioned over certain stars. These are sprayed using opaque white, which is applied in each case to the center of the mask.

HIGHLIGHTING

There are various techniques for adding light, form and contrast to a shape, to prevent the subject from looking flat. Highlights draw the viewer's attention and can be used to excellent effect to emphasize the points of visual focus in an image.

Using an Art Knife Blade
1 Although the leaves are shown here with sufficient contrast and form, they lack the surface texture and highlights which would enhance their appearance.

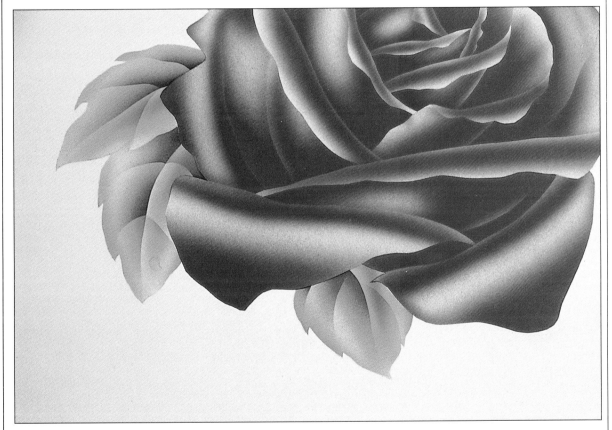

Using the White of the Board
This is an example of leaving the white of the board to form a natural highlight in an area of color. It is achieved by carefully controlling the amount of gradation and strength of shading when spraying the color.

2 By using an art knife blade to scratch into the sprayed colour, the highlights in the leaves are defined as fine white lines.

Using Opaque White
1 The artwork has been covered with masking film and the complete flag exposed for spraying, as it is intended to increase the contrast by overspraying highlights.

2 Opaque white is now sprayed freehand in the appropriate places, bearing in mind the chosen direction of the light source.

3 When the required depth of contrast has been achieved, the masking film is removed, revealing a more pronounced image.

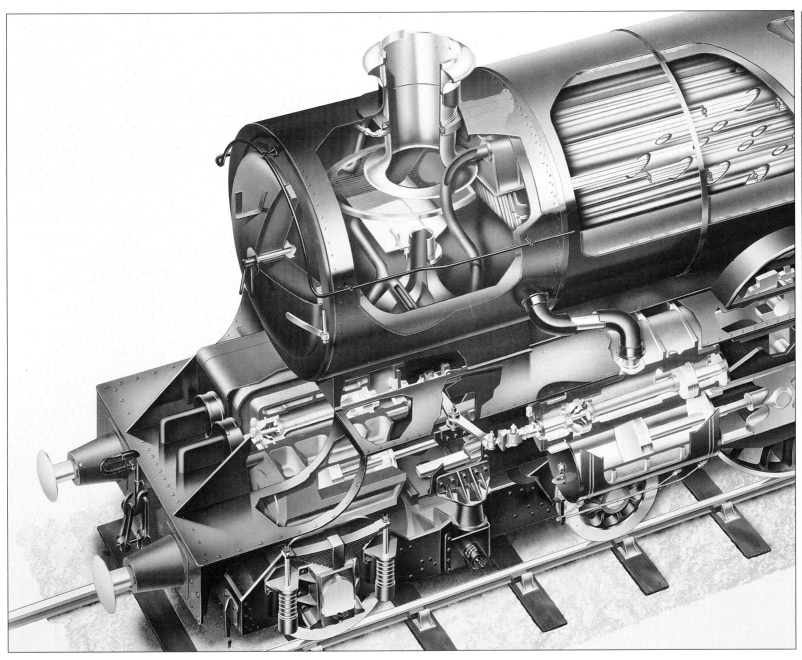

Great Western Railway King Class 4-6-0 locomotive *King Edward II* (detail)
James Weston

Without highlighting, most illustrations would look bare and unfinished. They would lack that final quality which enhances, complements and clarifies the image portrayed.

Highlighting is, therefore, along with RULING and LINING-IN, an important and integral part of an airbrushed illustration.

The example shown here is a detail of the complete illustration reproduced on page 102. All techniques described in the practical demonstrations of highlighting have been used on this illustration, with the exception of scratching out with an art knife blade, because this is not suited to the surface quality of the paper on which the illustration was drawn. The underlying white of the paper is evident on the highlight to the smoke box and boiler, and in the polished steel of the pistons and valve rods. Opaque white has been used on the suspension springs to the bogie axle, the lightening holes of the bogie wheels, some of the pipework and the running boards.

To appreciate fully the techniques of highlighting, reference should also be made to the various effects to be seen in many of the other finished illustrations.

KNOCKING BACK

When it is not possible to take a photograph of a subject in the exact conditions required to show it off to advantage, it is usual to resort to the technique of knocking back the less appropriate areas of the image by overspraying with either dark or light shades. To maintain interest and visual impact, it is not necessary to eliminate these areas completely.

This technique is used extensively in photo-retouching and can also be applied to airbrushed artwork when, for example, the background detail of an illustration appears to compete too strongly with the subject.

3 A dark tone of transparent colour is sprayed over the exposed surface of the print.

Darkening an Obtrusive Background
1 In this photograph the primary subjects are the headstones in the foreground. However, the intensity of the light is such that the highlights on the tree compete with those on the ground and on the headstones. To overcome this, it is necessary to knock back the tonal contrast in the tree. Prior to spraying, the photographic print is dry-mounted onto board.

2 The whole print is covered with masking film, and the area of film covering the tree trunk is cut out and removed.

4 When the required depth of shading has been applied, the masking film is removed, leaving the foreground untouched and the tree trunk now appearing to be set back, but without losing its natural contrast.

Weakening Background Tones and Contrast

1 This photograph shows a racing car with figures and details in the background. The latter appear, because of their close proximity, to be on the same plane as the car and therefore it is not absolutely clear where one ends and the other begins. To rectify this, the background must be knocked back. The first stage is to dry-mount the print onto board.

2 Masking film is placed over the whole print area and the sections covering the background and track are cut and removed for spraying.

3 The exposed areas are over-sprayed with white. This is not so opaque as to destroy the definition, but it causes a surface effect of light "veiling" over these parts of the image.

4 Once the revised shading clearly separates the background from the principal subject, the masking film is removed. The difference in clarity and emphasis between stage 1 and the completed image is obvious, and it has improved the impact of the picture.

LETTERING TECHNIQUES

The use of an airbrush in lettering is helpful when flat or gradated color is required as a backdrop, or when a characters or words are to be treated as objects and sprayed to give form. This is often seen in advertising, a typical example being the rendering of words and letters to create the impression that they are made of chrome, or some other highly reflective material.

Using Self-adhesive Masking Film

1 The sans serif character "E" has been drawn on detail paper and transferred to board. A sheet of masking film is applied and the character cut out.

2 The film covering the character is removed, and the exposed shape is then sprayed in the required color and style of finish; here the paint has been gradated leaving a reflected highlight, or glow, to the lower part of the character.

3 The masking film is removed, leaving a strong, hard-edged finish.

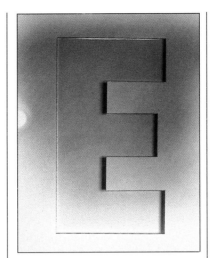

Using a Stencil

1 The same style of letter form is now drawn on stiff cardboard and the shape cut out. In the example shown, the character is comparatively easy to work with, having only straight lines and right angles. Others which incorporate curves and acute angles may appear neat and accurate at the stencil stage, but any slight imperfections in cutting will be more than noticeable on the finished artwork. Practice in cutting is therefore recommended.

3 Removing the cardboard shows that the character has slightly soft edges as a result of residual color seeping under the edges of the stencil.

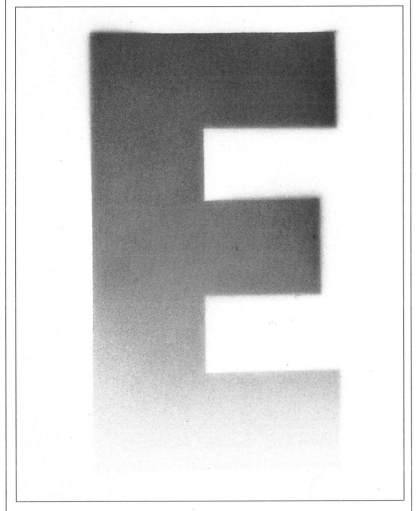

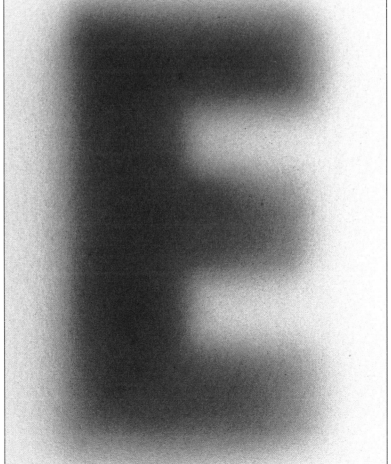

2 The cardboard stencil is held close to the board on which the finished artwork is to appear. It is then sprayed as required.

4 In this example the card stencil was held further away from the board, giving even softer and more blurred edges to the character.

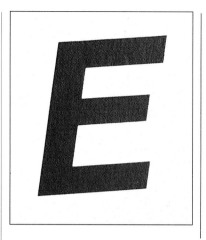

Using Dry-transfer Lettering
1 An italic character "E" has been rubbed down on board.

2 What will become the background or base color is then sprayed over the character and surrounding area.

3 The dry-transfer character is removed by using low-tack drafting tape to pick it up. Although not shown in this example, it is obviously possible to spray a second color over both the character and existing base color. Further characters may also be laid on top of the base color; when the area is re-sprayed and the characters removed, they would appear on the artwork in the original base color. However, extreme care is needed in removing the dry-transfer lettering so as not to damage the sprayed color underneath or, indeed, the surrounding color.

BLACK CADILLAC

Black Cadillac
Dave Bull

This is the title from a poster illustration which has been hand-drawn in a style befitting the period of the car. The rendering has been executed to make the lettering appear black and shiny. Again, as with the body of the car, pure black has not been used – you rarely see a pure black with no color bias – but blue and blue-black have been chosen. The top half of the lettering, down to the hard-edged mask representing the reflection of an imaginary horizon line, starts with an opaque blue-black gradated into deep blue which in turn gradates into a very pale blue just above the horizon. From the horizon line down, gray-black has been sprayed in a GRADATED TONE toward the base of each character. To guarantee an equal and even number of gradated tones, all lettering would have been masked and sprayed at the same time.

The complete illustration from which this title was taken can be seen on pages 108 and 109.

Judas Priest
Mark Wilkinson

The lettering reproduced above is a classic example of how two words have been rendered with an airbrush which almost makes them an illustration on their own. It is representative of a trend which started in the 1960s and shows little sign of abating. As a style, it is very popular in advertising and the music world; the example above is the name of a group airbrushed for the tour posters.

The approach has been to create an impression of a highly polished and smooth-surfaced, metallic logo. As a technique, it follows closely with that described for CHROME EFFECTS, except that an intentionally exaggerated choice of colors has been used. Hard-edged FILM MASKING has been used throughout, with an extensive use of reflected colors. The whole image relies solely on the color and shading to hold it together, as no lining-in has been used. In masking letterforms which are shown with beveled edges, accurate and neat mask cutting is essential, for a slight imperfection would soon "jump" out and spoil the illustration.

LINE CONTROL

Line control techniques develop, with practice, the skills needed in controlling and handling the airbrush. In application, any of the techniques shown can be used as part of the general process of arriving at a finished piece of artwork and, more often, in adding the finishing touches which enhance the detail of an illustration.

Using a Ruler
This photograph shows a line being sprayed with the aid of a ruler. The ruler must be held at an angle until the line is completed with the correct air pressure. When using this technique on finished artwork and with a mask to protect the ends of the line, it is always advisable to start and finish the line on the masking film rather than at the edges of the masked shape, to avoid including any irregularity caused by starting and stopping the flow of medium through the airbrush.

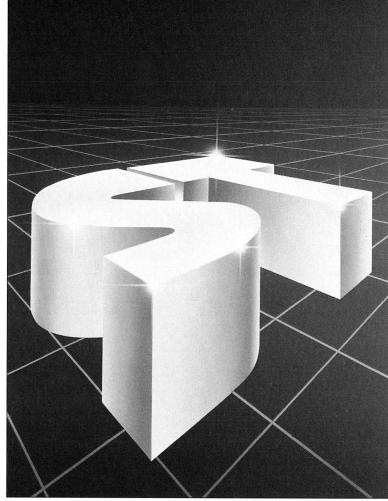

Freehand Spraying
This photograph demonstrates a vital element in the ability to control an airbrush. It shows the freehand use of an airbrush to produce fine, straight lines. The initial problem when first attempting this is the tendency to spray lines which curve toward the ends; this is because of the natural, flowing movement of the hand and a conscious effort is required to prevent it.

Using Masking Film
This illustration shows a magazine cover, on which the initials ST have been drawn three-dimensionally on a base representing a two-point perspective grid. The technique involved covering the artwork with masking film and cutting along each of the grid lines: these lines were left covered while the base color of dark blue was sprayed. When the color was the right density, the film was removed and a paler blue was over-sprayed to tint the grid lines.

LINING-IN

While the major part of an illustration may be completed with an airbrush, it is unlikely to be left without any drawn or hand-painted lining-in. The reason is to establish and de-lineate detail which could not successfully be applied with the airbrush, regardless of the skill of the illustrator. Lining-in becomes, therefore, a very important part of the process of completing an illustration and should be applied with the same care as that given to the airbrushing. So often, beginners to airbrushing tech-niques see lining-in as a boring chore–the final stages in complet-ing their artwork–with the conse-quence that a good piece of airbrushing can easily be ruined by rushed and poorly applied hand-work.

Lining-in may be completed using pencil, paint, crayon or ink, or a combination of media and with any of the wide range of drawing aids available to illustra-tors such as ellipse templates or French curves.

1 The basic details and form for a face profile have been sprayed in using various masks and stencils as appropriate.

2 Freehand brushwork is now applied to bring out the finer details such as the eyelashes, the iris, and the eyebrows.

3 Finally, using a sharpened white pencil, highlights have been drawn in to complete the picture.

LIQUID MASKING

Liquid masking is achieved by using a rubber-based solution which is applied to the surface with a technical pen. The commercially available varieties of liquid masking, also known as masking fluid, are usually tinted to assist in their application. When dry, they leave a water- and paint-repellent film. Color can be sprayed over and around this rubbery skin formed by the dried masking, and the mask is subsequently peeled or rubbed away, taking care not to damage the surface color.

Masking fluid is particularly useful for covering small and intricate details, when more conventional methods of masking become cumbersome and difficult to cut accurately. It can be laid on a clean, unsprayed surface or overlaid on areas previously sprayed. However, on certain surfaces such as rough-finished boards and papers, extreme care is needed when removing the masking to avoid surface fibers being damaged. If in doubt, it is advisable to test the fluid on a sample of the paper or board to be used.

On completion of each stage in using masking fluid, the brush used to apply it should be thoroughly cleaned in fresh water, never the same water which is used to mix the colours for spraying or cleaning the airbrush. Before proceeding with successive stages of spraying, it is essential that each application of masking fluid is allowed to dry thoroughly.

Dot Pattern Sample

1 In this example, liquid masking is used to create a layered dot pattern in selected colors. In the first stage, twelve roughly equal spots of fluid are laid down in three horizontal rows.

2 Here the first glaze of transparent watercolor has been sprayed over and around the masking fluid.

3 The original twelve spots of masking fluid have been removed by careful rubbing with a finger, leaving the white of the board showing in their place. A second pattern of masking fluid dots is then applied and allowed to dry.

4 A second glaze of color is sprayed over the first. The true color is apparent where it covers the white spaces left by the first application of masking fluid.

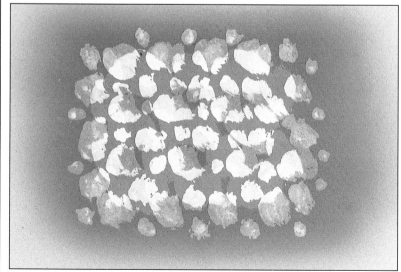

7 The final result is visible on the removal of the third layer of masking fluid. Naturally it is possible to add several layers of masking fluid and an equal number of glazes as desired. It is also possible to apply the masking fluid within clearly defined parameters on occasions when self-adhesive masking film or any other type of mask is inappropriate. Its use depends very much on what is to be achieved.

5 The second layer of masking fluid is removed and a third applied. The white areas of the board which are visible are the result of the second layer of masking fluid overlapping the first.

6 A third glaze of color is sprayed over the whole area.

Partial Removal of Liquid Masking

1 Five horizontal stripes of masking fluid are applied to the board.

2 The first glaze of transparent watercolor has been sprayed.

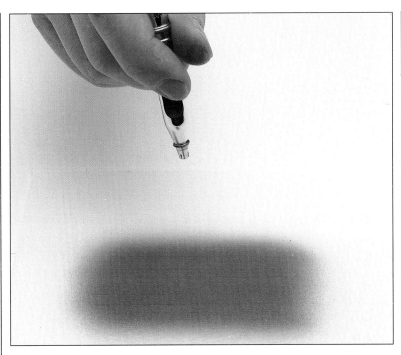

3 In this stage the first layer of masking fluid has not been completely removed. This is deliberate and is achieved by rubbing a finger unevenly over the surface. When the required amount of white surface is visible, a second glaze of color is sprayed.

Using a Ruling Pen

Liquid masking applied with a ruling pen allows for fine linear detail to be drawn where the white of the artwork or a previously sprayed base color shows through after spraying. In all cases the masking fluid must be allowed to dry thoroughly before spraying, just as the sprayed color must also be allowed to dry before removing the fluid.

This particular technique requires extreme care in the removal of the masking fluid because the sprayed color is easily damaged. While it is possible to draw straight lines with masking fluid on a rough-surfaced board, a hard china-clay surface is preferable, as the fibers of the board are less likely to be damaged by "furring" and removal of all of the masking

1 In this example, a series of horizontal lines have been ruled using masking fluid. These are then oversprayed.

4 The remaining masking fluid is finally removed, with the first glaze showing clearly on the stripes and appearing visually at the front, while the second glaze appears as a

backdrop. Again, as in the first example, additional layers of both liquid masking and glazes could be added if desired.

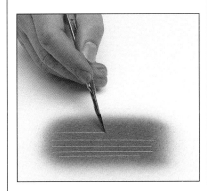

2 When spraying with watercolor or gouache, it is advisable to remove the dried masking fluid with the tip of an art knife blade, as shown here. With waterproof acrylics, it is possible to remove the mask with a fingertip, although care is required when spraying to prevent a build-up of paint that binds the fluid permanently to the artwork.

LOOSE MASKING

This refers to the use of paper and cardboard masks which, depending on use, give a clear but soft delineation to the sprayed edge. Besides giving specific effects, loose masking is a quick method of spraying areas without having to resort to masking film, as long as care is taken with the direction of residual spraying. Reference should also be made to ANGLED SPRAYING, CARDBOARD MASKING and TORN PAPER MASKING.

Using Paper Masks
1 Paper masks cut accurately to a pre-determined shape are laid directly on the artwork and sprayed over with a variety of different shades. Because the paper is directly in contact with the artwork, the edges are fairly well defined, with only a small amount of residual paint seeping underneath.

2 In this example the paper masks are held a distance away from the artwork, which allows for more color to spread under the mask. This gives a much softer finish to the edges; this softness naturally increases the further away the paper mask is from the artwork.

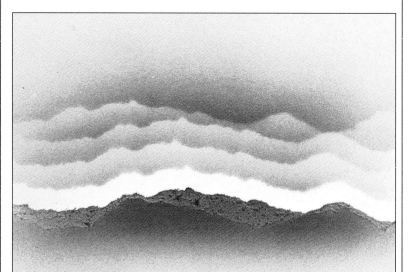

3 Here paper masks are used again, but on this occasion the paper is torn rather than cut. This example shows the effect when the mask is laid directly on the artwork. The irregular texture of the torn edge is accurately reproduced.

4 The same torn paper masks are used here, but held away from the artwork, giving the softer effect.

Using Cardboard
1 Cut cardboard, as shown here, gives very much the same effect as cut paper, although it is possible because of the increased thickness to limit the amount of residual color seeping under the mask.

2 The cut cardboard is used again, but held away from the artwork, giving softer edges.

Using Absorbent Cotton
To enable even more hazy, abstract shapes to be sprayed, cotton is taped in place on the artwork and oversprayed. This can be extremely effective when, for example, stylized skies with soft clouds are needed, although care is required not to spray over the tape as well as the cotton, or to allow residual spray to encroach and cause the silhouette of the tape to become visible.

Pop!
Brian Robson

An airbrushed illustration will often show the use of many different techniques. Although the effect is often heavily dependent on FILM MASKING, it is unlikely that an illustration will be completed without recourse to more than one masking or spraying technique. The above illustration is a case in point: it shows the use of loose masking to achieve a particular finish. While the majority of the color has been sprayed with hard-edged masks, the darker shades on the cast-iron saucepan supports have been sprayed with a loose mask, held slightly away from the surface of the artwork. This gives the impression of representing the glossy enameled finish of the real thing, without appearing too severe, as harder contrasts would make them look chromed.

When assessing which technique should be used, film masking or loose masking, consideration needs to be given to the desired finish and, as important, the materials and surface finishes to be rendered in other parts of the illustration. Yet again, pre-planning is useful.

OVERSPRAYING

Keen observation of the range of values in color, light and shade will make it apparent that the base color of an object is rarely seen by itself. The reflective nature of light means that other colors will be included, usually from objects or colors immediately surrounding the principal object. Additionally, the composition of some subjects means that the colors and shades cannot be separated and sprayed in isolation from each other. This then requires the application of overspraying to model shape and form. The use of overspraying when airbrushing is similar to overpainting and gives depth and body to a subject.

1 The preliminary drawing of a clenched fist has been drawn in pencil on detail paper, with the tonal values shaded in. These will be a useful reference when spraying the image.

2 Once the drawing has been corrected, the outlines are transferred to illustration board.

3 The drawing is covered with masking film and the complete exterior shape of the fist and the finger joints are cut in the film. Starting with the thumb, the mask is removed and hinged; the spraying is carried out with a medium shade using an appropriate color in gouache.

4 Darker shades are added over the medium ones, thus increasing the apparent depth of the subject.

5-8 The spraying sequence now proceeds with each individual finger until all have been modeled with the airbrush using the medium shades. At all times the separate mask pieces are cut and hinged to allow for accurate repositioning. In a subject such as this, good control of the airbrush is essential due to some areas requiring a hard-edged finish, where one finger is touching its neighbor, but where a finger joins the back of the hand, a subtle freehand technique is required. The depth of contrast must also be carefully controlled, so that on completion of the modeling of the form, there is no evidence of the sequence followed.

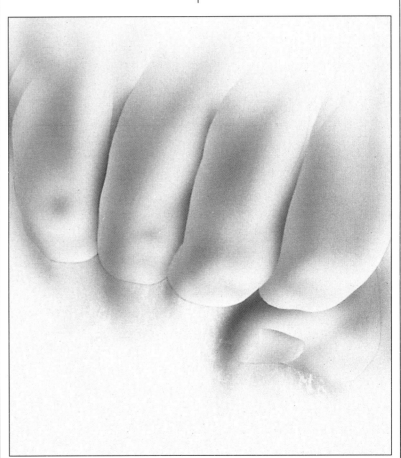

9-12 The process is repeated re-using the previously hinged masks, but this time each finger is over-sprayed with the darker shade.

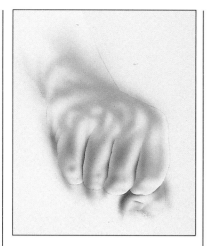

13 When both tonal values have been sprayed onto the fingers, all separately hinged masks are completely removed from the artwork. The medium shade is then sprayed freehand to model the back of the hand and the wrist.

14 A medium-dark shade is now oversprayed to increase contrast and to indicate natural shadow.

15 The darkest shade is added, primarily over the shadow area on the back of the hand.

16 Finally, a very light shade, which is almost pure white, is oversprayed to add highlights to the fingers and knuckles.

17 The artwork is completed on the removal of the final piece of masking film. Depending on the size and purpose of the illustration, additional detail could be added with pencil and brush.

RULING

Together with LINE CONTROL and LINING-IN, drawing straight lines with a ruler is an essential technique for adding detail and finish to an airbrushed illustration. It must never be rushed, as it could so easily make or mar the finished work.

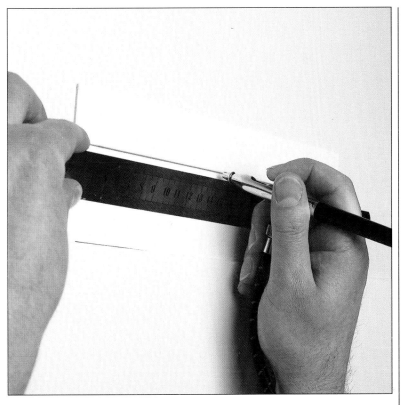

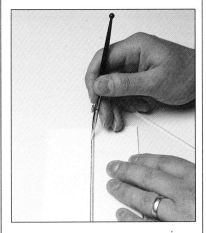

Using a Ruling Pen
The traditional and indispensable ruling pen is shown being used against a T-square. When using a ruling pen, care must be taken to maintain the same angle throughout the length of the line. It is also important to hold the pen at a slight angle to the T-square or ruler to prevent paint or ink from flooding underneath the edge.

Using the Airbrush
A line is being sprayed using a ruler, held at an angle, as an aid. This gives a clean finish with varying degrees of gradated shade extending from the edges of the line, depending on the strength of medium and the air pressure allowed through the airbrush. With less pressure, the line would appear grainy.

Using a Paintbrush
This photograph shows the illustrator drawing a clean, even line with a brush, using a ruler to ensure straightness. This technique requires steady pressure to maintain even thickness along the required length of the line.

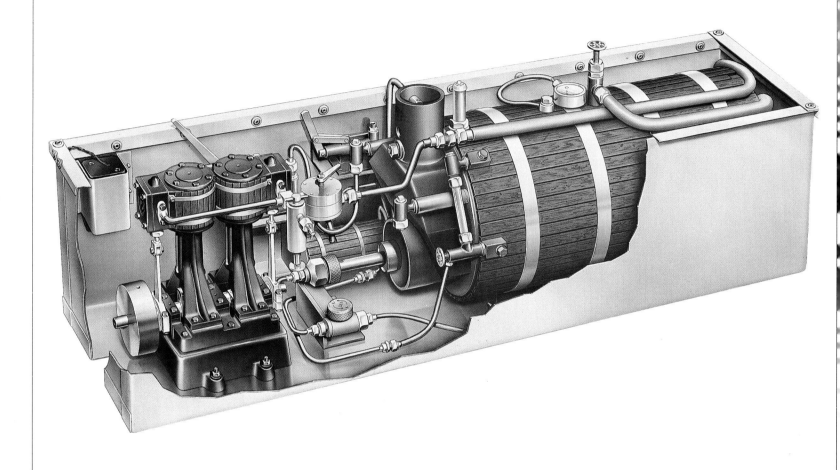

A self-contained model steam power plant
Peter Jarvis

This three-quarter view perspective illustration was commissioned by Argus Books Ltd for the book *SS Great Britain: the Model Ship*, and it clearly demonstrates the application of RULING and LINING-IN with a ruling pen and a fine sable brush. The technique adopted followed conventional methods for the preparation of full-color, airbrushed artwork for reproduction, using masking film.

However, the subject is made up of many small components which could not be airbrushed and which required extensive hand-painted work. In addition, it was decided to present the subject in a new, unused state which would enhance the various components and the materials from which they were made, but which would also add contrast between the different surfaces and the way they had been machined or finished. To create some of this contrast, a ruling pen was used.

The aluminum casing which contains the boiler, pumps and twin-cylinder steam engine has straight lines on those edges which would show a shadow. Edges facing the light source have been highlighted with a straight line which is a much lighter mix of the base color. The detail, HIGHLIGHTS and contrast on the rivets have been applied with a brush, as have the edges of the cuts. These are rendered in two shades of red, to show the thickness of the aluminum, with the leading edge picked out in a very light gray, while the shadow edge has been picked out with a dark gray. The red castings forming part of the boiler fittings were first sprayed; semi-opaque white highlights and shadow lines were applied afterwards by hand. The brass nuts also have a sprayed base color, with shadows and highlights subsequently added. This approach has been adopted throughout the illustration.

An airbrushed illustration such as this, composed as it is of so many small details, requires an extensive use of hand-rendered ruling and lining-in. As much, if not more, patience is needed at this stage of an illustration to ensure that the finish is compatible with the quality of the airbrushing. Inexperienced artists should be wary of rushing the work.

SCRATCHING BACK

The point of a new on an art knife blade is an effective and indispensable tool for adding fine highlights and texture to illustrations; this kind of detail sharpens the finish of an illustration and adds crispness to it. To achieve the effect, the surface of the artwork is scratched back to expose the white of the board.

Thin Highlights
The illustration of part of a palette shows one use of a an art blade to scratch back thin, white highlights on the straight and curved edges. Although not very wide or pronounced, they are enough to add to the quality of the finished illustration.

Sprayed Highlights
In this artwork of an axehead slicing through material, scratching back is used to enhance the machine surface finish of the blade and to create a sprayed highlight which emphasizes the cutting edge of the blade.

Thick Highlights
In this example, highlights in the eyes, eyebrows and lines surrounding the eyes have been subtly scratched out, giving emphasis to these features.

SPATTERING

Spattering can be achieved either by lowering the air pressure allowed through the airbrush, or by fitting a splatter cap in place of the usual nozzle. Additional control is achieved by varying the distance the airbrush is held away from the artwork and adjusting the combined amount of air and medium which is allowed through the airbrush. The effect is to give a stippled or grained finish with varying densities and sizes of dots.

Because a splatter cap can create quite a crude finish, practice is required before attempting to use this technique on serious illustration work. However, the use of a splatter cap does have very practical applications. It can be used to represent the ground and thereby add interest and contrast, especially when the principal subject is of a polished nature; it can also be used to represent unmachined castings or the surface of a section in a cutaway illustration, to name but three examples. The use of spattering to create texture, and the finish achieved from it, does not preclude its use in adding, in a controlled manner, form and tone to a shape or object.

Two practical demonstrations are included here which illustrate how spattering can be used to simulate specific textures.

1 The above demonstrates the basic effect obtained when using a splatter cap fitted to an airbrush. The variety in density and size of dots is achieved by controlling the distance the airbrush is held away from the artwork. Not all makes of airbrush include the splatter cap as an accessory.

2 This example shows a fine spatter effect which has been sprayed from a standard nozzle by using decreased air pressure.

Galaxy Effect
Using a solid black or blue-black base to the artwork, opaque white is oversprayed through a splatter cap to give an impression of a galaxy of stars. This could be further worked on by applying hand-painted or sprayed "starbursts." The base spraying and the initial stars could also be sprayed with a variety of shades and colors.

Stone Finish

1 This shows one method of spraying a stone. The shape of the stone is first drawn on board and the whole area is covered with masking film, with the shape of the stone cut out. Gouache is sprayed through a splatter cap.

3 The form of the stone is modeled by overspraying the shadow tone using a standard nozzle.

2 A second color, slightly lighter in shade, is now sprayed, again using the splatter cap.

4 The masking film is removed from the artwork, revealing a simple but effective rendering of a stone. With further practice it is possible to increase the variety of shades and the number of colors, even to the point of using the splatter cap

Rubber Texture

1 The second illustration demonstrating the application of a splatter cap is a rectangular box which is sprayed using watercolor to resemble a piece of rubber. This example again uses both the standard nozzle and the splatter cap. In the first instance, the shape is drawn and the artwork covered with masking film. The basic shades are sprayed using very low air pressure, beginning with the face nearest to the observer.

2 The side of the box is exposed and sprayed, again using both the standard nozzle and the splatter cap to develop the texture.

3 The top is the final surface to be sprayed. By following the sequence illustrated, there is no need to recover the previous stages with masking film: successive sprayings increase the tonal depth. Not only does this speed up the process, but it prevents errors which can be made by repositioning the film inaccurately, which tends to create unsightly double edges on the finished artwork.

Birthday cake
John Brettoner

This illustration demonstrates an excellent application of the use of SPATTERING, although close study will reveal that it also includes many other techniques described in this book. Interesting contrasts have been made between the cake, which has been sprayed without a splatter cap, and the headstones and the foil-covered base, which are spattered. This has created a strong visual image, which emphasizes differences in the surface textures and the various materials.

The headstones were conventionally sprayed with a base color to establish the general shades and the color variations between the different types of stone. Following this, the shadow edges to the chipped and damaged areas of the stones were added by brush. Spattering was then oversprayed on the base color using a mixture of whites, grays and blacks. Next the HIGH-LIGHTS to the chipped edges were applied with opaque white, with LIN-ING-IN by brush completing the headstones.

The cake base followed much the same sequence as the headstones, with the base color and form being applied first, without a splatter cap. The spattering was then oversprayed using a mixture of opaque white and blue-black, the latter in varying densities depending on the direction of the light source. Hand-painted crease marks and highlights were added, with shadows on the crease marks being applied with transparent watercolor, allowing the spattered effect to show through.

4 When the required tonal values and depth of contrast have been achieved, the masking film is finally removed.

STARBURSTS

This is a particularly effective airbrush technique which can be used in many different ways. Besides the obvious use in rendering realistic impressions of stars in a night-sky or descriptive detail in fantasy or science-fiction illustrations, starbursts are also applicable in showing diffused reflections or dazzling highlights, as in the headlights of vehicles seen photographed with a long exposure.

The following sequence demonstrates the most effective method of applying starbursts, using an acetate mask. The reason is twofold, in that the artwork is always clearly visible, allowing for accurate positioning, and that a certain amount of residue color will seep under the mask, softening the edges slightly. Self-adhesive masking film can be used, but this will give a very hard-edged finish which, unless oversprayed color for the starburst is subtly applied, will be less convincing.

1 This stage shows the acetate mask with a simple cross cut into it. The lengths of the arms of the cross are cut much longer than required to avoid even the slightest hint of an edge appearing after spraying. Opaque white is sprayed through the mask, concentrating on the center of the cross and allowing the residual spray to find its own limits.

2 The mask is shown being removed, revealing the greater density of white at the center of the starburst, fading out toward the ends of the arms.

3 The finished example. If required, the number of arms may be increased in any proportion using the same mask, or new masks could be cut depending on the desired effect.

4 In this example, the same mask has been used twice, but in different positions and with different degrees of intensity at both the center and in the lengths of the arms, making the larger of the two appear brighter and nearer to the observer. Note, too, that they are both angled in relation to the artwork.

STENCILS

When it is necessary to produce repeat pattern artwork, the stencil becomes a useful aid, although excessive use of a paper stencil will soon give distorted images because of the effect the paint will have in wrinkling the paper. Thick cardboard is a more stable material for stencils, but it can be difficult to cut intricate shapes. The thickness of the cardboard may also cause a narrow, unsprayed edge around a shape, if the airbrush is held at an angle while spraying. Natural or man-made objects can also be used as stencils, giving an infinite number of patterns.

1 A simple shape has been cut into stiff cardboard for use as a stencil.

2 Here the spraying is restricted to the edges of the stencil, with no color being applied to the center.

4 A simple symmetrical pattern obtained by overlaying the same stencil.

3 The finished result shows, on the left, the effect when the stencil is held flat on the surface, while that on the right shows the effect when the stencil is held above the artwork. Notice that when it is held away from the artwork, the residual color encroaches over a wider area, both outside and inside the stenciled shape.

5 This example is the reverse, in that the stencil now consists of the shape originally cut from the cardboard. This has been laid on the board and the color sprayed around it. When using a flimsy stencil, such as paper, it is possible to hold it in place, but care is required to prevent the spray from producing a distorted silhouette shape of whatever is holding the stencil down.

6 Using the same stencil as in step 5, a multiple overlapping pattern has been achieved.

TAPE MASKING

People who do drafting work use a transparent, self-adhesive masking tape, called invisible masking tape, which is matte-finished. It is suitable for drawing or inking on, and therefore ideal for repairing drawings, especially when these are prepared on drafting film. This tape is also useful in airbrushing when, as in the example illustrated here, small areas have been exposed out of sequence. It may be cut and used in the same way as masking film and similarly has a low-tack adhesive which does no damage to the artwork.

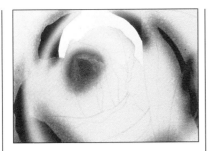

1 Referring to the example described and illustrated under the heading FILM MASKING, three stages in the use of tape masking are shown here. In the process of cutting and removing film for different areas of the rose, a piece of film was taken off prematurely. Matte transparent tape was used to re-cover the exposed petal, which was then cut to shape.

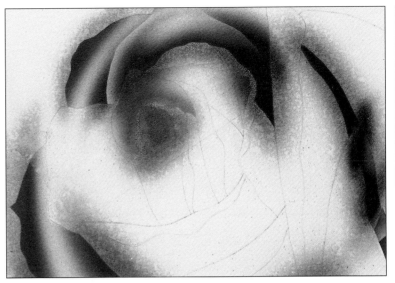

2 With the tape in place, the petal was sprayed corresponding to the correct order in the sequence.

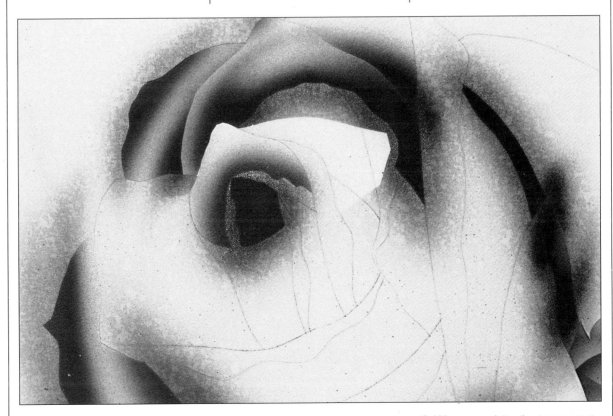

3 When complete, the transparent tape was lifted off and the spraying sequence continued.

TEMPLATES

Useful aids in airbrushing are the many and various die-cut templates used in drawing illustrations. These are used in much the same ways as hand-cut stencils. The examples which follow show simple applications for ellipse, circle and French curve templates.

There are two things which need particular attention if you are using plastic templates in airbrushing. One is that the sprayed color dries slowly on the plastic, so you should make sure the underside of the template is clean and all excess color has been wiped away if you are using it more than once. Also, if the template consists of multiple shapes, use tape to mask off the ones surrounding those being sprayed; otherwise, residual color may fall through and create shadowy silhouettes where color is not wanted.

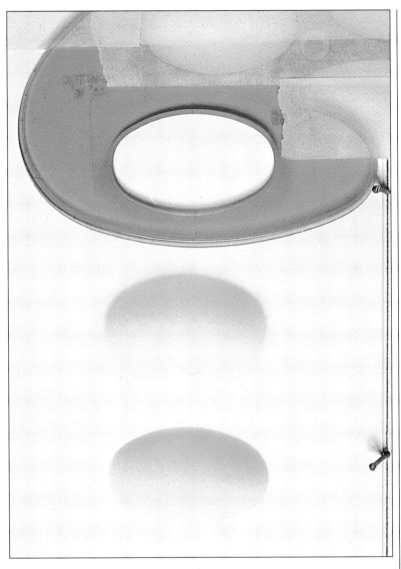

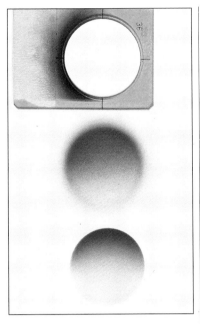

2 A circle guide template has been used here, both holding it away from and laying it on the artwork, as in the previous example.

1 This example demonstrates the use of a typical ellipse template. The spraying is directed through the required size and angle of the ellipse, either as flat color or, as here, gradated color. The uppermost ellipse has been sprayed holding the template at a distance away from the artwork, while on the lower one the template has been laid on the surface of the artwork.

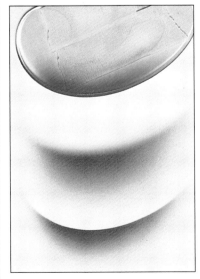

3 This shows a French curve being used in the same two ways. The use of French curves, as with any template, needs special care to prevent residual color from being sprayed around those parts of the curve not required.

TORN PAPER MASKING

If the exterior silhouette being sprayed is not confined by predetermined dimensions, torn paper can be an effective form of masking. To illustrate one application, it might be required to create an impression of the sea, and torn paper prepared in a variety of wave shapes could be used to define the waves over a pre-sprayed base color. By slightly moving the torn paper horizontally to the left or right after the first spray, the waves will take on a quite convincing appearance, albeit in a stylized manner. Reference should also be made to ANGLED SPRAYING, CARDBOARD MASKING and LOOSE MASKING.

Special Effects
1 In this example of special effects, a simple illustration of receding mountains is shown, and in the first stage, a torn paper or thin cardboard mask is prepared. The border of the illustration is protected with masking film which will remain in place until the final stage. Note that what has been removed from the paper mask is the shape of the mountain, and not the surrounding area. Because this first shape will be in the foreground, the mask is positioned on the lower part of the artwork.

2 The first application of color is sprayed in transparent watercolor, gradating from the top to the bottom of the mountain. As this mountain is nearest the observer, the strength of color and shading is the most intense – the subsequent stages will show a gradual softening of tonal values as they appear to recede from the observer.

3 A new shape is torn into the paper, positioned on the artwork and sprayed in a slightly less intense color.

4 The process is continued as the impression of depth is increased. It will be noted that shapes already sprayed are not protected by a mask. This ensures that the tonal value of those shapes representing mountains in front of the one currently being sprayed retain their strength.

5 Again the shape is changed, sprayed more lightly. It covering less area than before.

7 When the very pale shapes in the far distance have been completed, the torn paper masks are discarded and the sky is sprayed. This is a lightly gradated shade of color running from the top of the artwork to a level just above the mountain tops.

6 Another background shape is sprayed, maintaining the lighter shades established previously.

8 The masking film delineating the outer borders of the illustration is now removed and the final result gives an illusion of depth, distance and space.

TRANSPARENCY

This technique refers to objects which are transparent to a greater or lesser extent. It requires a far greater control in the application of sprayed color than does the representation of solid objects, because it is easy to overspray and in so doing to knock back the transparent effect, in which case the process has to start again. The example used here to illustrate transparency is a simple cube, and no allowances are made to include reflected colors or highlights which might be apparent from surrounding objects.

In advertising illustration, there are many examples of objects airbrushed in this way which would not, in reality, be transparent. Many of these illustrations come from the imagination of the illustrator and are done to achieve a particular effect and often for impact. To reach this standard requires skill, practice and an understanding of the changes in light and reflections as seen through a transparent object. GHOSTING is very much related to this technique, and the two may be used together in order to gain a better understanding of the application of transparent effects.

1 The drawing of a cube showing all six faces has been prepared and covered with masking film. The naturally visible left-hand face in the foreground is exposed and sprayed with a gradated shade of color running from the leading edge to that furthest away from the observer.

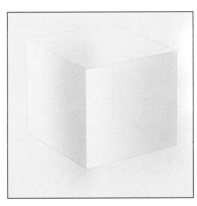

2 The right-hand face is now cut and sprayed, again with a gradated shade, but from the extreme right-hand edge toward the leading edge.

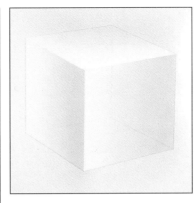

3 The top, horizontal plane is sprayed next, the shading running from top to bottom.

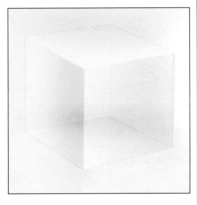

4 The inner face of the cube lying on the ground plane is sprayed next, with the depth of shading gradating from the furthest corner away from the observer toward the leading edge corner.

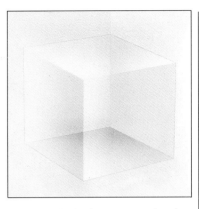

5 The vertical edge representing the corner of the cube furthest away from the observer is masked and sprayed with a gradated shade running from left to right.

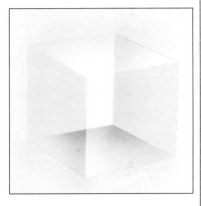

6 The left-hand inner face at the back of the cube is sprayed with a gradated shade.

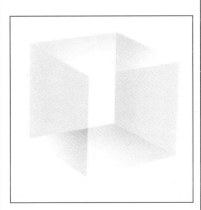

7 Finally, all masking film is removed.

Finger Style
Brian Robson

Some consider the airbrush to be a tool only for technical illustration, which has no place in any other type of graphic imagery. Such viewpoints misunderstand the reason for using any aid in the production of an illustration. If a desired effect or finish is best obtained with an airbrush, or any other tool, then would it not be appropriate and sensible to use it? The illustration reproduced here is a case in point, for it might at first appear that spraying would not be the best means of arriving at the finished result. Nevertheless, an airbrush has been used, showing the illustrator to have complete control over the airbrush and the density of color applied to each part of the illustration. It relies very much on the technique of rendering transparency, with FABRIC MASKING at the top left and bottom right contrasting well with the FLAT TONES of the two circle segments.

BACS
John Brettoner

As mentioned in the introduction to this technique, far greater control is required in the spraying of transparent objects than solid ones, especially if other objects are to be shown behind. Control is required both of the amount of color applied and the density of the shades, each being dependent on the degree of transparency of the object. Careful planning is also required to ensure that any oversprayed color is applied in the correct sequence, so that there is no doubt as to which surfaces or objects are transparent, and which are in front or behind. The technique applied to spraying transparent objects cannot be identified from a single example of a finished illustration. Because of this, preparatory color notes should be made before starting on a piece of finished artwork and the sequence of spraying worked out beforehand.

The example reproduced here shows a very simple, but highly effective, rendering of eight glass balls centered around a larger one carrying the BACS logo, all set against an opaque background with a subtle reflection of part of the grouping. The quality of transparency has been achieved by OVERSPRAYING the ball immediately behind the one in front with a soft shade of the latter's base color. This is particularly obvious with the black-and-white ball lying behind the gold-colored BACS ball. It will be noted that the ball at the back has a HIGHLIGHT which has been sprayed with a lower-key shade of the gold, rather than the white applied to its neighbors.

VIGNETTING

A vignette is a drawing which is not contained by any clearly defined borders or edges, but either fades into the background or stands on its own. In airbrush illustration work, vignetting is used to achieve the same result by gradating the colors that make up the background. Sometimes it can be used to fade out the object itself, especially if one side or area is considered unimportant to the central theme of the illustration.

Fading In a Background

1 An illustration of an apple has been drawn and, to protect it from the background spraying, has been covered with masking film. The edges of the square which will contain the apple and its background have also been masked.

2 The spraying begins with a gradual build-up of a gradated shade, from the outside edges of the box inward.

3 The shade is increased until the required depth is reached.

4 When the vignette is completed, the mask protecting the edges of the box is removed.

Fading Out a Background
1 In this demonstration a faded background is required, but gradated from the object outward. Here the apple has been protected with masking film.

2 Spraying has started from just within the edges of the mask and an even shade is built up all around the apple.

3 The depth of color is increased to harden the contour of the form.

4 When enough color has been sprayed, the mask on the apple is removed, showing the vignetted background outlining the shape and fading gradually outward.

WINDOW HIGHLIGHTS

By its very name, this technique refers to the reflection, usually on a curved surface, of a window. It is visible under a range of light conditions, but as a highlight is more pronounced when the light source coming through the window is particularly strong. As a technique, this is useful for enhancing the appearance of a highly polished, but opaque object in a stylized manner, especially when no other reference source is available. It is an extremely popular device and can be seen in airbrushed illustrations from any period. When taken further by the inclusion of surrounding detail, both on and near the window, the effect can be one of super-realism, a style developed with great expertise by many of the Japanese exponents of the airbrush.

Though effective, window highlights should be used with caution, and they are not applicable to all surfaces or subjects. For example, it would be inappropriate to use a window highlight on the hubcaps of a modern 18-wheeler, regardless of how polished and glossy the metal: the chances of such a vehicle being housed indoors so that it would accurately reflect patches of light passing through a window would be very slim.

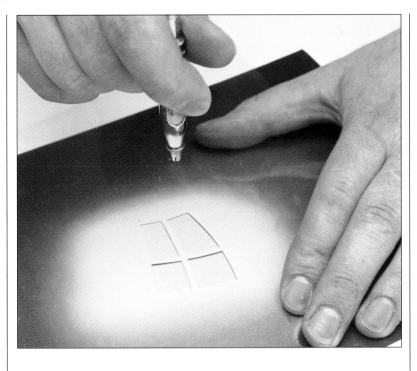

1 In this demonstration the window shape has been carefully cut out of acetate sheet and placed in the required position over a pre-sprayed base color. Opaque white is then sprayed through the mask.

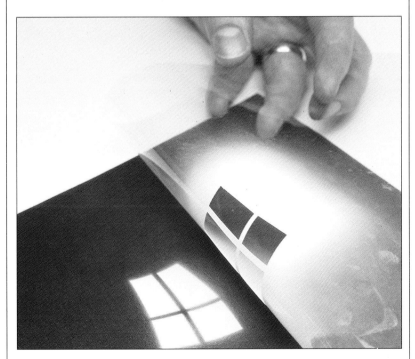

2 This photograph demonstrates the effect with the mask pulled back. Notice that the shape of the stylized window is curved. When used on a curved object, the curves of the window should conform to those of the object. It is, of course, acceptable to cut the mask with allowances for the distortion which sometimes becomes apparent through perspective, but this will require close observation of a real example. By using an acetate mask, the resulting effect will be to give a soft edge to the highlight. The degree of softness will be determined by the distance the mask is held away from the artwork. Of course, a hard edge could be obtained by using self-adhesive masking film.

PART II •THEMES

The following section of this book includes finished examples of artwork produced with the aid of an airbrush, either in whole or in part. All of the work has been produced by practising illustrators, and as stated in the introduction to the techniques section, have been selected because of the quality of technical skill apparent in the work as applicable to the airbrush. This is not to mean that the selection is completely representative of the standards being acheived today, for a combination of space restrictions and a lack of access to some illustrators work has meant that many examples which *should* be included have unfortunately had to be omitted. The Themes have been loosely divided under seven section headings; a cursory examination of some examples will show that they could equally be placed under other headings and therefore any aspiring illustrators should not restrict their study to those headings in which they have an interest, but should study *all* examples. By doing this a greater understanding of how best to use an airbrush for a specific effect will be gained.

It will be noticed that many of the following illustrations use the airbrush equally alongside hand-painted work. It is important to appreciate why this is so. Many students, when first introduced to the airbrush and what can be acheived with it, become seduced by its effects and often assume the airbrush is the only means by which to arrive at high quality and impressive illustrations. This is a wrong assumption. The airbrush should always be used *in context* and if only a small part of an illustration lends itself to being sprayed, then it should be so restricted. What should take precedence over all illustration techniques are the requirements of the brief and the expectations of the client.

Conversely, there are also examples reproduced here which, with the exception of linear highlights and lining-in, have been completely rendered with an airbrush. The subject itself and the impact the illustrator is endeavouring to achieve, will often determine this. Again, as with the actual techniques of using an airbrush, there are no hard-and-fast rules. Illustrators who work exclusively with the airbrush and who have achieved sometimes incredible standards of work with it, have spent many hours developing their technique. It does not come overnight, even though some do have a natural flair.

This section of the book should not be seen in isolation to the techniques, but cross-referencing between a number of techniques and specific finished examples will add to the illustrator's knowledge which, by practice, may then be converted into yet another acquired skill. The text which accompanies this section of the book has been deliberately restricted to commentary about the techniques and application of the airbrush. Only where preliminary preparation work may have had some bearing on how the airbrush was used, has such information been included. Finally, students are advised to keep a reference portfolio of published examples of airbrushed work; as do many of the professional illustrators. Not only will this keep them aware of current illustration styles, but it will also add to their understanding.

TRANSPORTATION

Transport and industrial themes are probably the two principal subject areas which result in more airbrush-rendered illustrations than any other. Transportation itself is vast and diverse. It encompasses nautical vehicles and oceanographics; aeronautics and astronautics; railroad engineering; and commercial, military and private vehicles to name but some of the subjects which, grouped together, contribute to the general heading of this particular theme. It is, however, true to say that the subject of shipping is one which has not received the attention of airbrush illustrators to the same extent as other areas of transportation. This is unfortunate, because the scope is so vast, but it is perhaps the sheer scale of a ship which has deterred professional illustrators from applying their skills.

Since the widespread introduction and use of the airbrush as an additional aid in the preparation and production of illustrations, illustrators have quickly appreciated the value of this tool in rendering the many facets of transportation subjects. In commercial use, the theme of transportation may be seen in advertising, posters, manuals, textbooks, and general and specialist magazines; in fact, across the whole publishing spectrum. The examples of finished illustrations reproduced here range from pure, traditional technical illustration through stylized advertising illustrations to accurate, super-real representations of subjects in natural environments. They demonstrate the application of many of the techniques previously described.

Before deciding on the application of sprayed color to render a transportation subject, it is essential to learn about the materials from which the subject is made and the finish applied to it for its intended use. Furthermore, one should establish early on, preferably at the drawing stage, or rough-color stage, the direction of the light source in relation to the amount of detail required to be shown. This is essential because any illustration of a complex subject, composed of so many compound surfaces, needs careful planning and if an airbrush is to be used, such planning will avoid the need to respray areas already completed. Illustrations such as those reproduced here cannot be rushed and, because they require many masks to be cut, time can be saved if sufficient preparatory work is completed before starting to airbrush the finished artwork.

Reference material for transportation subjects is abundant, if one has the patience to look, especially for historical subjects which may require visits to some of the specialist libraries or professional institutions. Often photography is

1959 Corvette by Vincent Wakerley

used as a foundation for an illustration. This is perfectly acceptable, but may create visual distortions if not used with care. It is not always possible to take a photograph and thereby make allowances for the exaggerated perspective which can occur. If this is the case, the subject needs to be traced and then corrected before it can be transferred to the artwork. Many students do not appreciate this need, because they do not see the subject on its own, but always think of it in the context of the surrounding environment. Taken out of this context, the distortion is sometimes quite incredible and the best way of assessing how much needs to be adjusted is to pin the tracing on a wall and look at it from a distance. A trained eye will soon be able to tell, and with a good understanding of the theory of perspective, it is a relatively easy matter to arrive at an acceptable drawing.

There is no special characteristic of airbrush technique which is peculiar to the spraying of transportation subjects. Time constraints are possibly the most frustrating thing to deal with, and students in particular should always be aware of this. Too often a student will start a complex airbrushed perspective of a transportation subject and approach it with enthusiasm, as evidenced by the initial quality of the first stages of spraying. But this is often followed by impatience to see the finished result, which leads to rushing the final stages of lining-in and ruling almost to the point of spoiling what could be an excellent piece of work.

Formula 1 racing car
Tom Stimpson

The representation of speed and movement in an illustration is not easy; this is an excellent example of how to achieve it with an airbrush and clearly demonstrates when not to show superfluous detail. The background, running into the road surface and then into the foreground, is shown by a series of horizontal bands of sprayed color, each of which has soft edges created by LOOSE MASKING. These bands become narrowed to lines immediately below the rear wheel and to the right of the reflected flame (see LINE CONTROL). This achieves the desired effect of indicating direction and, because no detail is shown, adds to the impression of speed.

The speed of the car is accentuated by the absence of any hard edges. In fact, a close examination will reveal that for each part of the car, its tires and the driver, the blurred edges are the result of spraying a given area twice, the first time with the base color and the second with a transparent overspray of white, but slightly out of alignment to the base color. This has also been done to the word Olivetti, whereas the additional and much smaller sponsors' names, Pirelli and Pernod, have been OVERSPRAYED, or KNOCKED BACK, with a very light horizontal band of a dark shade to give them a blurred effect also. It is possible to achieve many of these effects by the use of ACETATE MASKING or CARDBOARD MASKING.

To accentuate the intensity of the flame, the car and background are rendered with a very limited color range, with only the driver's helmet being subtly picked out and complementing the flame. This has added to the success of the image.

By way of comparison, it is worth noting the different techniques used to represent movement between this illustration and that reproduced on page 33. The racing car relies totally, and very cleverly, on illusion to trick the eye into reading speed into the illustration, which is further helped by the almost orthographic view chosen to show the car. That of the Porsche and tanker uses soft-edged lines of opaque white, fading out in the opposite direction to that in which the vehicles are traveling. Both illustrations use very blurred lines, either in the background or foreground, to add to the impression of speed.

British Leyland Mini 1275 GT
Paul Shakespeare

Following acceptance by the Patrick Collection of the illustration of the Datapost Ford Escort RS 1600i illustration, (see page 48), Paul Shakespeare was commissioned to produce a similar piece of work, reproduced here. It shows the Patrick Collection's own Championship-winning British Leyland Mini 1275 GT, which was built and raced by Richard Longman and Co. Ltd. The illustration had a double purpose; in the first instance, it was intended to be permanently displayed in a museum in Birmingham, England, and second, to be reproduced for sale as a poster. The completed illustration measures approximately 90 x 55cm (36 x 22in) and was completed on CS10 line board. Reference material included the car itself, manuals, and visits to scrapyards to determine the body shell shapes.

Besides being a classic example of the traditional use of the airbrush, it warrants comparison with the Ford Escort because of the circumstances under which each was produced. The Ford Escort was a special project completed while the illustrator was a full-time technical illustration student, whereas the Mini represents an example of his work after two years of full-time freelancing as an airbrush illustrator. The approach adopted in this illustration relies more on GHOSTING than on clearly defined cutaways to show the interior. While on this occasion this technique allowed more information to be conveyed, it did require very careful planning, because the brief also stipulated that the full exterior racing colors, which are not exactly bland or simple, must be clearly shown.

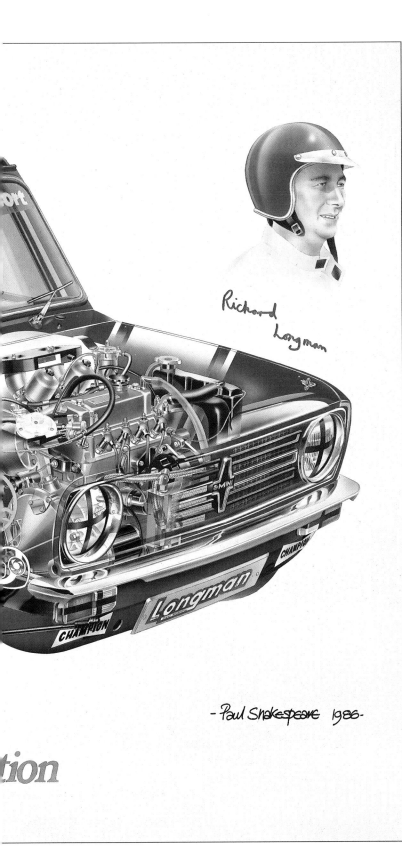

Richard
Longman

- Paul Shakespeare 1986 -

tion

A preparatory drawing was first completed and then transferred onto the line board. FILM MASKING was the principal method used in protecting areas of the artwork not being sprayed, with LOOSE and ACETATE MASKING being used to achieve soft edges where appropriate. Highlights derive from the white of the board, and from overspraying or brush-painting with opaque and transparent white. RULING has been kept to a minimum, with small details having the base drawing lines showing through to delineate edges, while larger components and broad areas rely on the changes in tonal values and contrast to maintain form and shape.

The extensive use of ghosting demonstrates two particular methods, depending on the location and extent of detail in a given area. Smaller fittings either have been drawn in full, as if the body was made of glass, or have a part fading away. The color scheme has been used to help define shape and changes in direction on the exterior bodywork, with gradated color fading into areas where internal detail is shown. Other parts of the body have been ghosted and over-sprayed with transparent color. This helps to hold the exterior together, as well as placing the interior in its correct location. The LETTERING TECHNIQUE combines flat color with surface rendering, depending on position and to show reflected highlights. Once the detail visible through the windscreen had been completed, it was all KNOCKED BACK with a GRADATED TONE of transparent white, at the same time creating a reflection at the far left-hand side. The same technique of knocking back was used on the rear side windows. The illustrator has done a successful job of maintaining form within certain areas

which have been ghosted. Take, for example, the offside main headlight: this shows little detail to the glass, compared to its opposite number, because of the ghosted detail behind. However, to describe the shape and to balance the two headlights, the protective black tape has been left and sprayed with opaque colors. Such small touches require practice if they are to work, as well as careful thought beforehand.

Great Western Railway King Class 4-6-0 locomotive *King Edward II*
James Weston

This three-point, cutaway perspective illustration, measuring approximately 240 x 120cm (96 x 48in), was commissioned for permanent display in a renovated rail station in England and represents the locomotive as it should appear after rebuilding. Because steam locomotives hauling passenger trains were kept in immaculate condition, it was decided that the airbrush was the most appropriate means of rendering the various gloss-painted metal surfaces. The time restraints imposed by the deadline also demanded a quick, but effective means of covering large areas, but with a result which still retained the "feel" and look of the subject. This completely ruled out any great extent of hand-painting. The illustration was sprayed with watercolor and gouache paints using a combination of ACETATE, CARDBOARD, FILM, LOOSE and TORN PAPER MASKING, with film masking predominating, on a Hot-pressed watercolor paper which had been dry-mounted on Masonite. The paper surface had to be treated very carefully because of the risk of damage to the fibers whenever the masking film was removed.

The first areas to be sprayed were those details shown within the cutaway and farthest away from the observer. This meant that if any color bled under a mask, it would eventually be covered by the detail in front, thus avoiding the use of scratching out or excessive overspraying with opaque white. No white highlights were added to the boiler casing or the smoke box, the natural white of the paper having been allowed to show through by spraying these areas with GRADATED TONES.

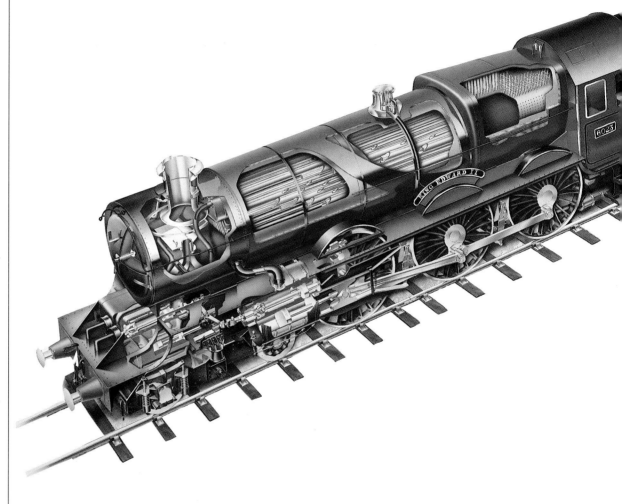

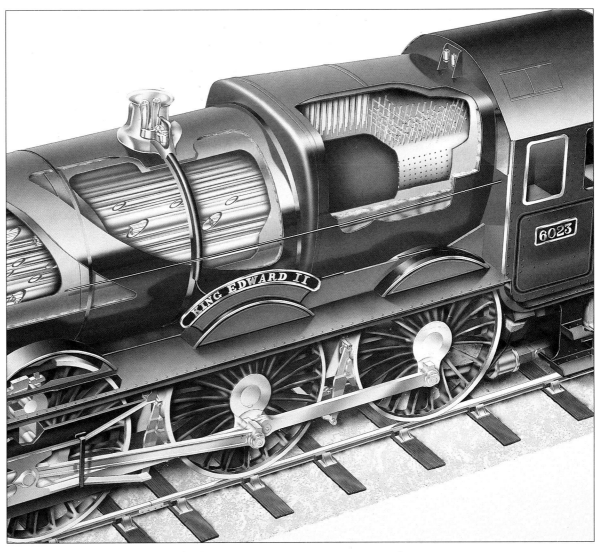

King Edward II locomotive (detail)
James Weston

This enlarged detail view of the main illustration shows the driving wheels, fire box, rear part of the boiler and part of the cab. It clearly shows the use of HIGHLIGHTING and RULING. In addition, the exterior of the boiler casing, painted green, shows an example of TORN PAPER MASKING in the line of the reflected horizon. To obtain a strong contrast, but with a soft edge, this reflection was sprayed three times, in the first two stages using torn paper, but varying the position slightly, and in the third overspraying with a freehand line

(see LINE CONTROL). The soft-edged reflection of the running board and driving wheel covers was achieved by the use of a cardboard mask held slightly away from the surface of the artwork. The cab roof, never as polished as other parts of the locomotive, demonstrates the application of a GRADATED TONE, with the detail of the driver's sliding hatch being picked out with a technical pen after spraying.

The texture of the ballast, in which the rail ties lie, is the result of first spraying a light base color and then applying, randomly but within the confines of the ballast area, dry-transfer texture which was then

oversprayed with the same base color. When this coat had dried, the dry-transfer texture was removed with masking tape.

McDonnell-Douglas F 15 Eagle
Christopher Sargent

These two illustrations are taken from a student project for a brochure design. They were produced with reference material from aircraft manufacturers and from commercially available information, such as specialist books and magazines. A hard, china-clay surfaced board was used for the artwork in both cases.

The top illustration shows an accurate, measured impression of the aircraft in flight against a backdrop of a stylized sky. The aircraft has been sprayed using FILM MASKING and gouache paints with extensive use of brush and technical pen to apply LINING-IN, to pick out panel detail and the cockpit framing. HIGHLIGHTING has been kept to minimum, being restricted to a hand-painted line on the nose and another over the sprayed form of the cockpit canopy.

The title of the brochure was masked with film while the backdrop was sprayed, after which it was edged with a blue-black holding line. The company names were hand-drawn in black ink before the transparent backdrop was sprayed. The sky effect is a good example of GRADATED TONE, GRADATED COLOR and ANGLED SPRAYING. The blue was sprayed first from top to bottom, making sure the color shaded into the white of the board, and then the artwork was turned 180° for the red. This was sprayed in the same way, but the color was kept much lower and nearer its base edge. Because the backdrop has been kept simple, the three-dimensional image of the aircraft, in particular the forward part, has been visually thrown foward, giving the impact required in the central subject.

The lower illustration is a three-quarter perspective view of the aircraft showing the positions of the engines, avionics, armaments, fuel tanks and flight systems. No structure has been indicated, although external panel lines are included. This is typical of the kind of illustration frequently used by the aero-space industry to advertise the systems layout of new aircraft. When produced in the manner shown here, it is necessary to give a clear representation of the exterior shape without detracting from the information being shown of the various systems contained within the aircraft. The most effective way of achieving this is by GHOSTING. In this example of ghosting, the technique has not been restricted to showing one area through another, but goes further and allows a third area to be clearly identified. For example, if one looks at the starboard wing, the fuel tank remains visible because it has been sprayed a transparent orange color. It was also necessary to show the rear starboard missile, which in the illustration is covered by both the fuel tank and the wing. The process was simple, but required careful control of the amount of color being sprayed at any given time. The missile was rendered first, then the fuel tank oversprayed, followed by the shaded form and highlight to the wing. The effectiveness of such an illustration may be judged on whether or not there are any areas of confusion caused by the ghosting technique. This example is an undoubted success.

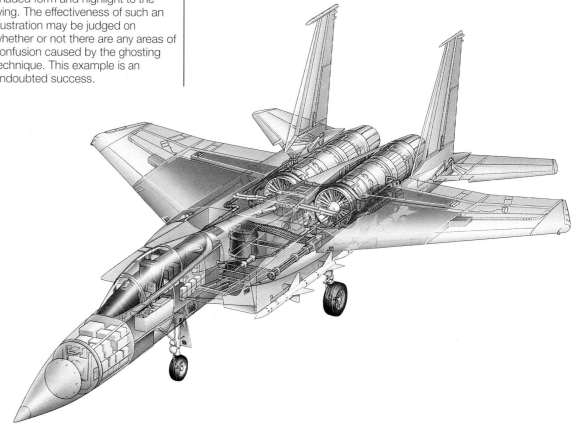

BAC/Aerospatiale Concorde SST
Tom Stimpson

This illustration is a beautiful rendering of an equally beautiful subject. The combination of an accurate representation of the only supersonic transport in commercial service with a vibrant and dramatic sky has been well executed. As an airbrushed illustration, it also combines well the opposing characteristics of HARD-EDGED SPRAYING and the softer effect of LOOSE MASKING, the former for the man-made object and the latter for the softer forms of nature.

The aircraft is shown having just taken off. To add interest and contrast to the view depicted, the illustrator has observed the interesting shapes of the CAST SHADOWS made by the engine nacelles, aileron actuator fairings and fuselage belly on the delta wing under-surfaces. These cast shadows have been oversprayed on top of the existing shadow, modeling the form of the wings and fuselage.

The sky includes the techniques of CARDBOARD MASKING and FREEHAND SPRAYING. The loose and cardboard masking are apparent in the cloud formations, which are edged by the light of the sun. Freehand spraying can be seen in the clouds at the top of the illustration and on the lower left. The rays of light coming from behind the central cloud have been produced by loose masking, while the color blending between the intense light and storm clouds indicate the application of GRADATED COLOR and TONE.

British Aerospace Sea Harrier FRS 1
Steve Upson

Aircraft are extremely popular subjects for cutaway illustrations. The aeronautical industry and press use them to advertise and describe new or up-dated aircraft, while the enthusiasts' magazines use them in support of detailed studies for modelmakers. The technique adopted is usually ink line, in cutaway perspective, with very few full-color illustrations being produced. The reasons for this are many, not the least being costs and time restraints, but more important, ink illustrations can be produced more quickly and allow the illustrator to adopt many shortcuts in how the information is conveyed. This is not possible when color is used, because each and every visible area of the aircraft that is shown must be fully identifiable as a component, system or structural part. It therefore requires somewhat more in the way of commitment and an appraisal of what to show and what to leave out, depending on the availability of accurate and authoritative reference material.

However, full-color perspective illustrations of aircraft are now being used more often because of the immediate clarity they offer, allowing the reader to acquire quickly an understanding of a particular aircraft's design and layout. The example reproduced here has been drawn to meet a specific need. It was commissioned by the British Fleet Air Arm Museum for display and sale as a poster, as part of a series illustrating a broad cross-section of well-known aircraft used in support of the Royal Navy. As with the aeronautical industry, the demands of the museum world are such that absolute accuracy is of paramount importance, and this illustration reflects that priority. It is a cutaway perspective illustration and is representative of the equal use of airbrushed and hand-painted rendering.

After some consideration, it was decided to use acrylics to render the complete illustration. Watercolors or gouache could have been used equally effectively, but the properties of acrylics offered distinct advantages for such a complex image. They are fast drying, and the fact that they do not run when additional color is overlaid or oversprayed, is useful when planning and rendering. Furthermore, there is less chance of the masking film lifting off any surface paint, which can be a frustrating problem with gouache, especially when, as in this case, the surface used was a Hot-pressed watercolor board. Another advantage of acrylics is the speed with which it is possible to lay solid, opaque color. Watercolors would require heavy spraying to achieve the same density of shade, increasing the risk of the surface becoming too wet and paint bleeding under the masks.

After the initial pencil drawing was transferred onto the board, additional detail was added, and then the whole artwork covered with masking film. Base colors were sprayed first on the rear fuselage structure, and this was continued until all internal areas had been sprayed. At first, all internal structural details were sprayed with the color representing the yellow-green protective epoxy paint, until British Aerospace informed the illustrator that those compartments accessible under normal maintenance procedures were painted off-white. This then required CORRECTION by overspraying with white, with the resulting mixture achieving the correct shade and color.

The technique of spraying base colors and principal highlights on all areas was followed throughout. Hand-painted details and LINING-IN were then applied, with a technical pen being used for the RULING and rivet detail.

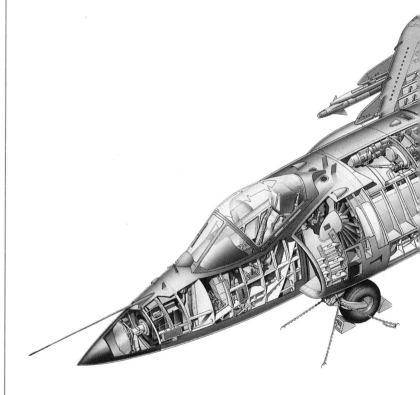

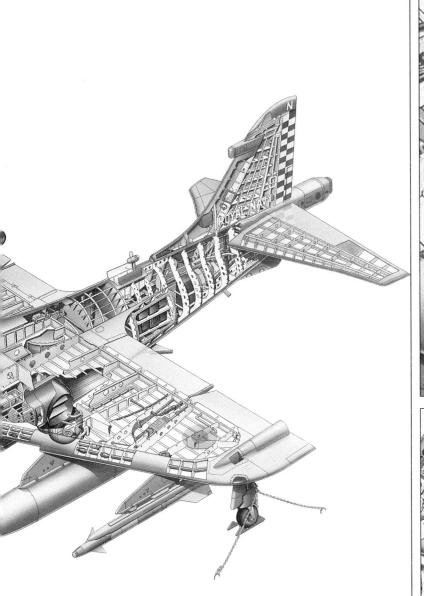

With the aircraft near completion, one of the final stages involved using GHOSTING of the Royal Navy roundels, the identifying marks on the wings.

The close attention to detail on this aircraft is superb. Note the subtle reflection of the squadron markings on the tail and the way in which they are rendered so realistically.

Black Cadillac
David Bull

This dramatic view of a Cadillac open-topped saloon car from the 1950s incorporates good examples of CHROME EFFECTS and LETTERING TECHNIQUES and shows clearly how colors are naturally reflected in a black polished surface. The use of reds and blues in the bodywork adds depth to the subject and creates the impression that the car is standing in an open environment at sunset. This effect is intensified by the way in which the chrome work has been sprayed.

A close examination of photographs of the subject or a study of the real thing is essential to achieve a realistic impression of chrome, which in an illustration such as this is nothing more than a series of abstract shapes sprayed with different colors. However, the illustrator has done his homework, for the effect looks like the chrome it is intended to be. The same is equally true of the reflections and shades on the bodywork.

For a description of the technique used to render the title of this poster illustration, refer to page 69.

The chrome bumper reflects not only the sky and horizon line, but the rough texture of the ground is captured, too. This gives the impression the car is standing in open country.

DILLAC

Mark II car, 1912
Tom Stimpson

This is a delightful period-piece illustration advertising Shell gasoline, designed to look like an old, torn and damaged sepia photograph. The painting has been completed by hand, with the CAST SHADOW of the image and the sheen giving the photographic effect having been sprayed with an airbrush. In addition, SPLATTERING has been used in the foreground, to give both contrast and texture to the ground surface. This is a particularly good finished example of how to combine successfully the two techniques of hand-painting and minimal airbrushing purely for the purposes of the intended effect.

The cast shadow has soft edges and its shape has been determined by the right-hand and lower part of the silhouette of the overall image, which is based on the Shell logo. The crease marks have been over-painted using white gouache applied with a semi-dry brush, so that the paint drags and breaks up across the surface, giving the impression of damage to the laminates of the photographic paper, which effect can be clearly seen on the fold at the point where the curve ends on the right-hand side. The HIGHLIGHTING has been sprayed freehand with white, with sprayed shading added to emphasize the folds.

Tire and broken road surface
Tom Stimpson

A dramatic advertising illustration using the fine, mechanical finish obtainable with an airbrush to render the tire, and contrasting with the rough texture of a broken road surface. The tire is almost metallic in its finish and at this scale needs to be accurately drawn. The CAST SHADOWS have been carefully thought out, with HIGHLIGHTS applied by airbrush and selected edges on the tire tread LINED-IN by hand. Where the tire is in contact with the road, it has been subtly KNOCKED BACK with an overspray of white, while the SPLATTERING technique has been used to add finer dust particles in the same area. A subtle shade of brown has also been sprayed freehand immediately below the two large pieces of stone which have been thrown up in front of the tire.

Jaguar XJS
Peter Jarvis

Commissioned for the cover of a brochure, which was a composite of other illustrations, this airbrush rendering of a Jaguar demonstrates OVERSPRAYING with a transparent medium. The hood, roof and sides of the car rely on allowing the white of the board to show through the red as a means of simulating a gloss finish to the body. The red has been sprayed with GRADATED TONES, using LOOSE MASKING, with RULING-IN and HIGHLIGHTING being completed on top and by hand.

Small, hand-painted DOT HIGHLIGHTS have been applied very selectively so as to not overdo the effect of intense reflected light. Sprayed dot highlights have also been added in selected places, primarily to the front of the car and offset to the left, which is the chosen direction of the light source. To accentuate the light source, white has been oversprayed on the windshield, with a stronger density to the left which gradates over to the right, KNOCKING BACK the interior of the car, although the seats and window framing remain visible. A more intense white has been sprayed immediately above the soft-edged reflection of the horizon on the side windows, which gives a slight luminous quality to the glass. A particularly effective touch is the use of the red base color reflecting in the chromed surfaces of the rearview mirrors and the trim to the headlights.

The soft-edged CAST SHADOW is a fine-grained effect of SPLATTERING, using low air pressure instead of a splatter cap. This enhances the impression of the gloss finish on the car by contrasting with it.

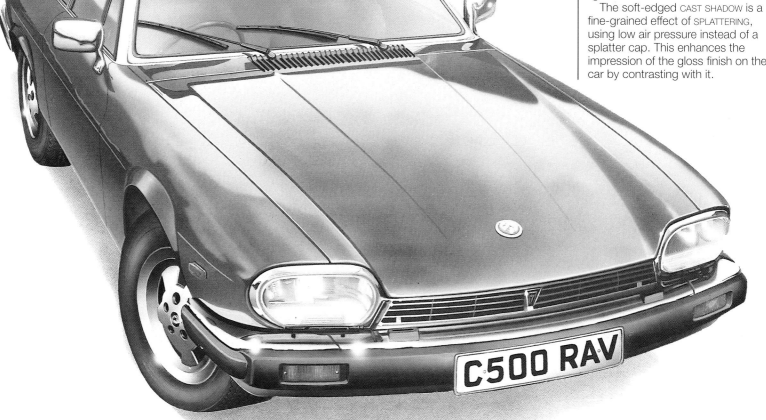

London Transport RM bus
Paul Shakespeare

This illustration is one of a series concentrating on aspects of transportation in and around London. It is an orthographic view of the front fender and represents a one-man operated vehicle currently in use there. Although it is a full-color illustration, the body and windshield are effectively black-and-white renderings, because no reflected highlights or colors from surrounding objects have been included. If such reflected colors had been included, it would have added confusion to the illustration simply because the composition precludes any background or surrounding information. If, however, the background had been shown, then obviously it would have been appropriate to include its effects on the surface qualities in the central image. Nevertheless, reflected color is applied selectively to the chrome headlight rims and within the glass as well.

FILM, ACETATE and LOOSE MASKING techniques were used in the spraying process, with ANGLED SPRAYING and GRADATED TONES being applied to the gray background. HIGHLIGHTS have been kept to a minimum, combining the white of the board with effects derived from LINE CONTROL, LOOSE MASKING and OVERSPRAYING. The ERASURE technique has also been used on the glass of the headlights and on some body highlights.

Daf military truck with helicopter
Tom Stimpson

The use of technically accurate perspective illustrations of subjects shown in their operational environment is increasing, at the request of manufacturing clients and their customers who need to assess the viability of their intended purchases. This is particularly true of the defence industry because of the intensely competitive nature of the business. A good, accurate illustration speaks volumes in any language, compared to the boring technical jargon often found in sales brochures. However, for the illustrator, it poses new problems. It is not only necessary to be able to demonstrate good airbrushing skills, but a need exists to be able to draw and paint natural scenes as convincing as the technical subjects. The illustration reproduced here combines both elements, resulting in an illustration which leaves little doubt as to the shape and function of the truck in relation to the helicopter and its cargo, with all being set against a realistic landscape.

Again, the combination of airbrushed transportation subjects with a hand-painted landscape, under an airbrushed sky, has been well handled. The truck and cargo have been sprayed with HARD-EDGED MASKS, keeping HIGHLIGHTS to a minimum because of the military nature of the scene. LINING-IN and RULING have been added with a mixture of opaque whites on finer details and lighter, soft-edged, subtle shades of the base colors. Although shading is limited to the areas of the truck and cargo which would not normally show detail, extremely soft shadows, sprayed freehand, have been added to areas such as the front protective grille, rear-view mirrors and the bracing of the cargo box. They are of sufficient density to add to the three-dimensional quality of the illustration.

The helicopter has been sprayed in the same base color as the truck, which improves the color composition of the illustration. A small amount of gradated white has been sprayed on the upper edges of the fuselage, engine fairing and main

undercarriage struts. Because the helicopter is hovering against the sky and mountains, the use of white is effective in making the whole illustration read as one, while the almost complete lack of it on the truck, which is set against the fir trees, does the same for that part of the illustration. The impression of rotating blades has been achieved by the use of GRADATED TONES sprayed twice through a loose mask, its position slightly different for the second of the two sprayings.

The backdrop consists of hand-painted fir trees in the foreground with airbrushed mountains, overpainted by hand, in the background. The sky has been sprayed using both FREEHAND SPRAYING and LOOSE MASKING, the latter for the clouds.

The form and shading on the soldier's uniform have been sprayed, with extensive overdrawing and overpainting by hand added afterwards. This helps to give texture to the clothes, in addition to making a contrast with the smooth metallic surfaces of the truck and box.

The windshield is a very effective example of TRANSPARENCY and GHOSTING. The shape of the far window is clearly visible through both the oversprayed glass and the arcs made by the sweep of the windshield wipers. The half-opened window shows a well-executed reflection of the sky, and also nearby fir trees.

INDUSTRIAL DESIGN

About thirty years ago, the airbrush was primarily seen as something which technical illustrators, working in the publications departments of manufacturing companies, used in the rendering of technical and mechanical subjects for a limited and specialist audience. Such renderings often took the form of a highly finished and prestigious illustration, depicting the subject in such a pristine condition that the user would hardly recognize it. However, the function of such illustrations served, and continues to serve, the potential customer in giving a clear idea of what the product would look like, which a photograph could not. Because of this, and due to their obvious similarities, industrial, technical and scientific subjects have much in common with those from transportation, in that they do, undoubtedly, lend themselves to rendering with an airbrush.

As a service to manufacturing, the technical publications industry has never been one to encourage the use of hand-painted illustrations, but has always seen the value of the airbrush. This has extended across the board, to the point where, today, airbrushed illustrations are not only accepted, but insisted upon by clients at the commissioning stage in all facets of the graphics business. For those working on a freelance basis, the variety of work may be extremely diverse in subject matter and, as with transportation subjects, it is useful, if not essential, to become familiar with the materials and finishes with which modern industrial objects are made. As with some of the examples reproduced on the following pages, an understanding of either the real or imagined environment is also necessary on occasions.

It is reasonable to state that the standards of airbrushed illustration today have been influenced by the incredible quality of work coming out of Japan, especially on transportation and industrial themes. This is not to suggest that the western world has not produced its own illustrators of a comparable standard. The Japanese influence is perhaps something worth looking into; it could be that recognition of the skills required to produce complex airbrushed illustrations has been more forthcoming in Japan from clients and design agencies. It could also be related to the age-old problems with which all professional illustrators are faced; time and costs. Nevertheless, the small cross-section of industrial-based work reproduced here represents the standards being demanded today, to which students of the airbrush interested in technical renderings should aspire.

There is much to be said in favor of the airbrush used on industrial subjects. Although it is demanding of both patience and skill, it is in fact often easier to render the complexities of modern technical subjects in this way than by hand-painting, especially if the subject is shown as a three-dimensional perspective representation. What must never be apparent on the finished artwork, and even more so when the illustration is reproduced, is obvious evidence of mask-cutting or badly applied lining-in and ruling. To qualify these observations, it must be stressed that a certain level of skill in hand-painting is a prerequiste to developing skills with the airbrush, for the two are inseparable and are often combined in a single illustration, as so many of the finished illustrations in this book will testify.

Video sport by David Weeks

Bolex camera
Nick Cave

This is a modern gouache rendering of an old and discontinued movie camera. It was measured and drawn from a real example, and the drawing was then transferred to a hard, china-clay surfaced board. Although it is rendered in the colors of the original, it is, to all intents and purposes, a black-and-white illustration. As such, the depth of the tonal values and contrast, and the location of the light source and resulting shadows, required careful consideration. However, the finished image works extremely well and combines an interesting mix of airbrush-rendered surface textures. These range from the hard, glossy black plastic lens covers, to the even-textured, mottled finish of the camera case, so typical of these subjects. FILM and ACETATE MASKING were used throughout, with CARDBOARD MASKING being used in selected places.

The biggest problem lay in how to achieve the mottled finish. Various experiments were tried with object and fabric masking, but none were convincing or gave a uniform finish. Eventually, a flat, printed texture similar to the texture on the camera was identified among the many graphic effects available as dry-transfer sheets (the same as the lettering sheets). The technique adopted was to rub down the texture and overspray with a medium strength GRADATED TONE of color; before this was applied to the finished artwork, however, many tests were made to guarantee success. When the required density had been arrived at, the texture was removed by carefully lifting it off with masking tape, which had been previously dragged over the corner of a hard surface to remove some of the adhesive. This was done to avoid lifting any sprayed color. When all was removed, a second coat of the same color was oversprayed. This had the effect of darkening the first coat, which showed the texture perfectly. During the process of spraying both coats, the form of the camera case and its reflections and highlights had to be developed at the same time, relying

on the white of the board to create the light tones, rather than over-spraying with white.

HIGHLIGHTING was carried out by brush and by SCRATCHING BACK. To intensify the reflective surface of the glass lenses, red has been over-sprayed on a blue-black base. Note that the camera, which is primarily matte black in the original, has been sprayed with a mixture of gray and blue-black. Besides being more realistic in terms of reflected colors, even on a matte surface, the finished illustration actually looks more convincingly black than if sprayed only with gradations of black paint.

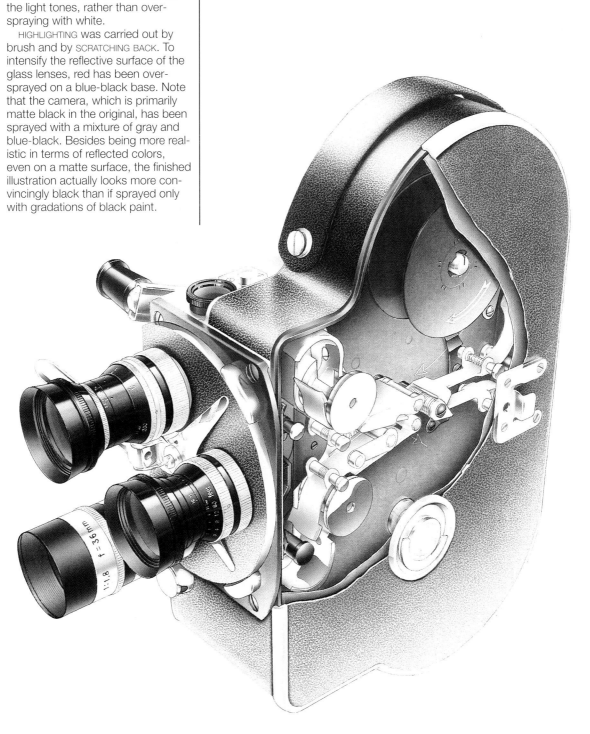

Gamer Professional 6 x 6 color IM enlarger
Jerry Cave

There are occasions when the information required of a subject by a client is not always suitably depicted as a perspective illustration; an orthographic view is often much more effective. This illustration of an enlarger is one such example, and it also demonstrates that the layout of the finished illustration had to be offset to the right of the total image area, to allow for running text to be incorporated on the left. However, regardless of this request by the client, it was still expected that the orthographic view should appear, on completion, to have form, contrast and shadows as usually applied to perspective illustrations.

The chrome-finished stand and lens adjustment control guide have been sprayed in varying shades of black and blue-black using LINE CONTROL to give a CHROME EFFECT. No reflected details or colors have been added, which maintains the very technical rather than realistic nature of the illustration. The spherical light housing, the lens casing and the support brackets have all been oversprayed with a light coat of opaque white SPLATTERING. Not only does this identify the surface finish, it also contrasts effectively with the semi-gloss finish to the support arms, securing levers and adjusting wheels.

It will be noticed that the main adjusting wheel on the enlarger stand is ridged on the rim, while on its flat surface it has a raised outer edge and raised disk at the center, but on the same level. This has been sprayed as one element, because the recess is so shallow, with the edges being subsequently applied by RULING and LINING-IN. This technique saves having to cut three separate masks, with the risk of their not being accurately aligned, and thereby guarantees even tonal values. The same approach has been used elsewhere in the illustration, in particular on the spherical light housing. Lining-in applied with a technical pen, brush and by scratching back has completed the illustration.

Hi-tech solutions to hi-tech problems
John Spires

Modern technology poses certain problems for the illustrator, especially when the illustration required by a client is not necessarily one thing or another, but a composite of many, often resulting in an almost surreal image. The illustration reproduced here is a case in point. The theme is obviously industrial in its broadest definition, but with the inclusion of the stylized and chrome-finished head, it could also be included under the subject of human form. Such combinations are not uncommon and demand a fair degree of flexibility on the part of the illustrator.

The illustration starts at the top with a three-dimensional drawing of electrical circuit components on a vertical plane, which runs into a two-dimensional, orthographic drawing of the same, shown as a draftsman's drawing. The components and wiring are set against a back-drop of a two-tone shaded blue which, as it curves into the horizontal surface, blends in with the very subtle blue-white backdrop. The transistors have been rendered conventionally, using hard-edged FILM MASKING and LOOSE or ACETATE MASKING to develop shading and representation of form. The blue-colored orthographic impression of a draftsman's drawing shows an extremely carefully controlled shading from dark blue in the foreground to a pale blue at the base of the curved vertical surface. This effect could be achieved by RULING the line first and then OVERSPRAYING with transparent white to obtain the GRADATED TONES or, alternatively, by carefully and meticulously cutting a film mask and then spraying gradated blue.

The head is rendered with a highly polished, reflected surface and has been made an integral part of the illustration by the use of reflected transistors and the lines of the orthographic drawing (see also CHROME EFFECTS). Without these, the head would appear almost in isolation, thereby spoiling the overall composition. The beams coming from the eyes and right ear have been oversprayed with transparent, gradated shades of color to allow the blue lines to show through.

British Telecom telephone
Paul Shakespeare

This is a cutaway perspective illustration of a cream-colored telephone, produced as a self-promotional piece of airbrush work. It was drawn up by measuring and dismantling a real telephone, and sprayed in colors which faithfully reproduce the original, in both the interior and the exterior. The illustration has been rendered in mixed media; inks, watercolours and gouache paints on a hard, china-clay surfaced illustration board.

The body and receiver have been rendered in black-and-white, with FILM and LOOSE MASKING to give both hard and soft edges. Highlights have been achieved by allowing the white of the illustration board to show through, with those of a lesser intensity being OVERSPRAYED with the base colors. The transparent plastic dial is a mixture of the cream base color, a subtle blue-gray and intense white highlights. Note the distortion of some of the numbers as they appear through the plastic; these small details always add to the quality of finish on an illustration. Hard, clearly defined "cuts" have been used on both the body and receiver to differentiate between what is normally visible and what is covered.

The rendering of the metal surfaces representing the bell and supporting brackets at the rear has been particularly well done. Not only does it indicate the reflective nature of the finish, but, due to the use of FREEHAND SPRAYING and LOOSE MASKING, these components do not come across as being of a hard, polished finish, but have a texture in keeping with the original. The subtle tonal values on both also reflect colors from components in the near vicinity, again very effectively controlled. The bell has one single DOT HIGHLIGHT, to help define its shape.

Red telephone
Lionel Jeans

Commissioned by a publisher for a book titled *How Things Work*, the airbrushed part of this illustration has been sprayed with waterproof inks using FILM and ACETATE MASKING. DOT HIGHLIGHTS have been applied to selected corners, but the majority of the telephone relies on GRADATED TONES and LINING-IN to delineate the three-dimensional image. A subtle CAST SHADOW with soft edges is used on the lower front edge to accentuate the raised under-surface of this part of the telephone. The computer-aided design technique used on the left was produced using red ink applied through a technical pen.

This illustration is typical of technical work commissioned with very specific requirements, which rarely allow the illustrator much freedom in using his or her own initiative in terms of the final shape and extent of detail. However, it does represent a good example of how a limited palette combined with a comparatively simple and straightforward technique can produce effective illustrations.

High-pressure water pump
James Weston

The illustration reproduced here is an example of the use of mixed media. The base drawing was completed as a conventional ink line, perspective-exploded illustration, finished with both thick and thin lines. This ink illustration was then photographed, and the sprayed watercolor and gouache colors were added to the photographic print after it had been dry-mounted onto a piece of board. There was a twofold purpose behind the approach adopted. The client

commissioning the work wanted an illustration for internal use to facilitate the ordering of spare parts, and an exploded illustration is the most effective, and traditional, method. In addition, a full-color illustration was required to complement another illustration, previously completed, of the trailer on which the pump was fitted. This full-color illustration was to be used in sales campaigns and as a training aid, so the use of color improved the image of the product as well as its legibility when displayed through a projector.

It was never intended to render the illustration as a super-real and accurate representation of the actual materials used, but to show a simplified indication of which parts were cast steel, matte aluminum, brass, stainless steel or mild steel. With the exception of the cast steel casings, which were oversprayed with white, all HIGHLIGHTING was maintained by the white of the photographic paper being allowed to show through. This included the LINING-IN to the uppermost edges of each separate component, except the rubber washers and O-rings.

It is interesting to compare the techniques adopted in the rendering of the chrome-finished central components with those techniques used to spray chrome on other illustrations reproduced in this book (see also CHROME EFFECTS). Each style serves a purpose, depending on what the client expects and the time restraints imposed on the illustrator. It never follows that the more highly finished an illustration is, the more effective it will be; simplicity can often be equally effective, if not more so at times.

Electric water pump
John Brettoner

An excellent comparison can be made between this exterior perspective of a household electric water pump and the industrial water pump in the preceding illustration. The airbrushed spraying and finish adopted in each are completely different, but both are successful and illustrate the diversity of style and technique that can be achieved with the airbrush.

The variety of surface finishes on the different components is shown to advantage in this illustration. The machined surfaces of the pipe connectors contrast well with the rough-cast surfaces of the bronze Y-junctions and end castings, even though both have been sprayed with the same base colors. These machine-made connectors could almost be described as having been sprayed following the technique used to achieve CHROME EFFECTS, but with an increased amount of form and color. The cast surfaces rely very much on SPLATTERING, with more subdued levels of highlighting in keeping with the nature of the material. The electrical motor has been sprayed in blue-gray to resemble a hard gloss, plastic-coated finish. This has been achieved by the use of LOOSE MASKING or CARDBOARD MASKING, with strong GRADATED TONES being used on the flats. The intensity of the LINING-IN and scratched HIGHLIGHTS enhances the plastic finish.

Because the motor unit comes with mounting plates already fitted, which not only attach securely the pump when in use, but also keep the motor above the surface on which it is mounted, a shaded and soft-edged CAST SHADOW has been used to explain this particular feature. The shadow itself fades into the surface of the artwork at a position where its function becomes unnecessary, or would distract the reader from the subject.

Computer
Tom Stimpson

The advertising industry comes up with many unusual ideas for getting the maximum impact in a sales campaign for a new product. This illustration is no exception and uses the image of the parting of the seas, from the Old Testament, to emphasize how revolutionary and incredible is the computer hardware. Such a combination of nature with modern technology can be very demanding of an illustrator's skills, and this particular illustration shows an equal use of the airbrush and hand-painting. Both the computer and the sky have been sprayed, with the parting seas being applied with a brush. The computer has been rendered using FILM MASKING, CAST SHADOWS, LINING-IN and RULING techniques. The chosen light source is in keeping with the sun immediately above the computer and hidden by the passing cloud. The sky is a good example of the use of FREEHAND SPRAYING, CARDBOARD and LOOSE MASKING, with the reflected edge to the central cloud being applied by brush and by OVERSPRAYING. The spray on the breaking crests of the seas has been indicated with spattering of opaque white; otherwise, the seas have been completely hand-painted.

North Sea oil rig
Tom Stimpson

As mentioned elsewhere in this book, the airbrush should be seen by the illustrator as just another tool which may be used to a greater or lesser extent, depending on the impression and style he or she intends to achieve. It is not the be-all and end-all of illustration methods, and under no circumstances should students think that any other method of illustrating is inferior. Quality is dependent on the skill of the illustrator and not on a particular method.

Compared to the majority of the illustrations reproduced in this book, and for obvious reasons, this illustration is an example of the use of an airbrush as a secondary rather than a primary tool. A cursory study may lead some to question its inclusion in a book specifically about airbrushing techniques, but a closer examination will reveal that an airbrush has been used, but very selectively and where hand-painting could not achieve the desired effect. Basically, this illustration has been rendered with a brush, but the VIGNETTE effect of the whole image, and the shaded base colors of the sky and sea have been laid first with an airbrush. In the case of the sea, extensive overpainting has been used to render the waves and movement. Additional uses of the airbrush are visible in OVERSPRAYING at the base of the rig legs where the waves are breaking, and on one or two of the strip lights covering the rig. This minimal use has been very effectively handled.

FOOD AND DRINK

Food is very much a subject of texture, be it in its raw or prepared state, and as many people relate the airbrush only to smooth, evenly finished surfaces, they find it difficult to see how the airbrush can be used successfully for such a subject. The evidence says otherwise! Representations in this category range from the impressionistic to the super-real, with illustrators such as Michael English and Masao Saito being outstanding exponents in the use of the airbrush to render food and drink. There are of course many other artists who excel in rendering these subjects, and a lot of work is required for advertising and magazine illustration, which demands high standards. It is interesting to note that many of the illustrators commissioned to produce images of food and drink are primarily *technical* illustrators, or at least started their professional careers as such. It would appear that the need to observe and understand the shape and form of things, which is one of the prerequisites of a good technical illustrator, comes into its own when rendering food and drink.

Although applicable to all subjects or themes, and regardless of technique, the ability to draw accurately is particularly important when illustrating food. There are many aids and systems which have been developed over the years for preparing drawings of technical subjects. They could be used on food subjects, but this would not only be unnecessarily time-consuming, but would tend to make the finished illustration rather mechanical and lifeless. Therefore, strong freehand drawing by observation is necessary, supplemented, if required, by photographic reference. Of course, one fundamental problem with fresh foodstuffs, or any botanical subject, is that when taken out of the growing environment, deterioration quickly sets in. This can have an effect on the quality of color and tonal values, especially if the illustration is of such complexity that the time taken to complete it exceeds the period during which the subject maintains its freshness. This is where photographs taken at the start of the artwork become invaluable, although it is not recommended that they be relied upon as the sole source of reference, unless access to the original subject is impossible. Photography is best regarded as a secondary source because the subject is, effectively, alive, and photography tends to stiffen everything. It also distorts shape and form – something which only becomes apparent when an image is lifted from a photograph.

The ability to observe is not restricted to the drawing

stage, but is equally important when spraying with the airbrush, and extends to the colors, shades, reflections and surface texture. The airbrushing techniques previously described are all usable, but the intrinsic qualities of the subject must never be forgotten. It is too easy to spray an apple, for example, with such a high degree of surface polish that it looks as if made of enameled steel. All very well if that is the intended effect, but is it really like that? Here again, a close study of how professional illustrators approach such a problem is a worthwhile exercise in itself.

The examples reproduced on the following pages demonstrate how to achieve effects ranging from those which are stylized, and therefore impressionistic, to super-real finishes. Some show emphasis on particular aspects of the subject, depending on the requirements of the brief. All show excellent application and control of the airbrush, with patience and careful planning underlying the quality of the finished work.

Green bottle by Mark Taylor

Red and green peppers
Brian Robson

An example of what is referred to as a super-real illustration! The peppers demonstrate excellent control in FREEHAND SPRAYING to create GRADATED TONES, with only the silhouetted shapes and other obvious hard edges being defined through FILM MASKING. To maintain such control in applying gradated tones on areas which cannot be masked with adhesive film requires much practice and skill in the use of the airbrush. Particularly effective and very well handled are the water droplets on the peppers and on the ground plane. In all cases, they have been achieved by masking and spraying the given areas with subtle changes in the shade of the base color. They have then had delicately sprayed, gradated tones of shadow added, with the final touch of intense white HIGHLIGHTS. The CAST SHADOWS and tonal gradations on both the peppers and the ground plane show the natural changes when objects as small as these are lit from a nearby and intense light source.

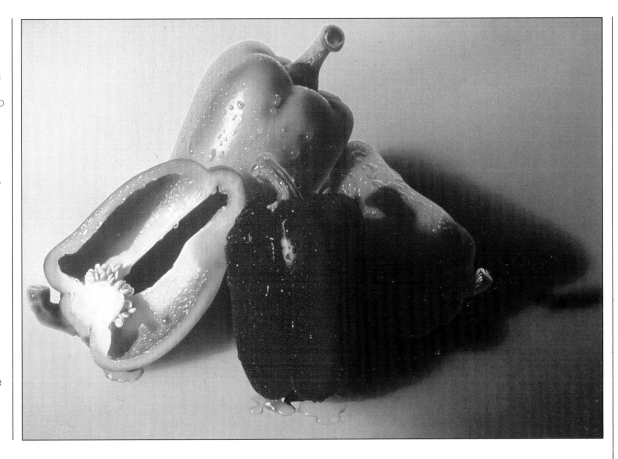

Fyffes bananas
John Brettoner

An excellent example of how to successfully use a technical implement to render a natural subject. The form, contrast and surface textures have been well observed within a composition which leads the eye directly toward the importer's name. The central purpose of an advertising illustration must be kept in mind, however creative the imagery.

While FILM MASKING has been used to maintain the shape of the bananas, the majority of the internal shapes have been sprayed in GRADATED TONES using ACETATE or LOOSE MASKING, to maintain the soft edges between one surface plane and another. Subtle HIGHLIGHTS have been added, with the effect obtained by using the ERASURE technique. Pencil and brushwork helps to delineate the bruising marks and the texture at the ends of the bananas. A gradated CAST SHADOW with hard and soft edges pulls the three bananas together.

Budweiser
Brian Robson

Even though it is included under the heading of Food and Drink, this illustration of two cans of beer shown from top and side could easily be defined as a technical or industrial subject, because if it were not for the brand name, the image would be nothing more than the airbrushed representation of metal. This draws attention to the fact that placing illustrations under thematic headings is for convenience only. It does not indicate that certain techniques are in any way peculiar to one particular subject or theme. In order to arrive at the widest understanding of airbrushing techniques, it is necessary to study the complete range of examples.

As an illustration, it is an excellent example of what can be achieved with a palette limited by its subject, for it could be described as primarily a black-and-white study. The use of local colors and their tonal variations, as in the reverse of the ring-pull and on the sides of the vertical can, has been carefully controlled. Neither fights for attention, or competes with the naturally limited color of the aluminum. Both of these areas of local color have been applied using film masking and include HIGHLIGHTS and GRADATED TONES to establish form and depth. On the turned-back ring-pull, a fine shadow line has been ruled in on the lower edge, while the top edge relies for definition on the difference in tonal values and color between itself and the surface of the can top. A subtle, soft shadow is enough to indicate the recess where the ring is attached, and a small reflection indicates the polished surface of the metal.

The top surface is sprayed in a subtle blue-gray, which appears to have a slight trace of red in it for warmth and depth. FILM MASKING has been used in the spraying of the outer rings, while LOOSE MASKING has been used to show the raised ridges and the indents.

The droplets of water are very clear and are a good demonstration for students trying to achieve similar effects. Those which sit on the curving line of the serving instructions printed on the can top show the distortion visible in reality. The droplets have been sprayed by circular and oval masks being cut in masking film or acetate, with the reflected highlights left covered and then sprayed with a gradated shade on the top left-hand edges. Shadows on the outside and opposite edges have then been sprayed, some of which are gradated away from the droplet. The same technique has been used for the droplets on the side of the vertical can. It is a very simple, but very effective technique, requiring careful and neat mask cutting and equally careful control in the spraying.

The product name on the side has been gradated to conform with the shape of the can and it has only one, clearly defined highlight, which also follows the vertical curve. Two DOT HIGHLIGHTS on the right-hand edge of the can top and overlapping the dark recess complete an excellent piece of artwork.

The central reflection is almost an illustration in itself. It shows the blue sky and immediate bottles around, and the use of the blue does not conflict with the brown of the beer. To enhance the effect, the blue is also picked out on the sides of the bottle and up into the neck.

Newcastle brown ale
Brian Robson

This illustration is comparable to the previous one and is also a good example of the airbrushing of clear glass with reflections, and the use of soft edges to show the bottles fading away into the distance. To achieve many of these effects, good, sharp photographs would be required as reference if the bottles themselves were not available.

The clear glass necks of the bottles have been sprayed with good line control of the airbrush (see also RULING). The colors used reflect the colors in the beer and in the surrounding environment. The attention of the observer is drawn to this central bottle because those in the immediate foreground and behind are sprayed with soft edges, using LOOSE MASKING. LINING-IN has been kept to a minimum, being used only on the label and on selected areas in the upper part of the bottle neck.

Whiskey tumbler
Pete Kelly

A third illustration in a sequence related to liquids, this time showing a different technique in the rendering of the condensed water droplets and the way in which this illustrator has chosen to indicate distortions through glass. As an image, this is very much more stylized than the previous two examples, which aimed for total realism.

The illustration of the whiskey tumbler relies very much on hard-edged abstract shapes to render the ice, whiskey and glass. GRADATED TONES of color and FREEHAND SPRAYING have been restricted within these abstract areas, defined by FILM or ACETATE MASKING. The larger water droplets basically consist of two tones of color; one sprayed to give form and the second to create shadow. No highlights have been used on them, other than the white of the board being allowed to show through. The melted ice water at the base of the tumbler shows a distorted WINDOW HIGHLIGHT to give the feeling of wet transparency. LINING-IN has been used on the base of the tumbler to reflect the color of the whiskey and the thickness of the glass at this point. The ice cubes, too, reflect the whiskey color.

Humbugs
Brian James

The glass jar in this image develops the theme of transparency represented by the liquids in the previous three examples. This illustration is a well-executed image using hard-edged FILM or ACETATE MASKING for definition, with GRADATED TONES within the shapes to give form and contrast. As a subject, the candy would also be a good test of an illustrator's patience to make sure that each appeared as well finished as the first. This is not meant to be flippant, but is a serious observation, because if only one small part of one humbug were to have even the slightest error or a clumsiness about it, the whole illustration would suffer. This obviously applies to any illustration which contains repeated renderings of the same object.

A close examination of the candy will reveal that they have been sprayed with an effective and comparatively simple technique. The stripes are laid in first, either masked and sprayed or applied by brush. The silhouetted shapes can then be protected by film masking and the shadows and changes in tonal values oversprayed, giving the candy's form. The white HIGHLIGHTS are the final detail, produced either by SCRATCHING BACK with an art knife or applying opaque white by brush. Highlighting technique often depends on the quality of the underlying surface, as not all artboards or papers lend themselves to the scratching back technique. The contrast between the candy seen through the glass jar, which have soft edges, and those seen sharply rendered through the open jar top and in the foreground enhances the overall effect.

Bowl of fruit
Brian Robson

This brightly colored illustration of a bowl of fruit is obviously not intended to show fruit quite as nature intended. However, its success lies in the careful observation of the surface textures and patterns varying between the different items. In the pear alone, the illustrator has used hand-painted blemishes, CAST SHADOWS, SPLATTERING, GRADATED TONES and, for the small reflected highlight to the top edge, the ERASURE technique.

In complete contrast is the way in which the grapes and cherries have been sprayed. The grapes consist of two shades of gradated and evenly blended colors, with clearly defined cast shadows and white highlights, which also blend in with the base colors. The cherries are delineated with ACETATE or FILM MASKING, forming the external edges, within which the form is modeled by gradated shades and intense, opaque white highlights. The wooden bowl displays a further textured surface with a much tighter pattern.

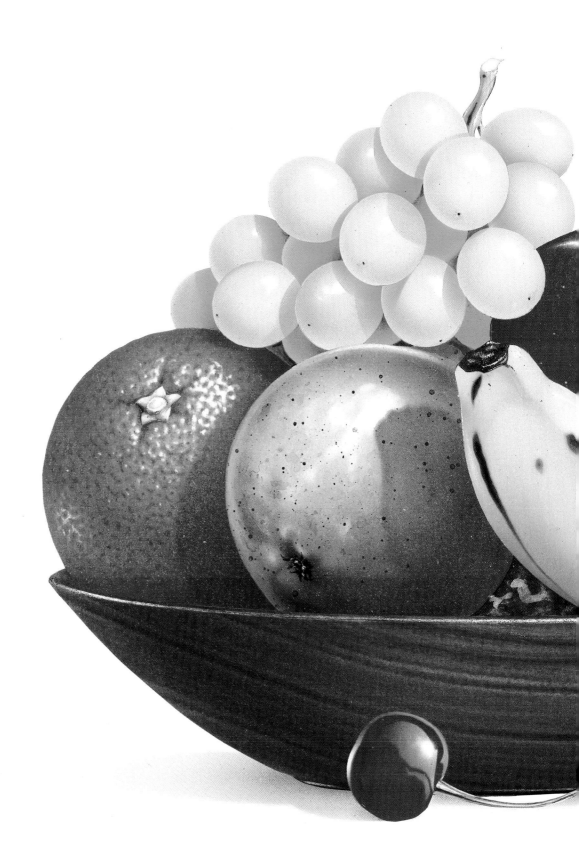

The evenly colored and regularly dimpled surface of the orange against the semi-smooth, mottled finish on the pear are typical examples of how the illustrator has paid close attention to surface textures.

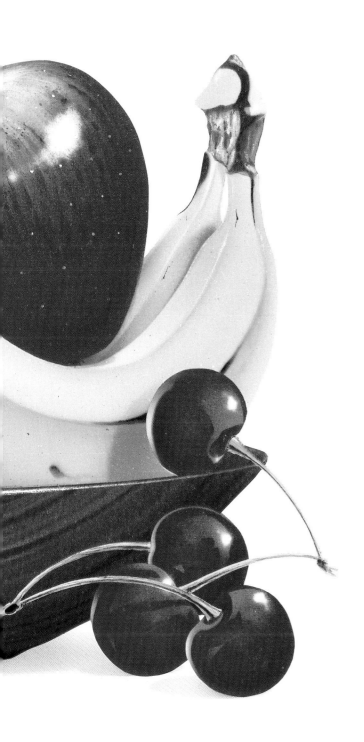

Cherries
Paul Shakespeare

A small, self-promotional illustration, measuring 18 x 25cm (7 x 10 in) and rendered in watercolor, shows three cherries lying in an aluminum ashtray; the illustrator shows particular interest in the color values of each element being reflected in and by the others.

Note the carefully controlled contrast between the smooth, highly reflective surfaces of the cherries and the dull sheen of the pressed aluminum ashtray. The use of the base color of the cherries in the warm gray of the ashtray ensures that the observer reads the correct relationship of the forms. Without this reflected color, the image might be ambiguous, with the ashtray and cherries appearing detached from each other. The composition and choice of the background color contribute directly to a simple, but effective illustration.

Students of the airbrush with a special interest in food subjects would be well advised to start with something on this scale, before attempting anything more complex and with greater variations in color tones and changes.

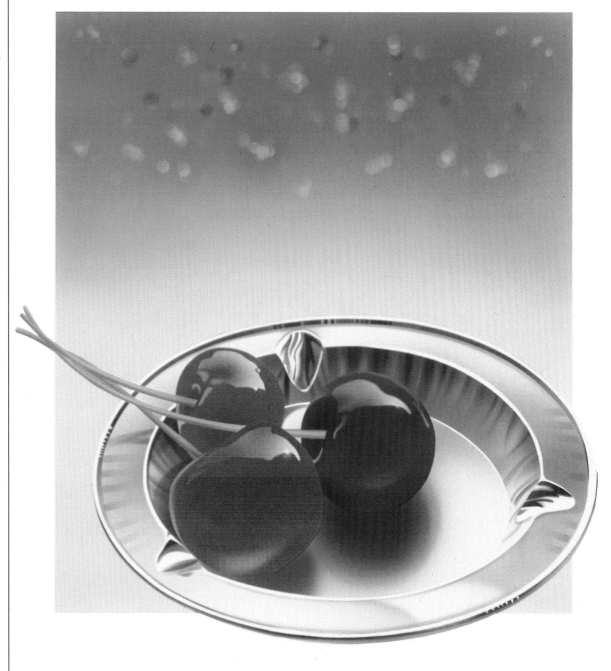

Strawberries
John Brettoner

Exaggerating the contrast between two surface textures in close proximity to each other is often a successful technique, popular with illustrators and their clients. This is a good example, with the matte finish of the leaves offsetting the pristine, glossy finish on the strawberries.

Taking the strawberries first, it can be seen that after spraying of the base color, the white HIGHLIGHTS have been applied by brush, with the edges roughened to blend in with the underlying color. The same technique has been used on the reflected highlights on the sides, but with a less pure white, tending to pink. The leaves, on the other hand, have been sprayed with a subtle grainy effect, in keeping with the "furry" surface typical of strawberry leaves. Brushwork or SCRATCHING BACK has been added to create highlights and texture. The three droplets of water add a touch of natural realism, with their combination of hard- edged and softly gradated highlights working very well.

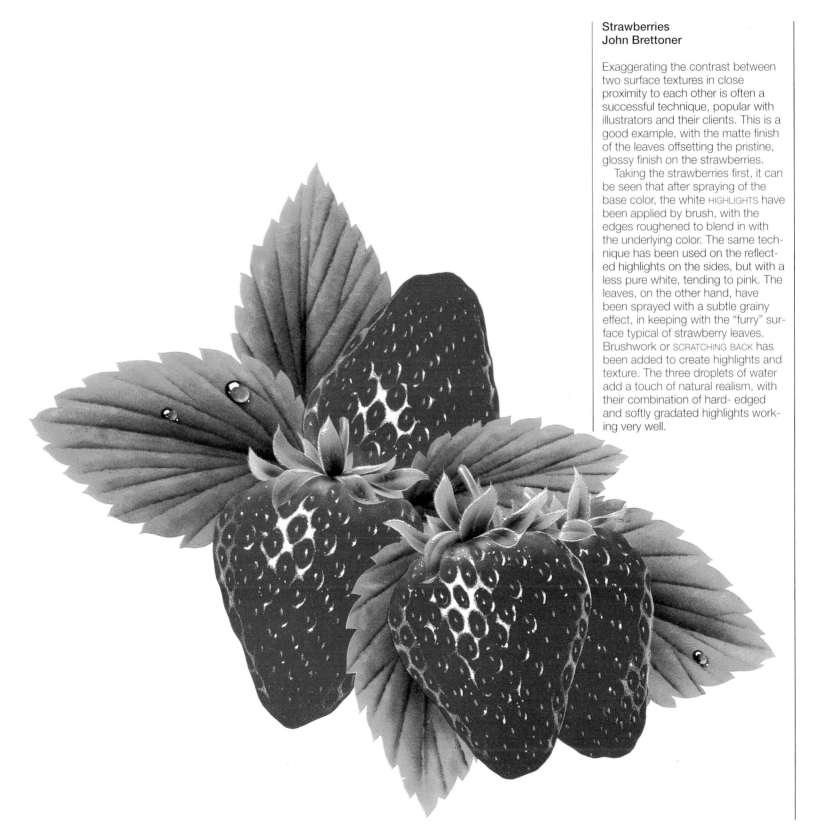

Apples
Brian Robson

This illustration is in the same league as the red and green peppers (page 127) in that it is almost photographic and comes under the heading of super-realism. Much use is made of water droplets, with the addition of strong HIGHLIGHTS to give the impression of recently cleaned apples. Although the apples are clearly shown in direct light, all CAST SHADOWS have soft edges with GRADATED TONES, allowing the natural reflected highlights to show through. The inclusion of the base color of the apples on the horizontal and vertical surfaces making up the foreground and background has been used to good effect in strengthening the apples themselves. Here again, a restricted color palette results in an excellent illustration.

Sliced apple with knife
John Brettoner

This is a stylized and almost surreal illustration of an apple; it even includes DOT HIGHLIGHTS elaborated with STARBURSTS, a technique not normally associated with this kind of subject. The highlight effects have been kept to a minimum and are therefore not overdone. Of course, the finish given to an illustration often depends on the requirements of the client, as may well have been the case in this example. For this rea-son, every illustration should be considered in terms of its likely con-text.

Returning to the technical ele-ments of the image, it will be noticed that part of a WINDOW HIGHLIGHT has also been included, to the left of the cut edge. As this highlight runs around to the central part of the apple, it becomes an abstract shape which has been oversprayed onto the base color, and is less intense. LOOSE MASKING has been used to edge the highlight on the handle of the knife, with the addition of scratching back to bring out select-ed detail. The technique of SCRATCH-ING BACK has also been used to show actual scratches on the blade. The reflection of the segment of the apple on the blade is an effective way of integrating the knife into the overall composition; students should always consider this sort of thing when planning an illustration.

Ovaltine milk chocolate
Tom Stimpson

Even though the food content of this illustration is limited to a small section of broken chocolate at the top of the bar, this has been very well rendered with a combination of FILM, and LOOSE MASKING. The darker "blemishes" in the chocolate have been applied by brush, as has the carefully executed embossed lettering, which has been ruled in. LINING-IN with the airbrush has been used on the soft highlight to the top of the segment. The torn foil is a good example of LOOSE MASKING on an extremely small scale and creates an interesting contrast with the neatly finished wrapping.

The remainder and majority of the illustration is a demonstration of LETTERING TECHNIQUES, but incorporating also a landscape and human figure. Careful drawing of the different letterforms has obviously been required. The landscaping combines brushwork and airbrushing in subdued colors so as not to detract from the chocolate bar. The same techniques have also been used on the smaller landscape behind the girl on the wrapper. The girl has been airbrushed, with extensive modeling to the face.

The whole illustration has been rendered to appear as a typical pre-World War II enameled sign, an effect emphasized by the use of intense white highlights in the four corners where the screws go through the metal plate. Additional white and colored linear highlights give the impression of the thickness of the metal.

Cadbury's chocolate
John Brettoner

This illustration must include more variety of surface textures than any other image reproduced in this book, and all have been achieved through airbrushing techniques. Because of this, it is worth spending some time examining the detail.

The illustrator has shown the smoothly finished black and gold fountain pen, a gold-edged leather diary, the mottled finish of a visiting or greeting card, the smooth dull sheen to the chocolates, the soft centers of the chocolates and the gold foil in which they are wrapped. All of these are shown lying on a textured and glistening fabric or paper. In addition, embossed, raised and hand-written lettering is applied to the chocolates, the diary and greeting card respectively. Other airbrushing techniques identified include FILM, and LOOSE MASKING, CAST SHADOWS, a style of CHROME EFFECTS, DOT CONTROL and HIGHLIGHTS, ERASURE, FABRIC MASKING, FREEHAND SPRAYING, GRADATED TONES, LINING-IN and RULING, OVERSPRAYING, and finally STARBURSTS – quite an impressive list of surface effects and techniques.

Corn
John Brettoner

The combination of the clean, crisp detail of the corn and plate with the soft-edged patterned tablecloth as a backdrop has made for a pleasing composition in this excellently air-brushed illustration. The color contrast between the corn, the plate and the mauve of the tablecloth, as well as the symmetrical and abstract shapes, adds to the total effect. Except for a small soft fold on the right of the plate and two folds on the lower left-hand edge of the tablecloth, the pattern has been sprayed with technical accuracy. The subtle folds or creases are just enough to identify the cloth and show that it is not just a patterned background. The plate contains some beautifully controlled GRADATED TONES within the CAST SHADOWS. The single DOT HIGHLIGHT on the edge combines with the changes in tone on the blue rim, caused by the shadow from the corn, to give the plate its glazed appearance. The corn itself is carefully observed, with each segment having its own gradated shades, principal and reflected highlights and shadow. Water droplets on the leaves, corn and plate complete the illustration.

The leaves of the corn have detail and grainy texture added by pencil or brush.

Parsnip
John Brettoner

The parsnip is a vegetable which, although conical in shape, is not symmetrical and contains undulations on its surface. This means it cannot be simply airbrushed following the technique described for the geometric cone under BASIC FORMS. The general principal of the cone in terms of placing gradated shadow to create the form can, of course, be adapted to the parsnip, but to develop a more realistic surface finish, some of the sprayed color should be applied *across* the surface rather than along its length. This illustration demonstrates this technique very effectively. However, it should be noted that the shades sprayed across the surface are not equal in depth or extent of the spray, even though they conform to the same general area. This has created the impression of the undulations, which affect the amount of light received on the surface at any given point. The same technique has been applied to the top edge. Note, too, that this method has not been restricted to just the shadow shades, but is applied to the base color as well. The whole parsnip has been sprayed freehand within FILM MASKING, with the darker blemishes and HIGHLIGHTS later added by hand.

The leaves are primarily hand-rendered, with sprayed color being applied to shadows and to the darker shaded areas. The green of the foliage is also introduced as reflected color on the end of the parsnip.

Oranges
John Brettoner

This is an image in very much the same style as the apple with the knife (page 137). The illustrator has achieved a dramatic effect by positioning the peeled part of the orange against the whole orange to the left, with the peel curling off to the right. The two textures also contribute to the overall visual interest. The HIGH-LIGHT on the complete orange follows the circular direction of the surface texture, gradating outward and into the more intense lower part. The same shading has been applied to the highlight on the peeled segments, with the surface texture being maintained throughout. Except for the base shades and the use of blended color within a silhouette defined by FILM MASKING, extensive use has been made of brush or pencil work. An airbrushed shadow, gradated to form soft edges, lies underneath the oranges, giving them a base on which to sit.

Falling apple
Brian Robson

A falling apple is shown as if it has been frozen in a photograph. The table and background are out of focus, but the apple is sharply defined, having been sprayed using FILM MASKING to describe the contour, and with GRADATED TONES applied by FREEHAND SPRAYING across the shadowed side. The dimpled bottom of the apple has been sprayed using LOOSE MASKING, as has the small area of shading immediately above it. A bright, gradated HIGHLIGHT has been oversprayed with a softer reflected highlight on the left-hand edge. Many water droplets have been scattered over the complete apple, which intensifies the shine and smooth surface texture.

The table has been sprayed with the leading horizontal edge almost as clearly defined as the apple, but the far side fades into the background. The grain on the tabletop is only clearly visible where it meets the front edge and although the far edge is visible, it is softly gradated to blend into the background. Notice how the illustrator has oversprayed the right-hand edge three times, moving the mask on each occasion to obtain the desired effect. The table legs, too, are shown as being slightly out of focus, with a blurred grain. The background is a mixture of gradated shades sprayed freehand.

FANTASY AND SCIENCE FICTION

A modern tool for a modern subject – this is a typical assumption about the use of the airbrush in science fiction illustration, but it is wholly inaccurate. The airbrush was invented in 1893, while the concept of fantasy and science fiction illustration, as currently understood, is a comparatively recent phenomenon. It is, however, extremely popular among artists and illustrators, both for personalized and commissioned work, and there is a surprising number of illustrators specializing in these themes.

Science fiction is a self-explanatory category, and the illustrations of these subjects will be obvious, but the concept of "fantasy" may require clarification in terms of how it is used in this book. The illustrations reproduced under this heading are included because they represent images which either are totally impractical in reality or are based on theoretical applications of modern technology, which in current practice may only be at the design stage. The nature of both fantasy and science fiction illustrations means they inevitably incorporate subjects equally at home under other headings – transport or industrial, human figure or landscape – depending on the main content of the illustration.

Common to all is the need for a vivid imagination, combined with an interest in the future and what it might or might not hold. Often such illustrations use dramatic settings in outer space or on fictitious planets as backdrops to the main subject. This requires skill in being able to render landscapes, but maintaining the sense of depth and perspective with which the reader is familiar; even though the theory of perspective may not follow the same rules outside our own universe, it is evident that many science fiction illustrations are depicted in an Earth-like environment or even on this planet as we know it. A good understanding of contrast and the effects of light and shade are also of paramount importance, especially when showing planets or spaceships against the intense blue-black of space, but with highlights created from the unfiltered light of distant suns. A good source of reference for these effects can be obtained by a close study of the many photographs taken by the American and Russian space agencies.

In terms of airbrushing techniques, fantasy and science fiction subjects do not pose any particular problems. Any illustrator with some experience of technical subjects will find the required skills easily transferable. The only area requiring possible practice beforehand will be in the rendering of backgrounds, be they skies or landscapes. Freehand spraying is a technique often found in illustrations using these themes, in particular on planets. All this requires is practice in controlling the airbrush and at the same time maintaining form and shape. The use of distortion is one method of creating emphasis in an image, but this again requires careful drawing to make sure that the effect works. Even though it is distorted, an image must never look wholly improbable, as this will offend the eye of the viewer.

Mechanical bird by Nigel Tidman

Faucets
Robin Koni

This is an excellent and beautifully finished piece of advertising illustration, which derives its impact from showing familiar objects in an unexpected setting.

The faucets are comparable to the finished illustrations selected to demonstrate examples of CHROME EFFECTS. In fact, the approach appears very similar, in that FILM and LOOSE MASKING have been used to arrive at the hard and soft edges representing the quality of the brass. In addition, the preponderance of blue from the sky and sea has been included as reflected color. This has been well controlled, because it would have been so easy to overspray, making the reflected areas turn a muddy green.

The sky represents an example of GRADATED TONE and ANGLED SPRAYING, although the change in tonal values from the top of the illustration to the sea level is extremely subtle. This is in keeping with the impression of warm latitudes. The clouds have been oversprayed and hand painted across the sky, with OVERSPRAYING of lighter wisps of white nearer to the horizon adding depth and distance to the image. The base colors of the sea demonstrate gradated and angled spraying, with overpainting by hand to render the wavelets and movement. The carefully controlled color changes in the sea enhance the impression of shallow waters running into deeper water toward the horizon, with the island offset to the left rendered primarily by hand in strong tones which almost match those of the sky. This gives a coherence to the background elements which does not detract from the purpose and principal image of the illustration.

The running water is a good example of accurate observation, as is the way in which it is shown hitting the sea, where light SPLATTERING has been used to indicate the small splashes of broken water.

Spaceship battle over London
Tom Stimpson

This imaginary, futuristic projection of an air combat scene over London is a classic example of what a highly skilled airbrush illustrator can achieve with the combined assets of a vivid imagination and strong, basic drawing skills. This and the companion painting overleaf are undoubtedly superb illustrations containing a vast amount of detail, all of which is in context with the overall image, and showing careful control in color and tonal balance. As such, they are worth detailed examination, because of the amount of information that less experienced airbrush illustrators can extract from them.

The composition has been designed to focus attention on the large attacking spaceship. Even though this black, delta-shaped machine is shown just above the absolute center of the illustration, the eye is drawn to it by the angle and positions of the two defending fighters. The sweeping curve of the River Thames, flowing below a modernized Westminster Bridge, also leads the eye toward the attacking ship. The clouds in the sky similarly focus the attention and increase the sense of distance as the cityscape fades away toward the eastern horizon.

Many different airbrushing techniques have contributed to the effects. Initial spraying has been applied through FILM MASKING, giving a hard-edged finish. The principal outlines to the spaceships are examples of where this has been used. CARDBOARD, LOOSE and ACETATE MASKING create the soft edges in varying degrees, depending on the distance they are held away from the artwork. An example of good control in using loose masking is apparent on the starboard wing of the defending spaceship, at the bottom left of the black attacking ship.

GRADATED TONES are an integral and important aspect, contributing to the illustration's success. The black attacking ship is completely sprayed using this technique, and it is important to note that the base color is blue-black, not solidblack. This gives it depth and solidity, also apparent in all of the illustrations reproduced in this book which show items or subjects which in reality are painted black. In fact, the port, vertical side of the black ship shows more blue than black as the color shades toward the nose. The same is true of the horizontal surface of the underside, which also reflects light coming from the ground.

Gradated shades help to give a three-dimensional quality to the skies and cityscapes. Further application of shading, among many other instances, is on the starboard fin of the defending spaceship which is just disappearing out of the frame. OVERSPRAYING is another technique used to good effect.

The quality of this illustration has been further enhanced by the finish and neatness applied in the LINING-IN and RULING techniques, including the LETTERING and use of HIGHLIGHTS. ANGLED SPRAYING, CAST SHADOWS, DOT CONTROL, FREEHAND SPRAYING, KNOCKING BACK and LINE CONTROL have also been used.

The protective domes covering the Palace of Westminster, Westminster Abbey and St. Paul's Cathedral have been oversprayed with gradated transparent white against a hard-edged mask.

London tourist ship over Tower Bridge
Tom Stimpson

This second illustration is more sedate, showing an eight- or nine-story, futuristic London Transport tourist spaceship, approaching an air-traffic control station from the former docks area. The time is early morning, and the use of reflected sunrise on the cityscape below, as well as on the spaceships and air-port, demonstrates an excellent understanding of how color and light are reflected, even on matte surfaces. As with the illustration on the previous page, the feeling of depth and space is accentuated by the composition and perspective, for although the eye is drawn to the tourist ship, it is then taken into the distance toward the rising sun, which is "off-stage" to the left.

Techniques used on the previous illustration have also been used here. For example, cardboard masking has been employed to indicate the difference between the reflected light of the sunrise and the shadow of the nose of the tourist spaceship. It is also visible on the underside of the shuttle-craft in the top-right corner. Notice, too, how the illustrator has applied GRADATED TONES within these loose-masked areas. This adds to the understanding of the shape of these vehicles.

The tourist ship uses a brown-black as a base color, to comple-ment the color of the morning sky and to allow the reflected colors of the sun to harmonize with the body of the ship.

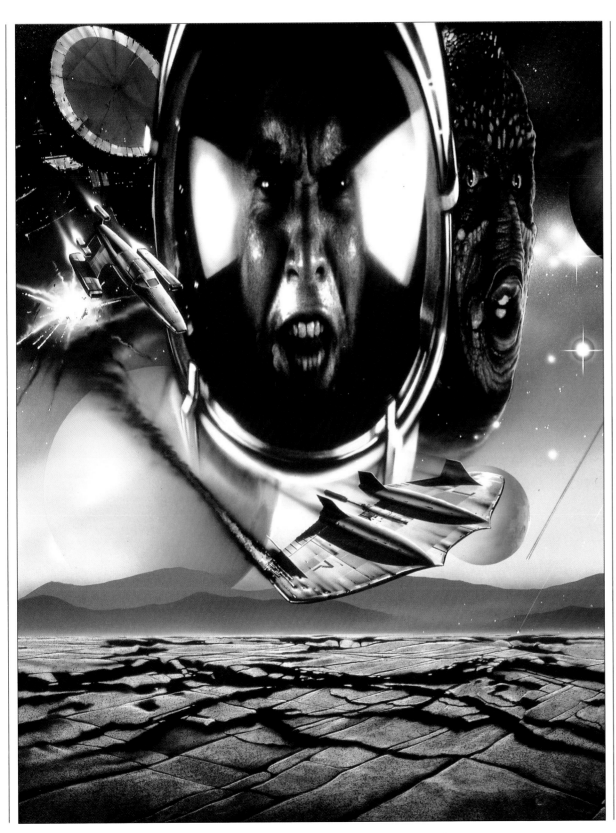

Spaceman
Tom Stimpson

A dramatic and powerful image which uses an incredible number of airbrushing techniques, and also hand-painting.

The sky contains some particularly ingenious effects. For example, the planet in the top right has a definite three-dimensional quality, which has been achieved by allowing a reflected HIGHLIGHT to show on the surface facing the observer. While this face is in shadow, the strength and depth of the shadow has been restricted to the right-hand edge and to the area where it lies against the face receiving light from nearby stars on the left-hand edge, where there is a very intense white highlight. This all combines to give this planet a very clear spherical shape (see BASIC FORMS). The same technique has been used on the two planets just above the horizon and below the spaceman, except that on the larger of the two, the illustrator has allowed the base color almost to blend in with the immediate sky color. The combination of the colors used and the way in which the airbrush has been controlled gives these planets a texture resembling that of marble.

STARBURSTS, DOT HIGHLIGHTS and HALOING have been used on selected stars, again demonstrating excellent airbrush control. The falling meteorites show careful line control, with overpainted highlights to represent the burning matter.

149

Spaceship approaching planet
Tom Stimpson

One of the advantages in drawing science fiction subjects is that the laws of physics and nature, as well as the limitations of man's technological development, can be totally ignored. Anything is possible and perfectly feasible within the mind of the illustrator. The illustration reproduced above shows one such example; the spaceship has an impressive sense of scale, created purely through the use of perspective. To set an imaginative design in an environment of space, with planets close by, provides us with some reference for judging the scale because we are familiar with the numerous photographs which have been taken within our own universe. The viewer is readily convinced that the image shows something incomprehensible in terms of the Earth, but acceptable in space.

It is also an interesting composition, for the front of the spaceship is immediately in line with the center of the ringed planet. This means the viewer inevitably notices the two at the same time. Offset below and to the left of the ship is another landscape of a planet or moon.

The technique of rendering the atmosphere of space, and the form of the ringed planet, follows a pattern which is popular with illustrators of these subjects. A backdrop of intense and opaque blue-black has been sprayed as a GRADATED TONE running into another, smaller area, of green-black shading. SPLATTERING has then been OVERSPRAYED in varying densities of opaque white to represent the stars. Selected stars have had DOT HIGHLIGHTS airbrushed in, while others appear to have been painted with a brush. The large, ringed planet follows much the same technique except that, because of its scale, additional spraying has been worked into it. The ring cutting across the planet has been masked off for the planet itself to be sprayed. The ring shows a combination of hard and soft edges, with some white overspraying to soften the inside curve where it turns toward the hidden side of the planet. The

planet has a very subtle gradated tone of reflected color on the edge opposite the light source, which blends in with the green-black of the main body. This has a soft edge where it runs into the highlight, which itself gets stronger as it is brought toward the outer edge of the planet facing the light. The edge between the shadow and highlight is broken up by subtle overspraying of the green-black and small wisps of a lighter color running more into the shadow side. This all gives the impression of surface texture on the planet.

To pick out detail, especially on the many panels and vents, much use has been made of RULING and LINING-IN. Intense white dots have been applied with a brush to indicate bright lights, with overspraying in white being used to show exhaust gases. The spaceship is a truly imaginative piece of design which works extremely effectively and, more important, convincingly. The color tones of the ship complement those of the planets and sky, all contributing to a cohesive composition.

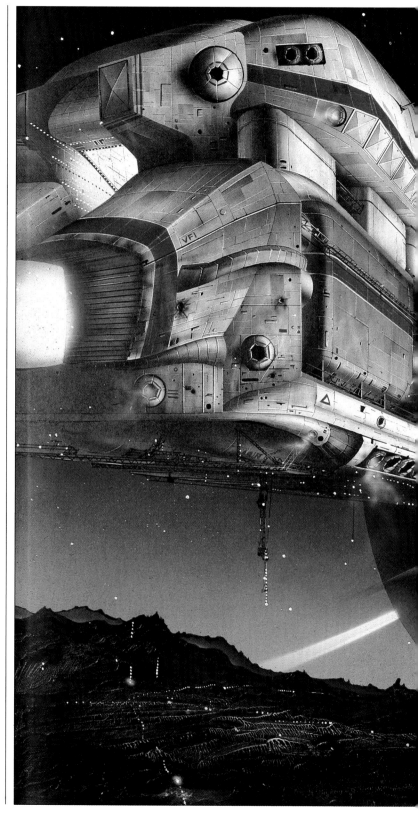

Subtle shading has been used to indicate surface weathering and panel detail, incorporating both hard-edged and gradated soft-edged shadows.

The distant planet shown in this detail is a complete disk the same color as the sky, with FILM MASKING used to delineate the external edge facing the light source and a LOOSE MASK to allow the light to blend in with the shadow side. From a distance, it appears that the reflected light is the only part which has been masked, but in fact, the whole planet has been defined in this way.

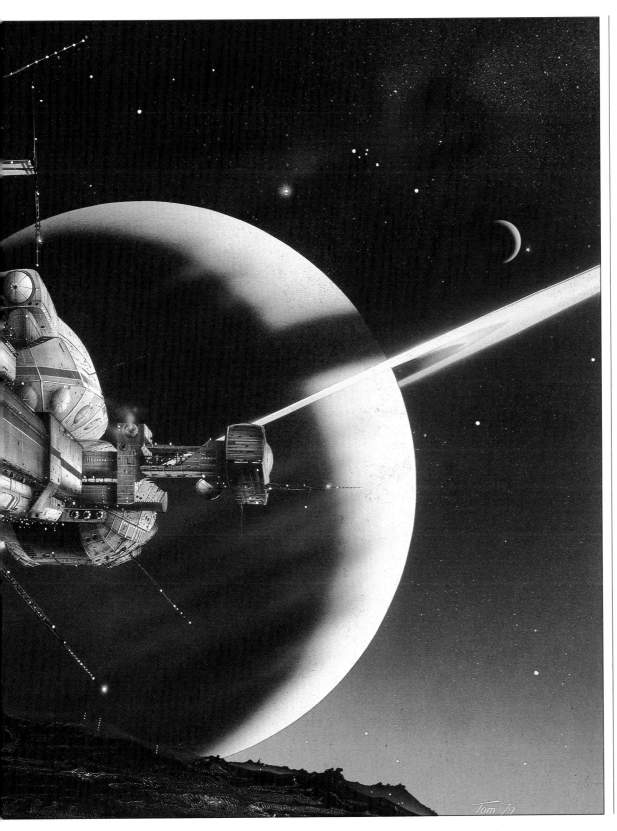

Tom 79

Starship approaching Jupiter
Lionel Jeans

This illustration is a self-promotional piece of work which was produced to show prospective clients the illustrator's skill in the use of the airbrush, as well as his ability to design science fiction images. It has an excellent feeling of depth and distance which has been achieved by finishing the American starship with crisp, hard edges, while the surface texture of the planet Jupiter is sprayed freehand and with GRADATED TONES only, the right-hand edge being sprayed against FILM MASKING. The reference for Jupiter came from photographs taken by the Voyager satellite.

Various intensities of SPLATTERING have been oversprayed onto the intense blue-black of space to represent distant stars. One or two of these stars have been further brightened by the use of DOT HIGHLIGHTS. The starship is basically formed by the white of the board, with minimal airbrushing being used in certain areas to develop the form, and with some panels being picked out. This was intentionally done to accentuate the intense, reflected light from the sun.

The detail on the starship was applied by brush and technical pen before the sprayed form was added.

Concept fighter and helicopter
Lionel Jeans

For an advertising illustration, modern and futuristic aeronautical developments are combined against a "computer generated" backdrop of planet and grid.

The method employed to depict the planet and grid was to carefully mask all lines and then spray a flat, opaque base of black waterproof ink. Once this was thoroughly dry, the FILM MASKING was removed, and the lines were then oversprayed freehand with opaque gouache, green for the grid and blue for the planet. This produced the effect of softening the lines very slightly, giving the impression of a glow such as seen on a computer screen. Where the lines intersect on the far side of the blue planet, blue-black was oversprayed to increase the three-dimensional effect.

The aircraft and helicopter were masked and sprayed using FILM and ACETATE MASKING, with CAST SHADOWS, HIGHLIGHTS and GRADATED TONES being applied in a manner comparable to the majority of subjects under the Transport and Industrial Design themes.

Syringe
John Spires

The work of inexperienced airbrushers often shows common faults caused by impatience – visible evidence of mask cutting, poor airbrush control and uneven colour application. These problems may also be the result of some students trying to illustrate complex objects and shapes before they have mastered the basic techniques. It is always advisable, therefore, to start with an object which does not demand too much pre-planning.

However, having said that, it is often the case that what may appear to be a straightforward airbrushing exercise in fact involves quite complex procedures. The illustration reproduced here is a good example of something which, superficially, appears simple in terms of airbrush technique. Detailed study shows that it obviously is not, and that it has required careful thought and pre-planning to arrive at the overall finish and effect. FILM and LOOSE MASKING have been used with great skill, which, combined with the quality of HIGHLIGHTING and RULING, makes this a superb piece of state-of-the-art airbrushed illustration.

While many of the techniques used in this illustration are described and illustrated elsewhere, it is worth mentioning the way in which the illustrator has approached the transparent body of the syringe against the blue of the tiles. The use of varying shades of the same blue to spray the syringe, as well as the way in which the refraction of the light distorts the shape of the tiles immediately behind, indicate careful observation and color application. Note, too, the density of tone in the blue where the syringe is part-filled with a clear liquid. The spring encircling the syringe and attached to the polished plastic handle also shows the natural distortion where it is seen at the back and through the body of the syringe.

The water running around and into the sink hole is an excellent example of GRADATED TONES, as is the CAST SHADOW of the large-ringed chain on both the tiles and the white of the board.

Killer Klowns from Outer Space
Tom Stimpson

Producing convincing fantasy figures which have movement and life in them is not just a case of using one's imagination, for a general understanding of anatomy remains necessary.

The modeling in the faces of the clowns has been distorted to make them appear quite the opposite of what one would normally expect when thinking of clowns – which explains the deliberate misspelling in the title! However, as a piece of imaginative illustration, the subject has been well drawn and carefully airbrushed. The faces have been developed by FREEHAND SPRAYING and with ACETATE or LOOSE MASKING using GRADATED TONES and soft edges to bring out the detail. The typical clown make-up has then been oversprayed within FILM MASKING to maintain the shapes; these have been cut to follow the subtle changes in direction caused through the various facial expressions and underlying shapes of the heads. This type of overspraying requires careful color control to ensure that the makeup, which is clearly defined, does not appear separate from the face on which it is shown, but is clearly a part of it and on the same surface. To contrast with the almost rubber-like texture of the clown's faces, their costumes have been rendered to represent silk, or a similar semi-shiny fabric. To create the surface sheen, the contrast between folds has been exaggerated, with intense HIGHLIGHTS being added to increase the effect. Extensive use is made of LINING-IN on both the faces and the costumes.

The title, combining airbrushing with RULING and lining-in, is a good example of LETTERING TECHNIQUES. The lightning flashes extending from each end of the title are freehand lines, overpainted at the center with hand-applied opaque white lines. The sky shows a typical and popular method of rendering a night sky, with SPLATTERING being used in varying densities to represent the stars and selected elements being over-sprayed with DOT HIGHLIGHTS.

Maplin catalogue cover 1989
Lionel Jeans

This is a complex multimedia illustration, with acrylics and waterproof inks used in approximately equal amounts. Among the many techniques which have been used to achieve the overall effects and impressions are ACETATE or LOOSE MASKING, ANGLED SPRAYING, CAST SHADOWS, FILM MASKING, FREEHAND SPRAYING, GRADATED TONES, HIGHLIGHTING, LINE CONTROL, LINING-IN, OVERSPRAYING and RULING. Of particular note is the excellent control of the airbrush in association with the loose masking of the edge to the huge sun, and the way in which a reflected glow has been achieved immediately around it. The clouds, too, have been very well handled, combining hand-painting and freehand spraying. The success of the clouds is demonstrated by the fact that it is difficult to identify the technique used, and this is something which all students should remember. If the technique is more apparent than the effect, then the illustration will not work.

Two low-flying craft cruise above the city. Note how the color of their bodywork is echoed elsewhere in the composition.

The use of simple shapes to represent a cityscape is very effective. The detail of the city and landscape was painted first, by hand, and then the whole area was oversprayed with a base of shaded colors, before applying shading to the shadows at the base of the skyscrapers.

HUMAN FORM

There remain some illustrators from the "old school" who believe passionately in keeping to so-called traditional methods of rendering the human form and will continue to cast aspersions on artists who use the airbrush. Fortunately, such short-sightedness is less typical of those responsible for commissioning illustrators, and there is increasing evidence in magazines and books that the demand for airbrushed illustrations of figures shows little sign of declining. In fact, there are some illustrators, notably from Japan, who excel in rendering the human form with an airbrush. Of particular note are Hajime Sorayama and Jun'chi Murayama, both of whom have had their work widely published in the west.

Alberto Vargas was probably the first popular illustrator to use the airbrush to render the human form. During the 1940s, he produced for *Esquire* magazine many illustrations of the immaculate "all-American" girl, with an anatomy which defied both nature and gravity. However, although his work was popular and widely received, his technique simplified the surface features of the human form – all the Vargas girls had, for example, unblemished and wrinkle-free skin. Although the pin-up style remains popular, the demands of a more discerning clientele means that the human form is now airbrushed and painted as it really is, with a degree of detail that would make Vargas blush!

The human form is considered the most difficult subject to represent accurately and convincingly in a drawing, and as a consequence, there are few illustrators able to draw figures without any reference. Often photographs or life studies are used, with changes being made to suit the attitude required. There are, however, many reference books on the subject for illustrators and visualizers. Once the initial drawing has been completed and transferred to the artwork, the next major hurdle is the color representing the flesh tones. When students attempt to emulate the illustrators who successfully use the airbrush on the human form, they come across a major drawback, which many do not recognize, which is that the illustration cannot be rushed. There are no short cuts when rendering something made up of so many compound curves, with sometimes very subtle shading changes. Too often, students become preoccupied with achieving the finished illustration, with the result that many attempts appear flat.

On some illustrations, it is necessary to apply as much hand-painted work as spraying. When this is required, it is essential that the two appear as one as far as the finished illustration is concerned. It looks very amateurish when the brushwork is not integrated with the spraying. The illustrations reproduced in this section show how different techniques and styles produce different effects. To develop expertise in the subject, further examples should be collected by students, to form a permanent reference source, which also demonstrates the trends in what is currently in demand.

Human hand by Mark Taylor

Man's face
Mark Wilkinson

This effective and well-executed illustration combines both black-and-white and color techniques. The shoulders and part of the outline of the head have been sprayed using ACETATE or LOOSE MASKING: sprayed color has been deliberately allowed to seep under the mask and blend into the soft blue which forms part of the background. At the top of the head, the degree of mixing between the two colors is far greater, often a characteristic of freehand spraying. The wisps of loose hair hanging over the man's forehead also show carefully controlled freehand work, as does the strong, contrasting shadow on his right. In order to give greater impact to the "torn paper" effect around the eyes, the strength of shading and shadows has been increased in relation to the rest of the face. This also adds to the impression that the observer is looking through the hole and seeing the real face behind.

Overall, this illustration gives the impression of being extremely simple in terms of airbrushing technique, regardless of the fact that it may well be photographically based. This could not be further from the truth, as is evidenced by the technique used to render the eyes and mouth.

Virgin's Miami
Brian Robson

An outstanding and beautifully executed example of the use of the airbrush to render the human form, this illustration has much to commend it. Various airbrushing techniques have been used very skillfully, and the composition is also well thought out.

The way in which the soft, blurred background of the spectators and visible areas of the field have been rendered contrasts with the main subjects – the players. The effect of the overall finish maintains the intended point of the image. In fact, the background is nothing more than soft-edged spots of three or four colors against an overall base color. Both of these elements are oversprayed with a gradated shade representing the shadow from the canopy covering the spectators. LOOSE MASKING has been used for a soft-focus effect in the scoreboard on the extreme left.

The ten players have all been rendered using FILM MASKING to maintain the clearly defined edges. The red and white team jerseys of those behind the front two players have been rendered in flat colors. The white shirts have as their base the white of the board. Both have then been oversprayed with CAST SHADOWS and with GRADATED TONES, showing form and folds in the material. Overspraying on the colored stripes and numbers has continued the form from the base colors of the shirts and trousers, with limited white highlights being used on the stripes edging the sleeves of the player in white.

The helmets of all the players have been rendered to represent the hard, polished surface of plastic, showing integral gradated tones, cast shadows and reflections from the stadium lights. Small white linear HIGHLIGHTS have been added to the face guards in just enough quantity to give them solidity.

The limbs and faces of the players have been carefully sprayed, with reflected highlights used to improve contrast. Note the use of shadows on the arms, which start with hard edges and then run into gradated shades; this effect can be achieved using acetate masks (see also OVERSPRAYING).

The players' numbers and wording on the helmets have been carefully observed, as all follow the correct contours and twists of the shirts and helmets. The title and the company logo (see LETTERING TECHNIQUES) have been rendered with the same care as the illustration, with the colors of the whole working very well together.

Although a very colorful and bright illustration, it is worth noting that in fact the illustrator has used a limited palette, which undoubtedly adds to the success of the image.

The two players in the foreground are treated in greater detail. This includes representation of the surface texture of the white shirt, but this has been restricted to those areas in shade. A screen with a uniform pattern of holes at 45° to each other has been used as a mask (see also FABRIC MASKING) and the resulting pattern oversprayed with the folds, making the holes appear just dark enough to be visible. This required careful control to integrate the screen effect and make it appear as intended, as texture rather than a flat pattern. Loose masking has also been used to spray the cotton texture on the cuff and elbow bands, again with the emphasis on those areas in shadow.

Laser lancers
Andrew Farley

This illustration should be studied in conjunction with the finished illustration used to demonstrate the application of CAST SHADOWS, as it is by the same illustrator and the two are intended to be seen as a pair. As with the first example, this rendering shows the observation necessary when trying to achieve the effect of light and shade on the human form under a specific light source, in this case at sunset. This is far more difficult than it may at first appear, because it is easy to spray excessive tone in the shadow areas and thereby lose the detail on the figures and their costumes. The tonal balance has been particularly well controlled on the girl's costume, where there are many loose folds.

Couple
John Spires

The rendering of the human form with an airbrush requires much skill in using the tool freehand, especially if large parts of a body are to be shown naked. This is because the human form has very little in the way of hard, clearly defined edges and even the shadows, which may have such edges, require FREEHAND SPRAY-ING due to the many variations in shading apparent within the shadow area. The faces, torso and arms in this illustration clearly demonstrate the variations in these tonal values. The same is equally true of the girl's yellow blouse and skirt, for the creases and folds must always appear to be related to the person who is wearing them, and not "put on" as some later afterthought. Freehand spraying has obviously been much used in this illustration, but use of FILM, ACETATE and LOOSE MASKING is also evident. Brushwork and SCRATCHING BACK have been used on the couple's hair, both applied to a base of sprayed color.

Girl's head
Brian Robson

The intensity of the vibrant colors used in this illustration is the result of the solid and opaque black background. This has allowed the illustrator to give a subtle finish to the tips and edges of the flames, which also blend in well with the hair. The simple treatment of the visor has ensured that the surface finish is clearly recognizable, with only the reflection of the fore part of the hair being added. The highly reflective surface of the visor is further enhanced by the matte finish of the white elasticized band which keeps it in place. This band is also a useful division between the two shades of intense red, which, if shown against each other, would clash and spoil the overall impact. The features and detail on the face have been kept to a minimum, using FILM MASKING and GRADATED TONES, concentrating the eye on the girl's hair as it turns to flame.

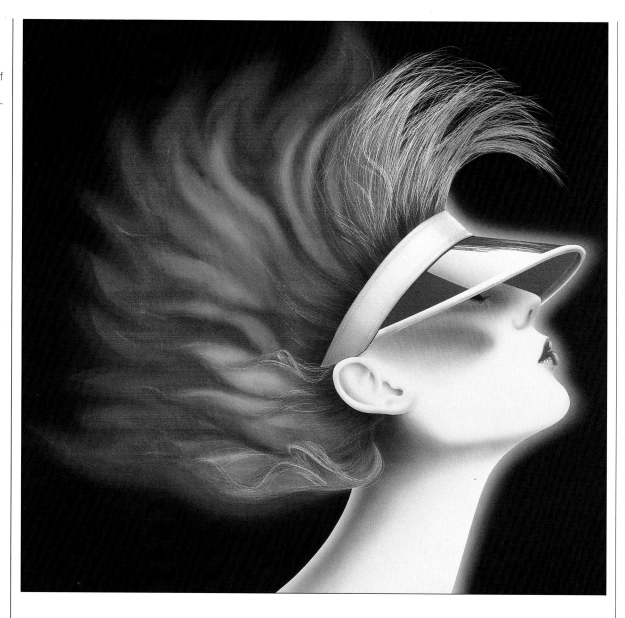

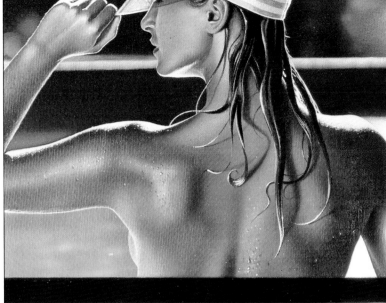

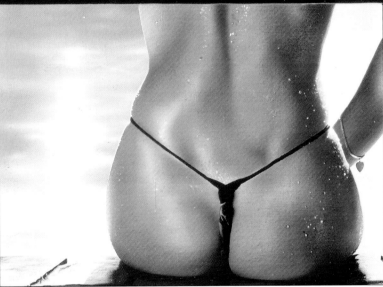

It is interesting to note the difference in texture between the two halves of this illustration. The central horizontal bar gives the impression of looking at the girl through a window. This impression is enhanced by the smooth texture with which the lower half has been sprayed and painted, while above the bar the illustration has a clearly defined surface texture similar to ribbed glass. It is likely the effect was achieved by using a medium grain canvas for the top and a pure flax, finely grained canvas for the lower half.

Girl with bikini bottom
Tom Stimpson

This illustration of an almost completely naked girl, her body illuminated by intense sunlight, again demonstrates the need for careful control in using the airbrush freehand. The various shade changes and natural HIGHLIGHTS could not be applied using masks in any traditional sense. The pure white highlights on the girl's face, shoulders, left arm and around her hips have been brush-painted after spraying the body, with the edges stippled to blend into the shadow edge. The water droplets have also been applied by brush, and consist of varying sizes of dots painted in a slightly darker skin tone with opaque white dots on top. The water of the pool and the background have all been rendered with soft-edged GRADATED TONES and minimal detail.

Heel with rose
Brian Robson

The impact of this illustration owes almost everything to the skillful way in which the illustrator has rendered the five basic surface textures in the image. First, there is the texture of the seamed stocking, in particular the heel. The whole foot has been sprayed in the necessary colors and with the appropriate shade changes applied as GRADATED TONES, after which the nylon texture has been added by brush. There are even slight blemishes in the run of the nylon. Note that the front part of the foot, because it is directed away from the observer, has been sprayed with soft edges to give the impression of being slightly out of focus. The spike heel of the shoe has HIGHLIGHTS achieved through FILM MASKING, and with a very subtle gradated shade of pink oversprayed on the left-hand edge, to pick out the color of the rose. This gives the shoe the impression of being made of black patent leather. The sole is sprayed with just a CAST SHADOW and gradated tone to give it form, which not only contrasts with the shine on the heel, but also indicates the matte white leather from which it is made.

The rose is also matte finished, but not to the same degree as the shoe sole. The contrasts between the different petals and the highlights clearly differentiate between the texture of the rose and that of the shoe sole. The rose also has droplets of water on some of its petals, the result of film-masked shapes sprayed with a slightly different shade of the rose pink, with shadows added and small, intense white highlights applied by brush or SCRATCHING OUT.

The final surface texture is that of the floor, which is airbrushed to resemble a polished surface. Yet again, the illustrator has successfully shown the difference between two surfaces which are basically similar in reality: the hard, shiny surface of the patent leather contrasts with the reflective floor because the latter has been sprayed with soft edges through LOOSE MASKING.

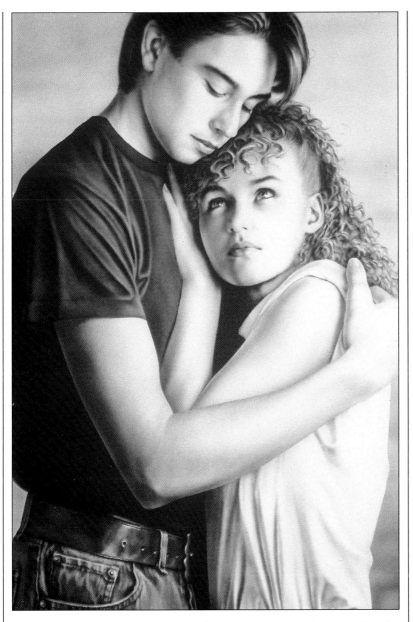

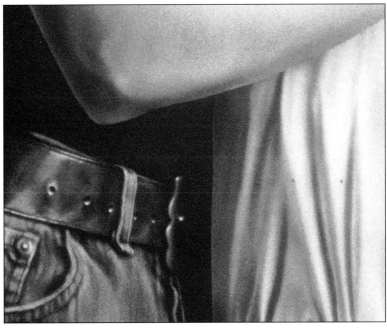

The detail of the young man's clothes and the way in which they hang have been well-observed, with the surface texture of the jeans and leather belt being particularly good examples.

Young couple in an embrace
Andrew Farley

Airbrushed black-and-white illustrations of any subject are always more difficult than those in color, because color detail is often relied upon to determine shape and form, whereas in black-and-white, a greater understanding of tonal values and contrast is needed to achieve a comparable effect. In this illustration, the monochrome rendering works extremely effectively and realistically.

FILM MASKING has been used on the principal shapes. The areas within the masking are modeled primarily and extensively with FREEHAND SPRAYING, with ACETATE or LOOSE MASKING in support.

Victim
Alfons Kiefer

Another good example of black-and-white airbrushing showing increased contrast between the lights and darks to add to the impact of the composition. The woman's face and neck have been well modeled by FREEHAND SPRAYING, with LOOSE MASKING used to pick out the immediate edges of some of the CAST SHADOWS. These shadows are also run into the GRADATED TONES of the face.

The sweater is a good example of the representation of a coarse-weave wool. This has been achieved by hand-painting the textured weave and then OVERSPRAYING form and shadow, which knocks the texture back so that it does not conflict with the other surfaces depicted. The hair combines a sprayed base tone with hand-painting to show detail and form. The HIGHLIGHTS have also been hand-painted with opaque white.

Woman with raincoat
Alfons Kiefer

Although this section of the book is concerned with the rendering of the human form, this illustration primarily demonstrates how to use the air-brush when depicting the material of a heavy waterproof raincoat, and as such it is a good example. It shows good observation, although the image is based on a photograph.

The use of reflected colors has been mentioned many times in this book, regardless of subject matter. This is because students often see only the local color of whatever it is they are airbrushing. Illustrations based on local colors and shades may well show evidence of good handling technique, but as finished and commercially acceptable illustrations, they fall far short of the standards shown in this book. In this example, the illustrator has chosen an intense green-black as his backdrop to the figure. The depth of green is allowed to come into its own in the bottom right-hand corner and as a glow around the woman's head. Variations of the green shades have then been incorporated into the colors of the raincoat, to good effect. And as green is basically made up of blue and yellow, the latter color has also been emphasized to increase the strength of the reflected light in the same areas as the green, with yellow-green also visible on the woman's hands and face.

Der Dritte Man '84
Alfons Kiefer

A realistic black-and-white illustration used as a title for a German article on spying has clearly taken inspiration from Graham Greene's *The Third Man.*

In this study, the artist has effectively used solid, opaque CAST SHADOWS with GRADATED TONES, not only on the raincoat, but also on the large cast shadow on the wall behind and on the shadow of the second man down the side street. The hat of the man in the foreground is almost a flat shade of opaque color, but just visible is the crease running down the front. To contrast with the obviously matte texture of the hat, the silk band running around it has been sprayed lightly enough to indicate the shape and form of the hat as a whole. Emphatic contrast is again used to good effect between the hat and the face, which is lit up by the lighted cigarette. It is in this immediate area that the illustrator has used the gradated cast shadows on the raincoat and facial features.

The wall behind has been sprayed with varying degrees of shading to represent weathering. This has then been oversprayed with SPLATTERING to give it texture. The joints between the blocks of stone and the cracks have been applied by brush, with white and light gray highlights on those edges reflecting streetlights and the glow from the match.

The base tones of the two main buildings have been sprayed with gradated color, to give the reflected streetlight effect, and then the details of the raised stonework have been lined-in with opaque black to represent the cast shadows. The same technique has been adopted for the windows. A freehand highlight has been sprayed over the neon light above the first entrance, with the lettering just visible, but not legible. As these two buildings run into the background, so the detail is reduced until the church and surrounding buildings become almost pure silhouettes. The sky is a gradated tone running from almost pure black at the top to a dark gray around the church spire.

Here, the application of the finished illustration is shown. The sky acts as a suitable base on which to place the reversed text and two-color title. The reversed text to the left of the man in the foreground is made legible by the cast shadow on the wall. Often illustrators are given rough sketch layouts on which to base their compositions, because of the need for many illustrations to be combined with overlaid text.

Man looking at model train
Alfons Kiefer

At first impression, this illustration appears to use the SPLATTERING technique as a background, thus giving emphasis to the man and the model train. However, a closer examination will reveal that with the exception of the white HIGHLIGHTS and the hair, the whole of the figure has been OVER-SPRAYED with splattering. The background and foreground, which form a continuous element, have been sprayed FREEHAND with GRADATED TONES of color radiating from a light source hidden by the man's head,

which is also gradated from top to bottom. The splattering has then been oversprayed, following the same pattern of gradation.

Although the man has been treated with splattering, the basic method of modeling his face, hands and clothes follows much the same technique as used in other illustrations in this section. However, of particular note because of their effectiveness are the intense white highlights which act almost as a profile to the man's outline. Naturally, these highlights conform to the shape of whatever part they are on, including the hair; on the hands and

the knuckles here, the highlights also have small touches which point in the direction of the light source. This is an excellent technique.

In complete contrast, the model train and its track have been sprayed without splattering. Even though this is almost out of character with the technique adopted for the rest of the illustration, the fact that not all of the splattering is immediately apparent makes the complete image work. Because of the scale of the train, much use has been made of LINING-IN and RULING.

ANIMALS

It may come as a suprise to find animal subjects included in a book on airbrushing. Many natural history illustrators would consider the airbrush the last piece of equipment they should invest in. However, there are those in art and design education who have the adaptability and foresight to recognize the value of the airbrush in this field of illustration, for the simple reason that there are occasions when it is appropriate. This has allowed students to be more versatile in what they are able to achieve as professional illustrators. As with most illustration techniques and media, each has its place and, used in the correct context to arrive at a successful end result, it becomes immaterial how the result was achieved.

There are many professional illustrators who use the airbrush extremely effectively for animal subjects. The Japanese, in particular, have quite a cache of them, whose work is reproduced around the world. When studying the examples reproduced, it will be immediately apparent that the airbrush is rarely the only tool used to complete an image, especially if realism is intended as the final effect. This is because of the nature of the subject, and in most cases, extensive handwork is necessary either before or after spraying. As with other subjects, there are no shortcuts.

The animal theme can be interpreted quite broadly. Images used in advertising and media contexts may require a somewhat different approach than that applied to a meticulously lifelike natural history rendering. These different aspects are represented in the following selection, as is the fact that the animal may be related to the human figure or other airbrush subject, or may be set in a context quite unlike that of its normal habitat.

Fairground horse by Brian James

Gorilla
Alfons Kiefer

The gorilla makes an unusual, but extremely effective airbrushed illustration. It is unusual in a technical sense because SPLATTERING has been used as a base coat for the complete animal. Oversprayed color and extensively applied brushwork have then been added to develop the form and detail. The base and detail coloring constitutes a more or less black-and-white rendering, requiring careful shading control so that each and every part of the gorilla appears legible. The animal has also been sprayed in a color not normally associated with the gorilla, but nevertheless, the impression is one which is both realistic and humorous. A particularly pleasing touch is the way the illustrator has linked the colors of the glass of beer with the gorilla's eyes.

Fine detail such as the hairs in animal fur can be created either by SCRATCHING BACK sprayed color or by adding careful brushwork. The rendering of the gorilla's coat makes an interesting comparison with the fur of the minks in the example on page 181, by the same illustrator. The difference in technique probably reflects the intended purpose of this illustration in relation to the other.

Pig and British Bulldog
Andrew Farley

Good observation at the drawing stage has resulted in these two illustrations retaining the natural characteristics of the animals, while incorporating the humorously caricatured features.

The shapes which together make up the pig can be broken down almost geometrically. For example, the pig's snout and neck are based on a truncated cone turned horizontally. This gives a natural indication as to where the soft-edged shadows and GRADATED TONES should lie. While this formula has been applied here, the illustrator has also used the gradated tones to increase the strength of the shadows in the folds of flesh on the pig's neck. Rather than spray these following the line of the cone as described in BASIC FORMS, the illustrator has sprayed in a circular direction around the snout and neck. This is very similar to the technique used to describe the parsnip on page 142, another subject which has a basically conical form. It is an effective and time-saving method, because the whole snout can be sprayed and modeled within the same mask. FREEHAND SPRAYING and ACETATE or LOOSE MASKING have been well applied around the snout to model the subject.

The folds of loose skin around the bulldog's face have stronger and more clearly defined edges, necessitating the use of more loose masking than on the pig's neck. However, the edges are still softly finished, with subtle blending. In complete contrast to the uneven surface texture of the dog is the smooth vest it is wearing. Hard-edged FILM MASKING has been used to define the edges and the Union Jack flag pattern. Except for a limited use of gradated tones on the shaded sides and around the buttons, the shape and fall of the vest are defined by the curves of the pattern.

Both illustrations use a background of gradated, ANGLED SPRAYING with soft-edged cast shadows linking the animals with the immediate surrounding areas.

Carp
Robin Koni

This illustration has been rendered in a simplistic, yet effective style. The lack of detail and surface texture has done nothing to detract from the quality of the image. Clean-cut FILM MASKS have been used throughout, with minimal GRADATED TONES on the fish and some FREEHAND SPRAYING on the leaves of the water lilies.

White horse
Andrew Farley

A romantic and stylized rendering of a horse demonstrates good FREE-HAND SPRAYING on the horse and careful use of loose masking to create the clouds over which it is walking. The tail and mane have a base of sprayed color, over which individual hairs or groups of hairs have been added, either with a brush or by SCRATCHING BACK to the white of the board. The sky has been sprayed freehand with stripes radiating from the lower right-hand side above the clouds. The stripes at the center have been sprayed with loose masks to increase the strength of the edges.

Out of the blue
Robin Koni

This illustration shows action and movement in a dramatic, super-real way, especially in the rendering of the dolphins. These have been sprayed using techniques described under chrome techniques, and also incorporate DOT HIGHLIGHTS.

Edible crab
Graham Austin

As mentioned in the introduction to this theme, there remain some who doubt the wisdom of using the airbrush to render natural subjects such as animals. While it would be possible to complete an illustration of this kind by brush alone, the finished image certainly benefits from carefully controlled airbrushing applied with some skill. The finish of the completed illustration is very much in keeping with the subject it represents. The illustrator has captured the smooth, multi-colored and slightly reflective surface of a typical edible crab. The intensity of the highlights has not been exaggerated, and strong shading, which in places becomes an opaque silhouette, contributes to a powerful three-dimensional image.

Roland Rat
Brian Robson

It is not often that an airbrushing technique is used to achieve a finished result that serves to represent the technique itself! This illustration does, and very effectively, in the torn paper effect and the GRADATED TONES of its CAST SHADOWS. These have been sprayed using TORN PAPER MASKING. Another effective technique is the use of SCRATCHING BACK to indicate the individual hairs in the rat's fur. These have not been randomly applied, but conform to changes in the gradated shading of the base color, which has been sprayed freehand. In contrast to the softness of the fur, the sharply delineated patterns on the shirt have been sprayed using FILM MASKING and then edged with a black holding line. Between the two is the subtly sprayed denim jacket. The rat's hat is a good example of how to spray a folded paper shape. A feature of this element is the soft highlighting, which can be represented either by scratching back or by erasure.

Marter für die Mode
Alfons Kiefer

This illustration could equally have been categorized by its human subject, but because the fur coat and the minks are so clearly its point, they are the focus of interest here as animal subjects. The realism of the minks against the stylized legs and shoes is also an important factor in the character of the illustration.

Close-ups of women's seamed stockings and high-heeled shoes are popular images with advertising agencies and have long been favorite subjects with many airbrush illustrators. As subjects for practicing airbrushing, the two are very useful because of the different surface textures in the nylon covering the leg and the invariably polished leather shoes. The illustration reproduced here takes the contrast of surface textures a stage further by the inclusion of the fur coat and the minks being spiked by the heels of the shoes. It was commissioned for a German nature and environmental magazine, and the headline accompanying the illustration reads *Martyred for Fashion,* for obvious reasons.

This is an excellent illustration which works extremely well. The shadow cast by the coat on the legs is basically soft-edged from a loose mask and gradates around the forms from left to right. The red patent leather shoes, on the other hand, have been more highly finished, with more distinct changes in shading used to increase the detail of the shape and form. GRADATED TONES with FILM and LOOSE MASKING have been used in applying the airbrushed color, and HIGHLIGHTING added to enhance the detail.

The smooth manmade textures of the shoes and stockings are contrasted with and complement the fur coat at the top of the image and the minks below. Both have been sprayed to establish the basic forms, with extensive brushwork, and possibly pencil work too, used to detail the fur of both the coat and the minks. Note particularly the way the illustrator has introduced a variety of colors into the base colors of the minks which gives them depth and a more realistic finish. In fact, the minks are superb examples of how it is possible to give so much "life" to the representation of animal fur.

LANDSCAPES

This book is not concerned with the techniques or definitions of fine art, but with an art form which has very specific commercial uses. In fact, without the client or commissioning agency, many of the finished illustrations reproduced in this book would never have been completed. On this basis, the rendering of landscapes is not easy, especially with an airbrush. The requirements of the client's brief often dictate what needs to be shown and how, and any impressionistic style which the illustrator may have developed in fine art terms is unlikely to be acceptable. The obvious exception, of course, is in the field of fantasy and science fiction subjects, but even here, there is a recognized approach underlying the finished image, regardless of the style of a particular illustrator. This may account for the fact that landscape is one of the least depicted subjects in airbrush art. In many cases, the landscape itself is rendered by hand, with the principal subject alone being airbrushed. To achieve a convincing result requires a level of skill in both airbrushing and hand-painting techniques which few illustrators have the time to develop. However, those that do are producing work of significant quality which ranks with the purer forms of airbrush illustration, and the examples which follow clearly demonstrate this.

As so many of the professional illustrations shown elsewhere in the book use landscape as an integral part of the composition, students wishing to explore further techniques and styles are advised to study these in conjunction with the examples specifically included here.

Blue pool by David Holmes

Cargo pallets
Tom Stimpson

This advertising illustration relies very much on the depth of the sky and landscape to achieve the desired impression, because the actual subject, the cargo pallets, is shown so small in relation to the overall image area.

The sky has been beautifully rendered, and to achieve such a result requires close observation of natural effects and good quality photographic reference: it is impossible to illustrate such a subject only by studying it in nature, simply because it is not static. Extensive use has been made of FREEHAND SPRAYING with ACETATE or LOOSE MASKING used to delineate the edges to clouds, although in some cases the effect has been maintained by freehand control of the airbrush.

The landscape itself has been completely hand-painted, with the sprayed sky and cloud color brought down and over the immediate horizon area.

The cargo boxes have been sprayed, with the addition of LINING-IN and RULING to clarify detail and structure. To give the impression of speed and direction, pale, transparent color has been oversprayed, sometimes blending in with the immediate rear of the box. This overspray has been gradated to fade away into nothing, which accentuates the feeling of speed.

Mountain river with car
John Spires

A limited palette has been used to good effect in this illustration, giving the distinct impression of a river at high altitude and in the colder northern latitudes. The river, although represented in stylized form, has a strong feeling of movement and relies very much on the white of the board to achieve this effect. The sky has been sprayed freehand and with almost a vignette effect, so that a central glow is apparent. The distant mountain ranges have a base of sprayed color, as do the rocks in the foreground, with all having highlight detail added by hand-painting. Soft gradated shadows on the snow direct the eye to the glow in the sky.

Seascape
John Spires

As before, a limited palette proves effective in a landscape view. The sky has a strong and rapidly GRADAT-ED TONE of color running into the clouds on the horizon, which have edges created by FREEHAND SPRAYING and loose masking applied to the sky area, since the clouds are pre-dominantly represented by the white of the board. The sea is hand-paint-ed on an airbrushed base, with SPLATTERING being used to indicate the broken spray where a wave has hit the rock, on the right of the illustration. As with the clouds, those areas of the sea which are an intense white have not been sprayed, but the white of the board has been allowed to remain visible. This saves time, but does require careful planning at the drawing and masking stage.

In the shade
David Holmes

This is an excellent example of how the airbrush can come into its own in the rendering of landscape subjects. Carefully controlled tones of primarily flat colors, and very limited gradated colors, have been used to produce an illustration which has the desired effect of depicting a bright, sunlit environment, such as in the Caribbean. As a technique, the application of flat color may appear easy, but to maintain an even shade requires as much skill as if the color were sprayed with gradations. Even with acrylics or gouache, the spray-ing is not made any easier, because of the need to make sure the color is thoroughly mixed beforehand and, of course, that there is enough time to complete each color area.

The sky and sea are the two major areas where GRADATED TONES have been used. To depict the white surf on the breaking waves, masking film has been kept in place while the sea was sprayed. The white of the board has also contributed to the umbrella, the table and chairs, the edge of the swimming pool and the house. CAST SHADOWS, blocks of flat color and gradated tones have been over-sprayed on these areas to indicate pattern, depth and form. The palm trees could have been either sprayed as flat color or applied by hand, especially if acrylics were used. The red-flowering bush to the right con-sists of dots in two shades of pink and white on a dark, solid base. The same applies to the bushes in front of the house, but the intensity of the pink has been subdued in keeping with the effects of distance. LINING-IN has been kept to a minimum, being used only on the table, chairs and roof.

Solitude
Gerry Preston

This stylized landscape illustration has a similarity to the traditional Japanese method of painting landscapes. With the exception of the branch, the heron and their reflections, the color effects derive from FREEHAND SPRAYING. Three GRADATED TONES of color have been used in the sky and for the water, with the area around the horizon and edge of the lake being the lightest. Oversprayed at this point, in very subtle shades, are the bank of the lake and its reflection. Thin wisps of moving water are represented by freehand spraying in the immediate foreground. The branch is a simple, effective silhouette, as is its broken reflection, while the heron is made up of two silhouette shapes in two separate tones of the same color. The heron's broken reflection is a single silhouette of flat color. Both the branch and the bird have been sprayed using FILM MASKING.

INDEX

CREDITS

Every effort has been made to obtain copyright clearance, and we do apologize if any omissions have been made. The author and Quarto would like to thank the following artists for their co-operation:

pp 10-21 Mark Taylor. **p22** John Brettoner, courtesy of Aircraft. **p23** Andrew Farley, courtesy of Meiklejohn Illustration. **pp24-26** Mark Taylor. **pp27-29** John Brettoner, courtesy of Aircraft. **pp30-32** Mark Taylor. **p33** John Spires, courtesy of Artists Inc. **pp34-36** Mark Taylor. **p37** Pete Kelly, courtesy of Meiklejohn Illustration. **pp38-42** Mark Taylor. **p43** Gary Cook © Bournemouth and Poole College of Art and Design. **pp44-47** Mark Taylor. **p48** Paul Shakespeare © The Patrick Collection, Birmingham and © Bournemouth and Poole College of Art and Design. **pp49-56** Mark Taylor. **p57** Mark Franklin © Bournemouth and Poole College of Art and Design. **pp58-62** Mark Taylor. **p63** James Weston © Bournemouth and Poole College of Art and Design. **pp64-67** Mark Taylor. **p69** (top) Dave Bull; (left) Mark Wilkinson. **pp70-75** Mark Taylor. **p75** (right) Brian Robson. **pp76-79** Mark Taylor. **p80** © Peter Jarvis. **pp81-84** Mark Taylor. **p84** (right) John Brettoner, courtesy of Aircraft. **pp85-91** Mark Taylor. **p92** (left) Brian Robson; (right) John Brettoner, courtesy of Aircraft. **pp93-95** Mark Taylor. **p98** Vincent Wakerley, Visage Design. **p99** Tom Stimpson, courtesy of Aircraft. **pp100-101** Paul Shakespeare © The Patrick Collection, Birmingham. **pp102-103** James Weston © Bournemouth and Poole College of Art and Design. **p104** Christopher Sargent © Bournemouth and Poole College of Art and Design. **p105** Tom Stimpson, courtesy of Aircraft. **pp106-107** Steve Upson © Bournemouth and Poole College of Art and Design. **pp108-109** Dave Bull. **pp 110-111** Tom Stimpson, courtesy of Aircraft. **p112** © Peter Jarvis. **p113** Paul Shakespeare © Bournemouth and Poole College of Art and Design. **pp114-115** Tom Stimpson, courtesy of Aircraft. **p116** David Weeks, courtesy of Kom Design. **p117** Nick Cave © Bournemouth and Poole College of Art and Design. **p118** Jerry Cave © The Gamer Engineering Co Ltd, Sherborne. **p119** John Spires, courtesy of Artists Inc. **p120** Paul Shakespeare © Bournemouth and Poole College of Art and Design. **p121** Lionel Jeans © George Allen & Unwin. **p122** James Weston © Bournemouth and Poole College of Art and Design. **p123** John Brettoner, courtesy of Aircraft. **pp124-125** Tom Stimpson, courtesy of Aircraft. **p126** Mark Taylor. **p127** (top, right) John Brettoner, courtesy of Aircraft; (bottom, left) Brian Robson. **pp128-129** Brian Robson. **p130** Pete Kelly, courtesy of Meiklejohn Illustration. **pp132-133** Brian Robson. **p134** © Paul Shakespeare. **p135** John Brettoner, courtesy of Aircraft. **p136** Brian Robson. **p137** John Brettoner, courtesy of Aircraft. **p138** Tom Stimpson, courtesy of Aircraft. **pp139-142** John Brettoner, courtesy of Aircraft. **p143** Brian Robson. **p144** Nigel Tidman, courtesy of Meiklejohn Illustration. **p145** Robin Koni, courtesy of Meiklejohn Illustration. **pp146-151** Tom Stimpson, courtesy of Aircraft. **pp152-155** © Lionel Jeans **p154** © Ferranti. **p155** (top, right) John Spires, courtesy of Artists Inc. **pp156-157** Tom Stimpson, courtesy of Aircraft. **pp158-159** Lionel Jeans © Maplin Electronics. **p160** Mark Taylor. **p161** Mark Wilkinson. **pp162-163** Brian Robson. **p164** Andrew Farley, courtesy of Meiklejohn Illustration. **p165** John Spires, courtesy of Artists Inc. **p166** Brian Robson. **p167** Tom Stimpson, courtesy of Aircraft. **p168** Brian Robson. **p169** Andrew Farley, courtesy of Meiklejohn Illustration. **pp170-173** Alfons Kiefer. **p174** Brian James, courtesy of Meiklejohn Illustration. **p175** Alfons Keifer. **pp176-177** (left) Andrew Farley, courtesy of Meiklejohn Illustration. **pp177**(right). **p178** Robin Koni, courtesy of Meiklejohn Illustration. **p179** Graham Austin © Blackpool and The Fylde College. **p180** Brian Robson. **p181** Alfons Kiefer. **p182** David Holmes, courtesy of Meiklejohn Illustration. **p183** Tom Stimpson, courtesy of Aircraft. **pp184-185** John Spires, courtesy of Artists Inc. **p186** David Holmes, courtesy of Meiklejohn Illustration. **p187** Gerry Preston, courtesy of Meiklejohn Illustration.

Acknowledgment

Special thanks are due to Tony Marshall, the Principal of Bournemouth and Poole College of Art and Design, and Stuart Cox and Ian Philips, of the School of Computer Aided Art and Design at the same college, for allowing the author the use of computer facilities with which to prepare the text for this book. Thanks to the college for allowing past and present student's work to be reproduced.